T0091693

Acquisitions Editor:	Paul Temme
Publishing Services Manager:	George Morrison
Project Manager:	Kathryn Liston
Associate Acquisitions Editor:	Dennis McGonagle
Assistant Editor:	Chris Simpson
Marketing Manager:	Rebecca Pease
Cover Image:	Liam Kemp
Cover Design:	Marco Lindenbeck, webwo GmbH, mlindenbeck@webwo.de
Translation:	Frank Wagenknecht
Composition:	Multiscience Press, Inc.

Focal Press is an imprint of Elsevier
30 Corporate Drive, Suite 400, Burlington, MA 01803, USA
Linacre House, Jordan Hill, Oxford OX2 8DP, UK

Library of Congress Cataloging-in-Publication Data
Koenigsmarck, Arndt von.
 [Femme Digitale. English]
 Virtual vixens : 3D character modeling and scene placement / Arndt von Koenigsmarck.
 p. cm.
 ISBN-13: 978-0-240-80980-9 (pbk.)
 1. Computer animation. 2. Computer graphics. 3. Three-dimensional display systems. I. Title.
 TR897.7.K63 2007
 006.6'96--dc22
 2007014120

British Library Cataloguing-in-Publication Data
A catalogue record for this book is available from the British Library.

ISBN: 978-0-240-80980-9

For information on all Focal Press publications
visit our website at www.books.elsevier.com

07 08 09 10 11 10 9 8 7 6 5 4 3 2 1

Printed in China

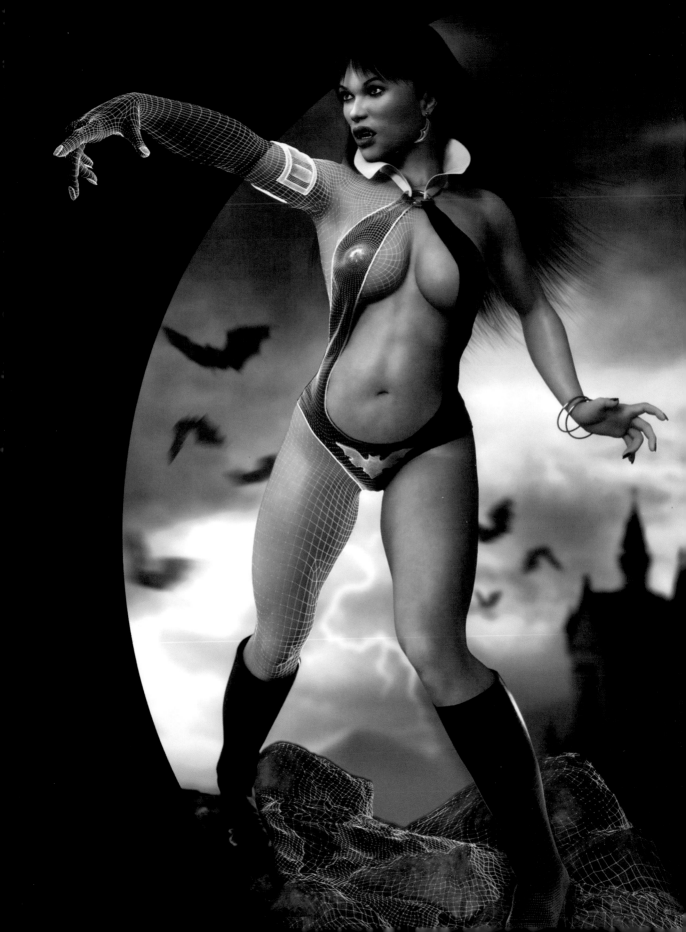

Virtual Vixens

3D Character Modeling and Scene Placement

Arndt von Koenigsmarck

ELSEVIER

AMSTERDAM • BOSTON • HEIDELBERG • LONDON
NEW YORK • OXFORD • PARIS • SAN DIEGO
SAN FRANCISCO • SINGAPORE • SYDNEY • TOKYO

Focal Press is an imprint of Elsevier

Renowned 3D Artists
Present their Work

From Head to Toe: Continuous Workshops for Modeling Virtual Characters

Introduction

Reproducing real or fictional figures has always been a main interest in the art world. Modern computer graphics continue with this tradition and enable the creation of more and more realistic three-dimensional (3D) representations. These characters can even be brought to life in animations, which has resulted in virtual stars having admirers and fans alike. Characters such as Lara Croft from the computer game "Tomb Raider" or the scientist Aki Ross from the movie Final Fantasy are known even to those who normally don't get involved with 3D graphics. It is noticeable that the majority of these characters are female. The main reason for this could be the fact that the typical computer gamer is mainly of the male gender.

For many years I dealt professionally with the subject of 3D graphics. Some readers might know me from my other articles and books about the 3D software Cinema 4D. Even though the work I do at my company Vreel 3D Entertainment (www. vreel3D.de) is mainly about the visualization of architectural projects, products, and work processes, I have not lost interest in working with 3D characters.

Structure of the Book

In order to give you the widest possible range of tips and inspiration to create 3D characters, I split this book into two parts. In the first half I present the worlds best 3D character artists. Names like Steven Stahlberg, Liam Kemp, and Marco Patrito are well known on the scene, but artists who are not as visible, such as Sze Jones from the special effects firm Blur Studio, are also represented. This way you can learn about different ways of constructing a 3D character and become inspired in your own work. I also give every artist space to talk about themselves. You will not only get valuable tips about how these professionals work, but also hear about their education, preferred software, and social and work environments. For this reason I am very grateful for their openness and proud to be able to present some of their exclusive material in this book.

The second part of the book invites you to bring 3D characters to life. There I present two extensive workshops that describe the complete work cycle of modeling 3D characters. This includes all necessary

steps, beginning with the first sketch and preparation of the template to modeling and texturing of the characters, and finishing with lighting and rendering. After you have completed the workshops you should be able to develop and pose your own 3D character. Since we won't use any previously made objects in these workshops, it will be up to you to use your imagination when creating your own virtual character.

Which Software Do I Need?

It does not matter which 3D software you work with as long as it is possible to construct objects from polygons and smooth them with subdivision surfaces. This can be achieved with all common programs like 3ds Max, Maya, Softimage XSI, Lightwave 3D, or Cinema 4D.

Downloading Work Material

I have provided the files that are necessary to follow all of the workshops. You can download the images and references (case sensitive) at http://www.vreel-3D.de/3DCharacter/Referenzen.zip

In this regard I would like to thank Dania Dobslaf for acting as my model, and Richard Polak and Peter Levius, from the website www.3d.sk, who provided me with additional reference material.

I hope you have lots of fun reading this book and wish you success with completing the workshops.

Arndt von Koenigsmarck

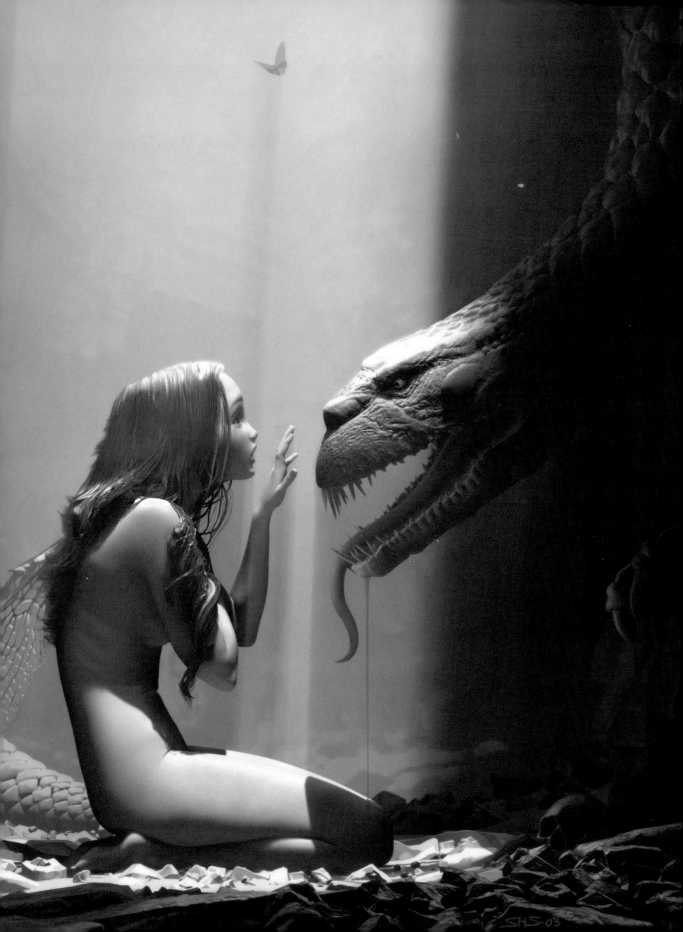

Steven Stahlberg

Born in Australia, raised in Sweden, and at home in Hong Kong and Malaysia, Steven Stahlberg is one of the most well-known artists in the field of modeling unearthly yet beautiful 3D women. But this is not his only subject. His work appears regularly in magazines and books worldwide.

» I was fascinated by computers early on; however, some time passed until I got my first PC including AutoCad in the early 1990s.

I had just finished modeling my first model, a Stuka-bomber, when I stumbled upon a Silicon Graphics computer in a shop for office supplies in Hong Kong. I was fascinated by its speed and display quality, so I grabbed it.

There were already several programs installed on the computer, such as Alias Quickmodel and Wavefronts Personal Visualizer, which I upgraded over the years to Alias Animator and finally Power Animator.

These were good times and I almost felt a kind of magic. The work was like an adventure, since hardly anyone worked with 3D visualization and you had to learn everything on your own. Sometimes I even photographed the models on the screen in order to reproduce, forward, or be able to print them.

I worked from a tiny office in my living room in Hong Kong, and was constantly working on projects. This was not an easy job because of the daycare my wife was running. Toddlers played around me all the time.

At that time a close relationship to the company Optimage in Kuala Lumpur developed, where I worked mainly on advertising. Later I became a partner in the firm. Business was good, but after eight years I felt burned out. On top of that, the fees for 3D illustrations kept declining and financially it became too tight. It was time to look for something else.

Work

Coincidentally, at that time I got an offer for a job in Texas. They saw my work on the Internet and contacted me. You have just got to love the Internet. This job came just in time, even though it took another year until all the necessary paperwork for the work permit was completed.

Since 1996 I worked on a realistic-looking female character. This work got me the job creating the world's first commercial 3D character for the Elite modeling agency. It became a small sensation at the time and was covered by several TV channels and mentioned in multiple articles.

The burst of the Internet bubble at the end of the 1990s brought the project to a halt. Because of that I moved back to Malaysia in 2002 and worked again at the agency Optimage, which was now called Optidigit. The agency closed in 2005 and yet again I am my own boss. ≪

Work examples, workshops, and additional information about Steven Stahlberg can be found at his website www.androidblues. com.

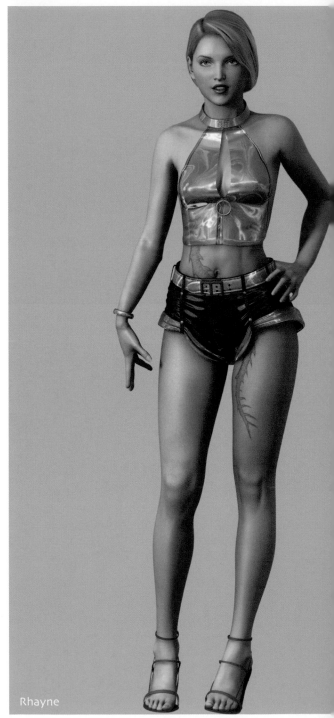

Rhayne

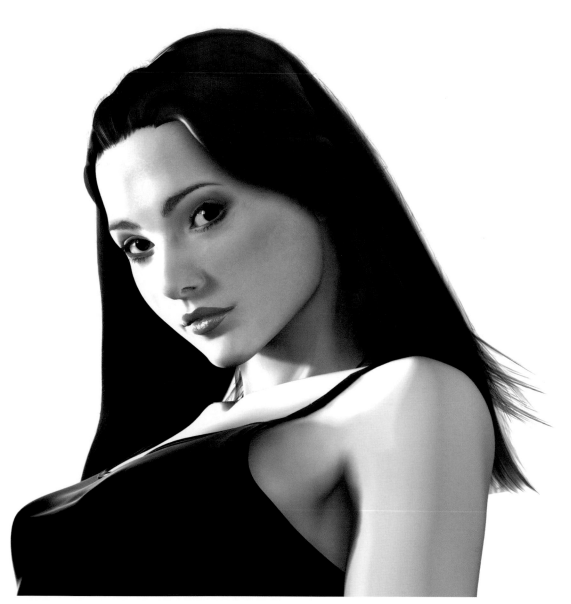

Katrina

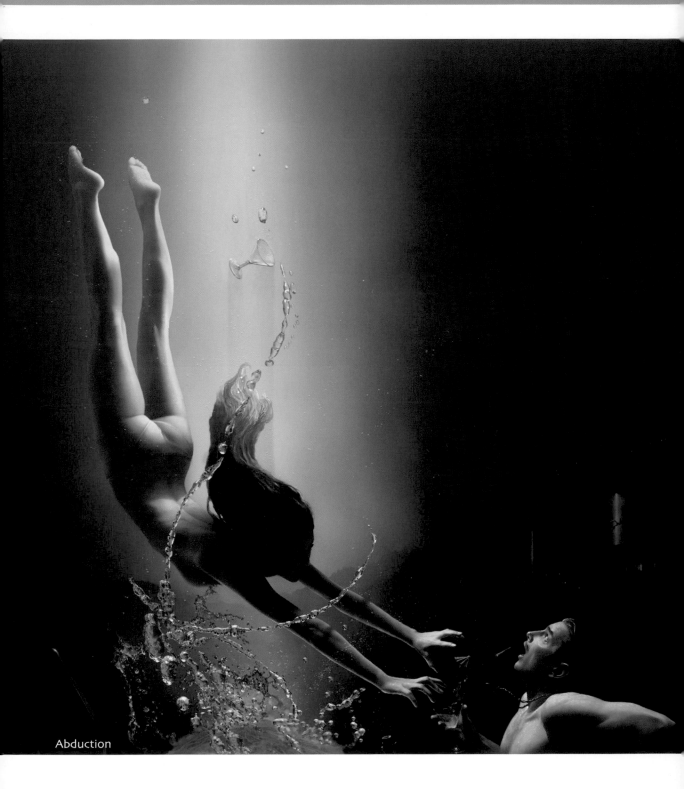

Abduction

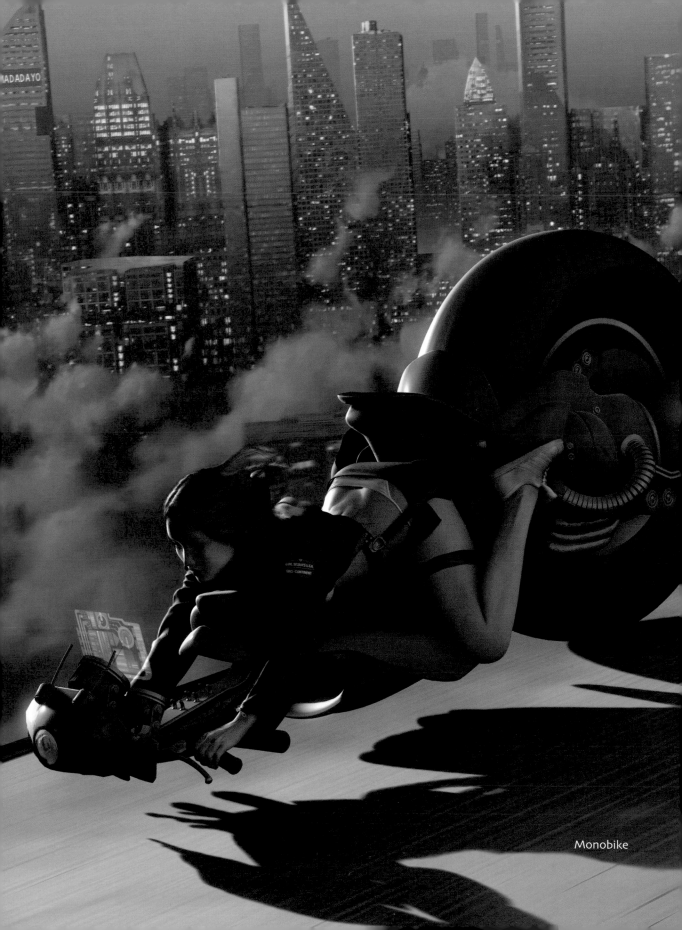

Monobike

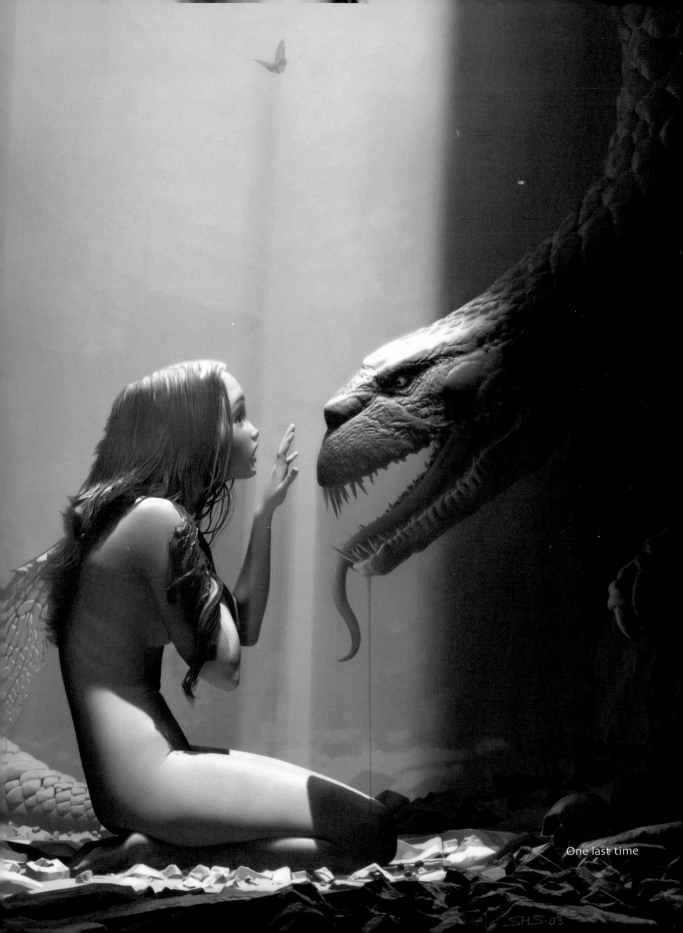

One last time

SHS·03

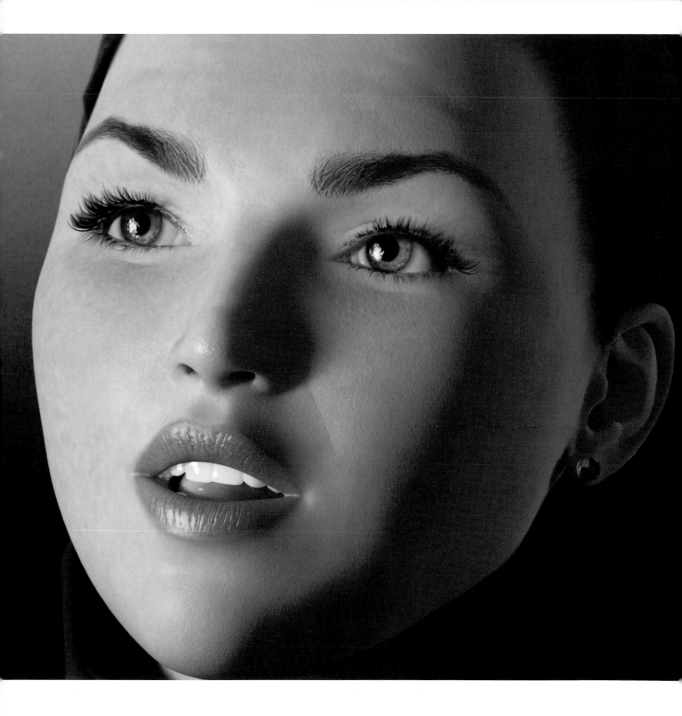

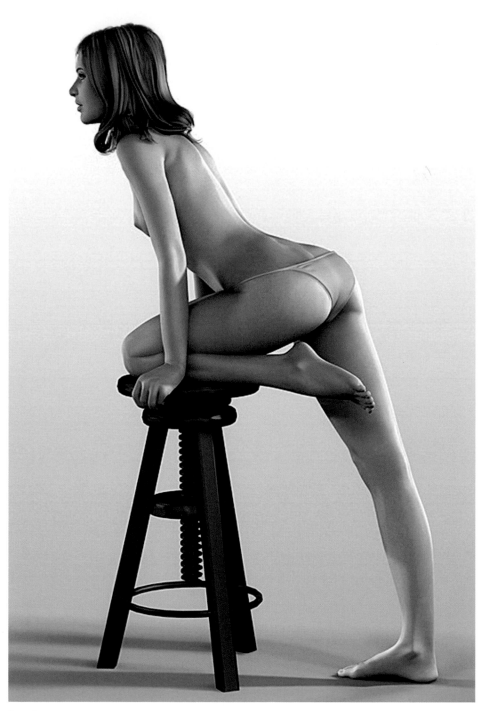

Stool

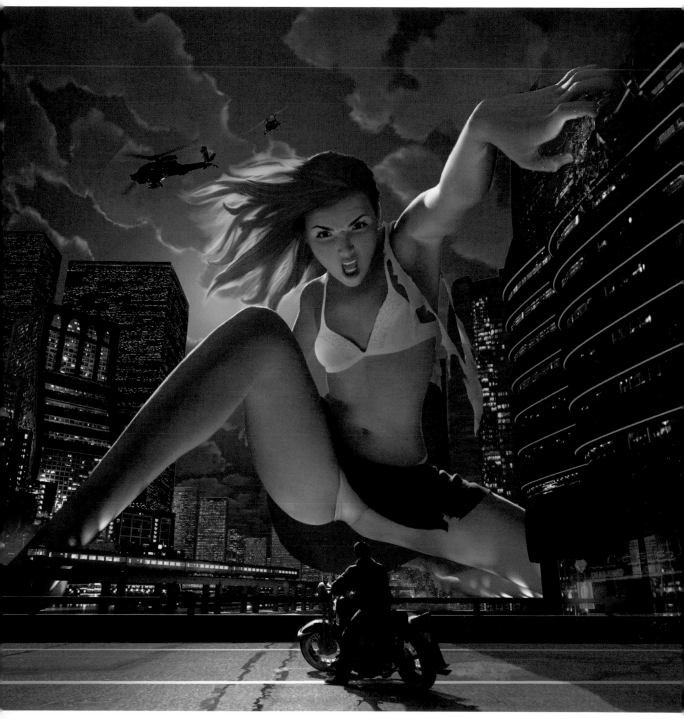

Psycho girlfriend

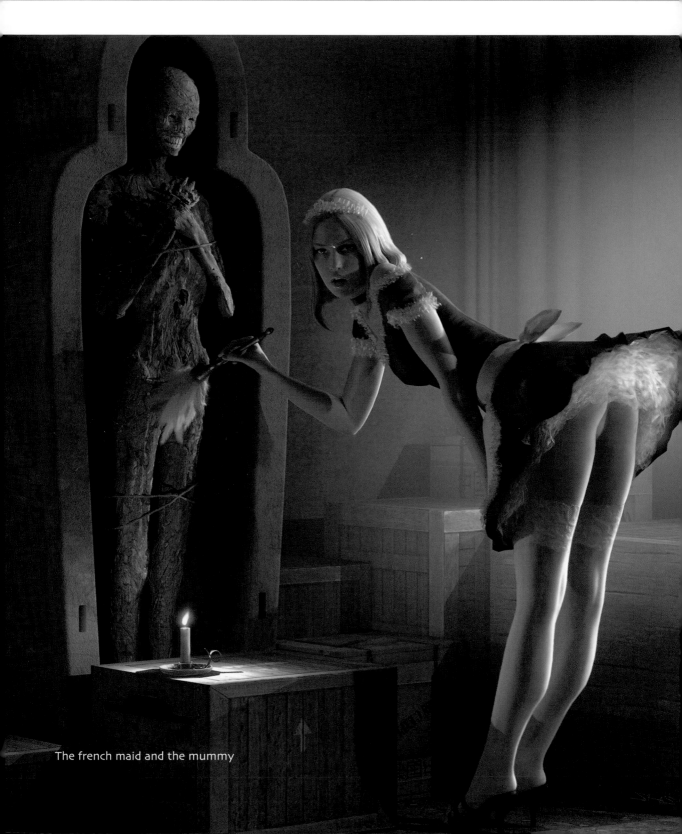

The french maid and the mummy

Insights into a Work Example

The following work-in-progress sequence of Steven Stahlberg demonstrates the development of a poster image for a customer. Because of the complexity of the scene and the time available until the deadline, this work also includes traditional painted elements, such as the background. Generally Steven Stahlberg doesn't have reservations about mixing different techniques and styles.

The basic idea is the taming of a monster by an enchantress. The saurian and the female character were modeled in the correct pose and only minimally prepared for the animation.

This means that even though the face of the enchantress is prepared for different

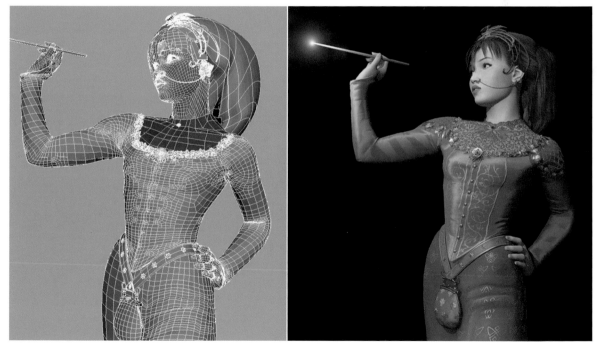

The Enchantress

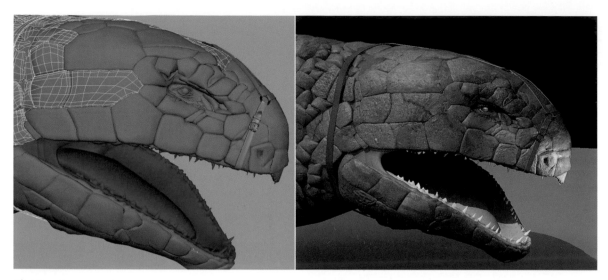

The Saurian

expressions, the body has only stiff joints. The reason for this was the tight deadline and the available budget.

The customer thought this was not dynamic enough. The image was supposed to look more like an imminent fight. Therefore, a simpler solution had to be found in order to increase the threat from the monster. The wand that was initially used was considered to be too weak of a weapon and the relaxed expression and posture of the character was no longer appropriate.

The separation of the left hand from the waist and the removal of hair from the forehead give the pose more tension. The futuristic weapon leaves no doubt as to the threatening appearance of the scene.

But now the weapon doesn't fit the appearance of the traditionally dressed character. Also, the saurian, despite its size, looks more romantic than futuristic and more closely resembles mystic creatures. If

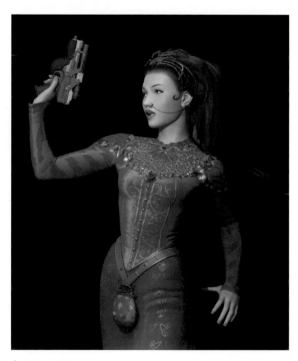

A new pose

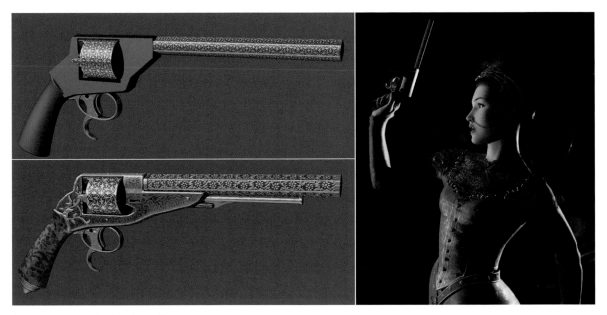

A new weapon is developed

a weapon has to be used, then it should be one from the appropriate era.

A Victorian-looking pistol with a richly decorated grip and barrel is then developed. The attitude of the character now looks more like it is geared toward an enemy, similar to a duel.

Pictures of the Grand Canyon were used as templates, repainted and rearranged in order to combine the separate characters in the scenes. The opponents now meet for the first time.

The colors of the clothes are adjusted to the new background. Supporting special effects, such as the sheen of the hair, are added. The latter effect was painted since it is easier to create and to correct. In most cases it also looks better, more natural.

After several conversations with the customer, the idea of the weapon was discarded. Even with all the adjustments, it

just didn't fit into the mystic theme of the scene. So Stahlberg is back to using beauty for a more magical and romantic taming of the beast.

The weapon disappears completely and is replaced by a sort of energy field. He tried different positions of the hand and several facial expressions to visualize the energy flow, while otherwise making the enchantress look more enticing.

Finally, the light effects are supported by painted lightning. The difficulty is in trying not to overdo the effect so the viewer is not distracted from the characters.

Following is the final image that was approved by the client. This work in progress demonstrates how much effort still has to be invested into a scene with seemingly perfect characters and how to make the story of the image believable in order to capture the viewer.

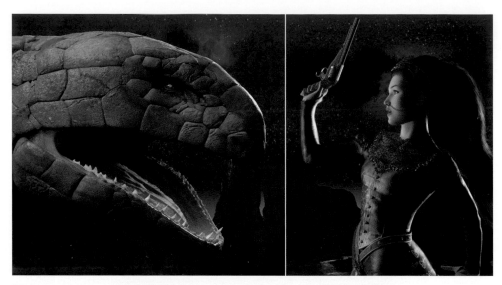

First composition of the characters

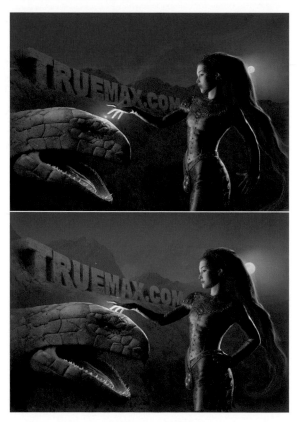

Implementation of the energy field

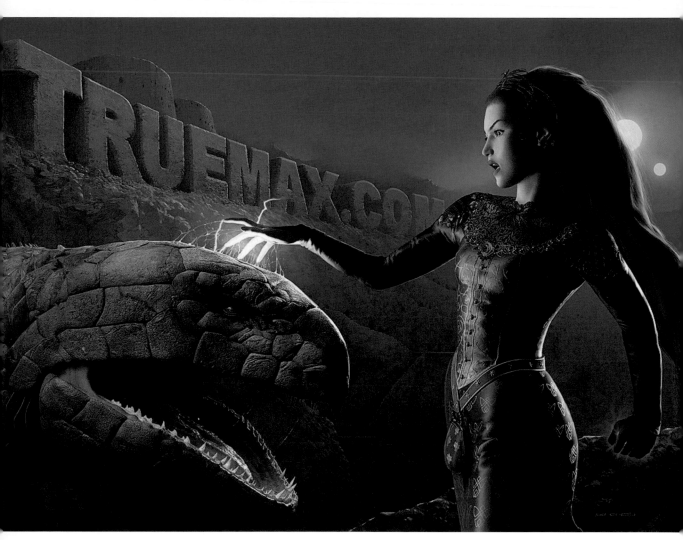

The final composition

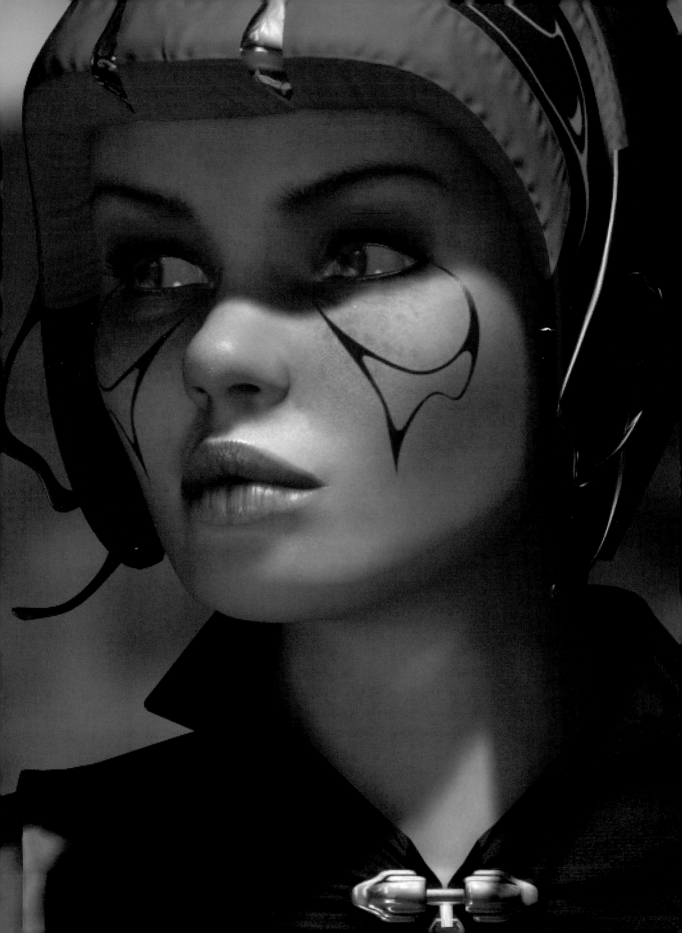

Marco Patrito

Marco Patrito is one of the few artists who works professionally with 3D graphics and traditional comics.

Over the course of several years he has published his works in printed and multimedia format. This gives him the freedom to animate his characters or to support parts of his stories with music composed especially for them.

» I had a traditional background as an illustrator before I discovered 3D. Back then my tools consisted mainly of a pencil, brushes, and an airbrush gun. At that time it was common for all who created 3D images to have mostly technical backgrounds. Many were traditional programmers, while I earned my money with drawings, photographs, as a comic author, and with hundreds of cover illustrations for science fiction novels.

In retrospect, this education was very helpful since it helped me to overcome technical obstacles with creativity and artistic skills. You have to keep in mind that 3D was still in its infancy.

We are talking about 1991, when I first had the idea for "Sinkha," a science fiction 3D comic in printed and multimedia format on CD-ROM. It was supposedly something that hadn't been done before. However, the time it took to finally publish it put a damper on my enthusiasm.

Ultimately, it was at that time when my "Sinkha" project was born. Since then I have been working with 3D graphics. «

Technical Qualifications

At that time I worked with the Stratavision software, which had a very good render engine. But when modeling faces or bodies you could lose your mind. Therefore, I switched to Lightwave. Once in a while, mainly for 3D architecture, I used Studio Max.

Finally, I ended up with Maya, which, despite some weaknesses, appears to be the most complete 3D software.

Over the years the programs have evolved rapidly and rendered creativity, which was previously needed to solve problems and challenges, unnecessary. At the same time new playing fields for individual abilities appeared.

As for modeling and animation, there were extraordinary changes. This is only partly true for rendering. In my work I always look for a balance between harmonious images and hyperrealism, while following the traditional styles of science fiction and fantasy illustration.

Besides photo realism, the quality of my first 3D software is not far from the current capabilities.

Back then Stratavision already provided radiosity, even though the time it took was not practical. This is not the fault of the software though, but rather the computers available at that time.

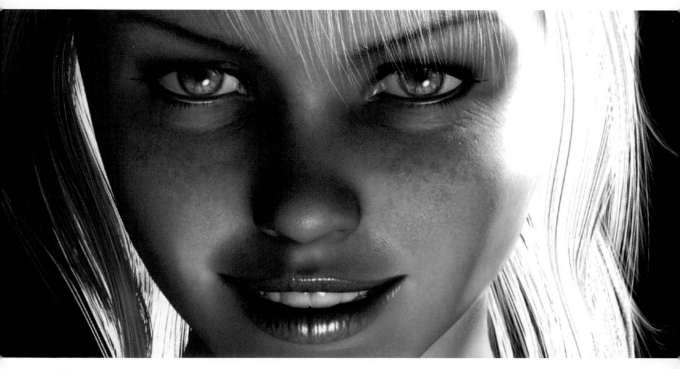

Hyleyn

The "Good" Old Time

The first version of the main character Hyleyn was created in 1992. I modeled her with only a handful of polygons. The geometry was so simple that nowadays everybody would laugh about it, even if she would have been modeled only for a video game.

In those first years the technical problems took center stage. I occupied myself mainly with rendering and backups. Now it is almost unimaginable that I had to cut the model in half in order to be able to save it on two floppy disks. The following year I invested in

an external magnetic drive. It was twice as expensive as my current PC, but I could then save up to 40 MB.

The old Hyleyn model and the rest of the characters of the first "Sinkha" episode were not prepared for the typical animation of today. They were staged like puppets, with moveable joints. The body parts were loosely stacked together as separate objects.

In postproduction I then applied a slight motion blur to hide the partially visible overlap at the joints. At that time there was no common and affordable tool for character animation.

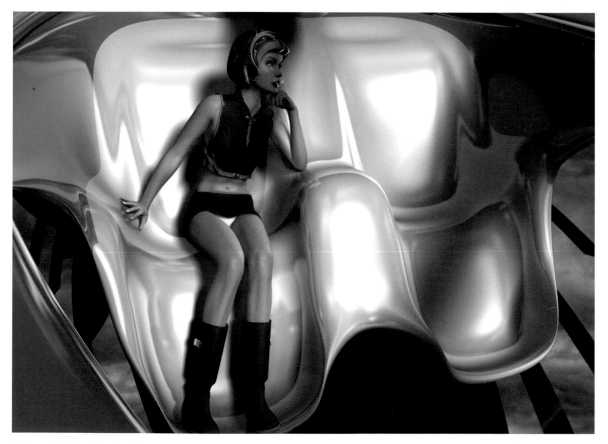

Hyleyn inside the shuttle

When I began to work on a new episode of the "Sinkha" project in 2000, I decided to start from scratch. I looked for good animation software and decided on Maya. All characters were modeled again and were also prepared for future animation.

Method of Operation

Primarily I start a new character with a piece of paper and a pencil in my hand. A bunch of sketches follow, including rough details, which probably only I can decipher. In the end I have a rough idea of the finished character.

Next, I start the real modeling. Generally I prefer polygons over Non Uniform Rational B-Spline (NURBS).

Apart from my sketches, I don't use any reference images of real people. I also never used a 3D scanner or digitizer. For the animation I use the rigid skin technique. At first glance this technique appears limited, but as the complexity of the character builds, I can handle it better than the smooth skin technique. Skin paint and a huge selection of deformers—mainly Free Form Deformation (FFD)—give life to the characters Hyleyn and Darshine and also simulate realistic muscle behavior.

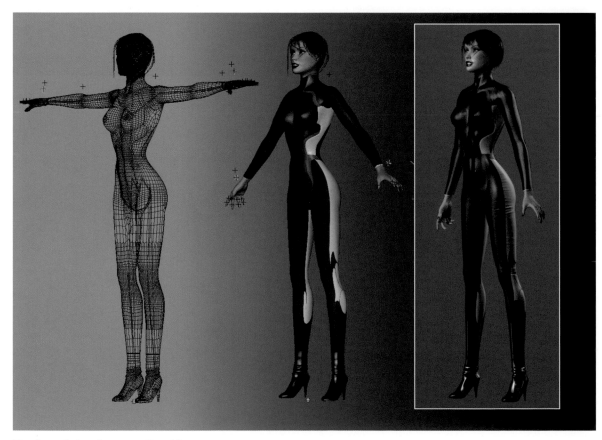

Rigging of the character Darshine

As for the expression, I use blended shapes where at least two different facial expressions are mixed.

Before all necessary target expressions are created, I use several deformers and polygon tools to create a neutral facial expression as the base.

Because of the chosen method of animation, it is not possible to combine head and body to one object. Therefore, I have to use a trick in order to connect both objects. First, I carefully align the neck and head to each other. Three polygon rows of each object overlap each other so that a transparent gradient in the main material cancels out part of each overlap. This technique proved successful with the visual connection of polygon objects.

The subsequent dressing of the characters should not be underestimated. Anything that should not look like an unadorned, loose hanging dress requires extensive work.

I only use the cloth simulation of Maya for wider coats or capes, as I soon discovered how much time it takes to create realistic clothes with this tool.

Controlling the result is especially difficult. Often it looks perfect from one direction, while from another this illusion is mercilessly destroyed.

After numerous tests I decided to use separate models for the clothing, which I attached to the deformed skeleton of the character. Additional FFD lattices, which are controlled by driven keys, give the clothes individual and fabriclike properties. A skirt, for example, slides naturally when Hyleyn angles her leg.

Lastly, I have to admit that my decision to give the main characters jumpsuitlike clothes made my life a lot easier. Tight-fitting clothing also looks sexier.

 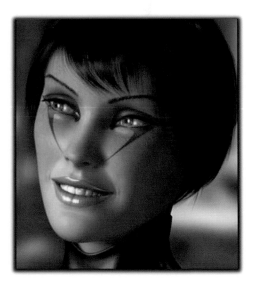

Expression for the character Darshine

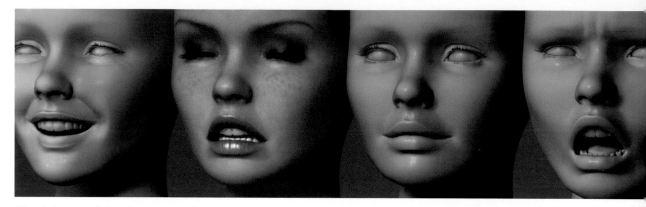

Blend shapes of the character Hyleyn

Finally, it is very important to use high-quality material to get a believable result. Thus, I begin working on these materials during the modeling phase.

For the texturing of the skin I use the Maya tool called Surface Luminance. Once you understand how this tool works, it will allow you to mix different textures for the different layers of the skin. This happens automatically, based on the actual lighting of the surface, and depends on the adjustment of the color and brightness values between the lit parts and the parts located in the shaded areas of the surface. With some skill, subsurface scattering effects can be simulated without having to deal with a long render time. The textures are either created in Photoshop or in a 3D paint program without using any reference material.

As for the future, I am working for the first time on an integration of 3D elements with real environments. This is possible by using current render methods such as radiosity, global illumination, image-based

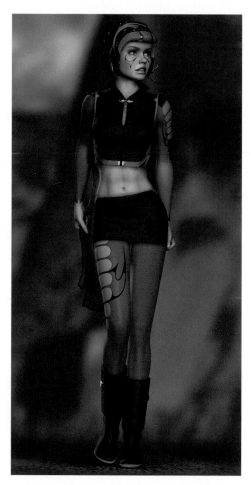

Hyleyn with automated cloth simulation

lighting with HDR images, and better quality materials.

The destination of my journey is still in the dark, but two other characters are already taking shape. They will again be female, where one character will be an artificial being while the other is going to be extraterrestrial.

You can learn more about the "Sinkha" saga at www.sinkha.com.

Work

The two main characters, Hyleyn and Darshine

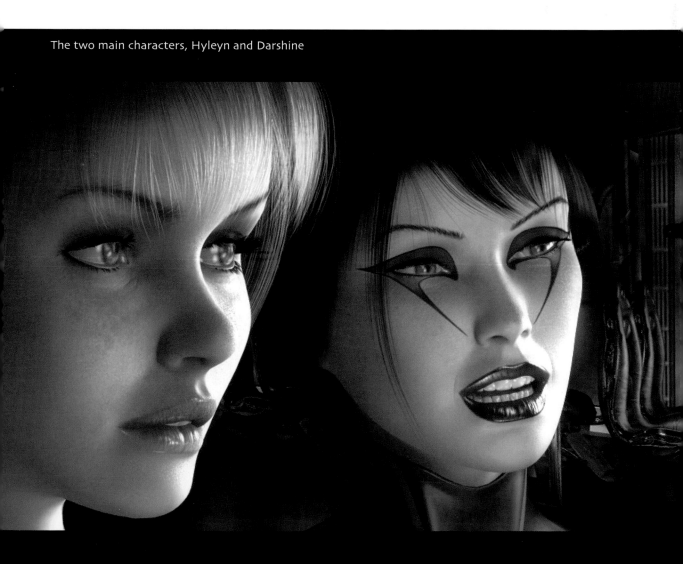

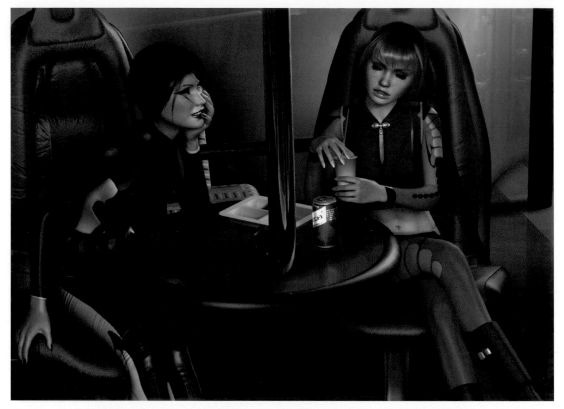

There is also a lot of work in creating the surroundings

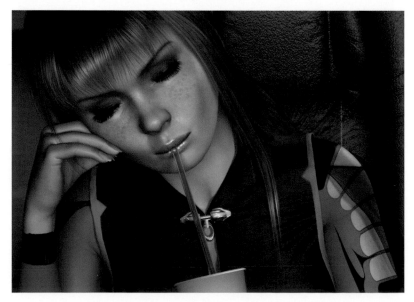

Hyleyn

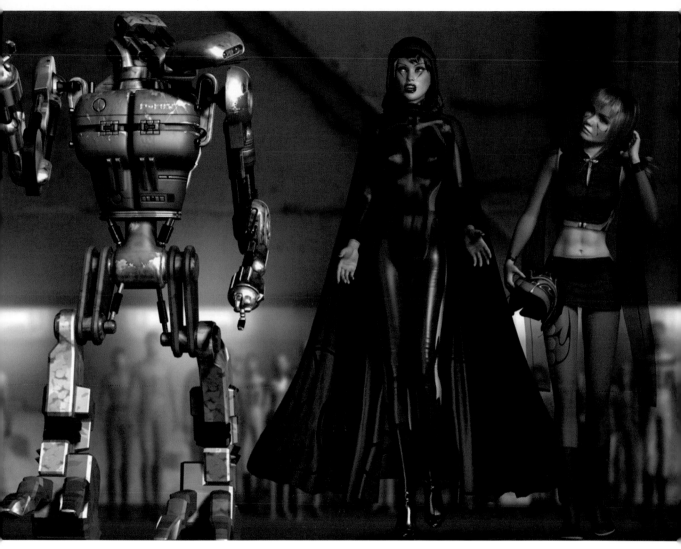

Hyleyn and Darshine visit foreign worlds

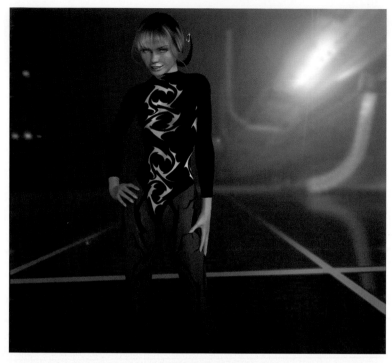

Marco Patrito always plays with new outfits and designs for his characters

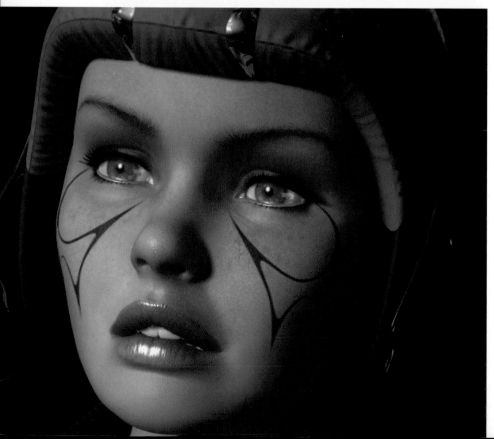

New accessories and changing makeup make the characters look alive

Creating a Technical Procedure

In the current episode of the "Sinkha" saga the two main characters have to be X-rayed. Since bones and inner structures of the characters are supposed to be visible while the characters remain present, a simple solution had to be found.

Marco Patrito found a solution by portraying the scanner as a glasslike surface with slightly reflective properties. That way the characters placed in front remain dimly visible as a reflection.

Because of the highly transparent nature of the material, a second model with the innards of the character had to be placed behind the glass. The pose was carefully planned so that the bones behind the glass looked like they fit to the body.

This could be partly automated, with the reflection and transfer of the bone structure of the character to the bone model. In extreme cases this would also work in animations.

The two images on page 33 show how appealing the two characters and the achieved effect look.

Hyleyn has to be x-rayed

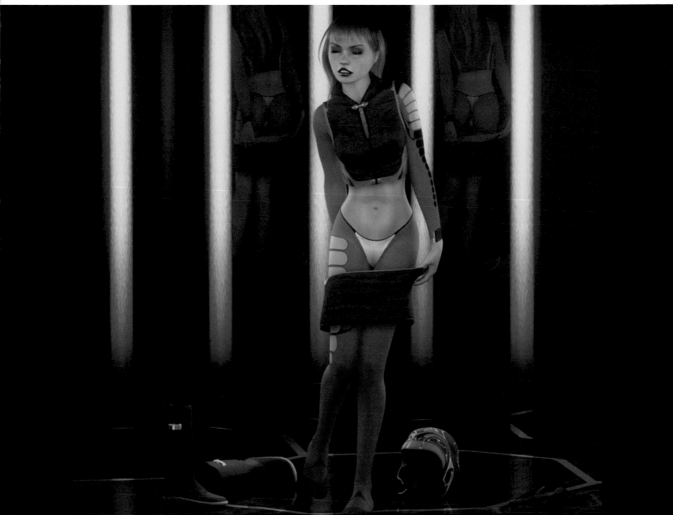

Hyleyn

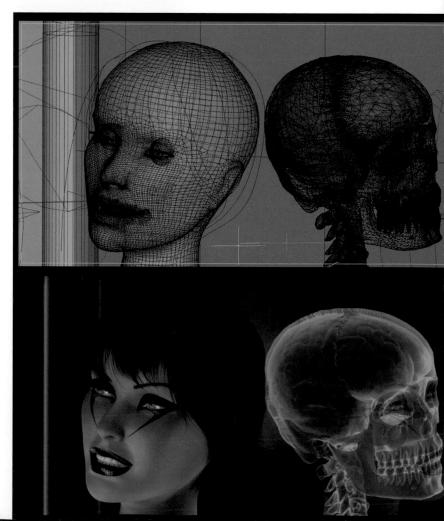

Setup for the X-ray of the
characters

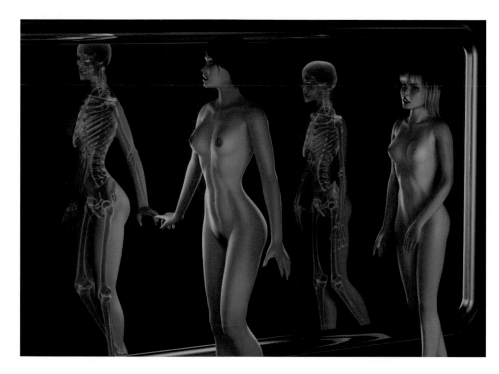

Overlapping of
bone model and
reflection

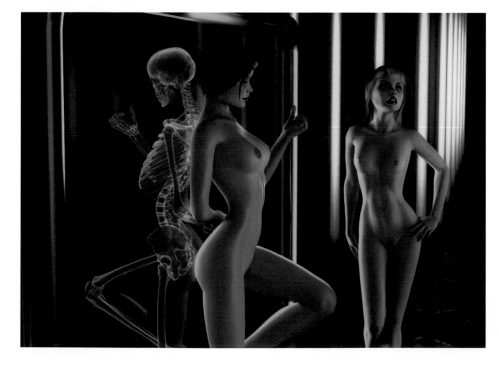

A feast for the
eyes even as a
skeleton

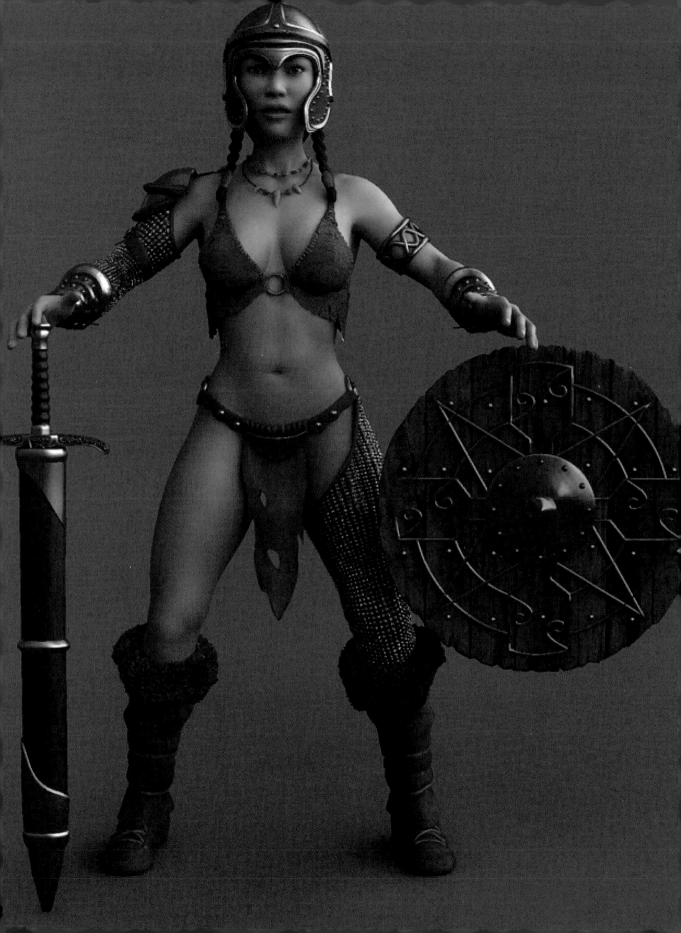

Daniel Moreno Diáz

» I was born 1972 in Madrid and enjoyed drawing, painting, and modeling objects in my younger years, when I used pencils, ink, or clay. A focal point was always the depiction of humans and characters of all kinds. Therefore, I studied traditional graphic design. I learned how to work with the PC by taking courses during my studies.

As a postgraduate I was confronted with the hard everyday work life, working freelance and developing mostly interactive CD-ROMs. Then, about three years later, I stumbled accidentally into a project that dealt with video games. It was produced by the team of Pyrostudios, which developed, among other titles, "Commandos 2," and later the third part of this successful series.

This work combined so many of the things I had always wanted to do. As a result, I have been with Pyrostudios since 1998. am responsible mainly for modeling and texturing of game characters, package design, and advertising collateral.

As for my method of working, I allow myself to be influenced and inspired by different media. These include not only movies and comics, but also the work of other artists who do not necessarily have anything to do with 3D graphics. Working with characters or organically shaped objects is the most fun.

I prefer to use photographs as reference material in order to have a solid base for my work. This way I can be sure that basic properties, like proportions, are correct.

When there is no good material available for the planned character, I create what I need by combining different images in Photoshop. Improvisation is a permanent part of the artistic process.

In addition to these image templates, I also use simple scribbles and sketches that help me with planning the pose and viewing angle. It doesn't matter how detailed the drawing is. It is the sketch of the theme that helps to determine the outcome of the image.

So far, I prefer to achieve a mix of realistic elements and an illustrative look, as used in comics, in my private works. I try to make the characters look as alive as possible.

Lastly, the result plays only a secondary role. I simply like to work with 3D objects and am pleased to learn something new every time I work on a new project. Each time is a challenge trying to improve your technical or artistic skills. **《**

More information can be found on Daniel's website at www.guanny.com.

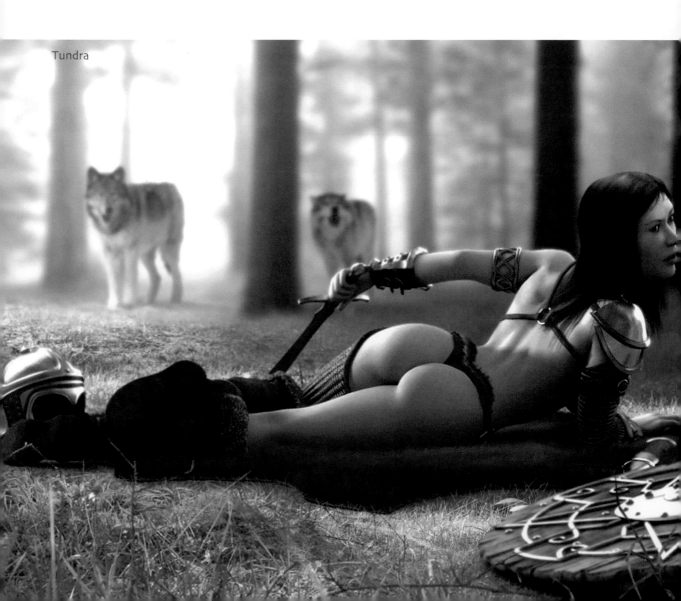

Tundra

Work

For the body I use a series of anatomical photos of women's bodies as reference. The torso is modeled from a cube (box modeling). The difficulty here is to find the right size for the added subdivisions. Arms and legs are extruded directly from the former cube.

> Extruding: This action duplicates and then moves single faces or larger, connected areas of the surface. That way, dents and bulges can be created in a short amount of time.

I start with a low-density mesh. Only when the edge loops are placed and arranged to my liking will I continue to add further subdivisions. This procedure requires relatively little effort since the added subdivisions automatically follow the existing edge loops.

> Mesh: Common term for a 3D object made from polygons.

As commonly practiced, I model my characters in a neutral pose. I don't use the T-stance, but rather a pose more suitable for future deformations. In this pose all joints, such as the knee or the shoulder area, are slightly angled, which makes them easier to deform.

> T-stance: A pose where the arms are held parallel to the floor. The legs are stretched and the feet are close together.

Modeling of the body

Since I have an exact idea of the finished project even before I start working in the 3D program, I model only the parts that will be seen later in the image or animation.

Because this character will wear tall boots and a helmet, I do not have to model the lower leg, nor a large portion of the head.

Arranging the surface into groups

After modeling I arrange the character into different groups, as can be seen by the different colors in the figure. This makes it easier to unwrap the mesh and the creation of UV coordinates.

UV coordinates: Every polygon can be assigned to a certain area of an image or material. This ensures that when the character moves, the material on the skin doesn't "slip" around. It is therefore necessary to assign each polygon its exact position. This information is saved in the UV coordinates. This principle works best when every polygon of the object has its own area of material. There shouldn't be any overlaps between these areas.

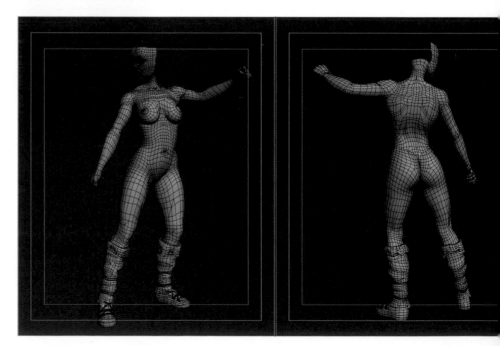

The character in a pose

I have already positioned the character into a pose as shown in the figure on page 38. It is a warrior and therefore will get a light armor, shield, and sword. The boots were already modeled. The missing lower legs are not noticeable anymore.

Since I like the pose, I continue to add the tight-fitting parts of the clothing and the armor. These areas are the loincloth and the top and the forearm protector. The helmet, weapon, and shield easily can be created separately and placed in the appropriate locations.

In this way I create all desired poses of the character. Should the warrior be needed in an animation, it would make more sense to work differently. But since these will be still images only, I do not need to spend time with the weighting of the character and its armor.

Weighting: This is the connection of polygon corner points of the surface to a deformation. A percentage can be assigned to each point that determines how much it is influenced by the deformation. Weighting gradients allow a soft deformation, over a certain distance, which appears very natural compared to the abrupt movement of a mechanical joint.

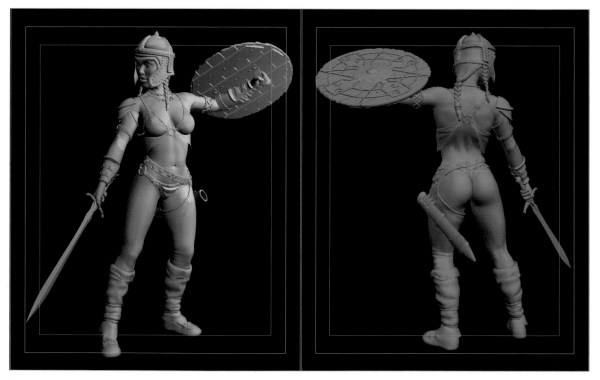

The character with added clothing and weapons

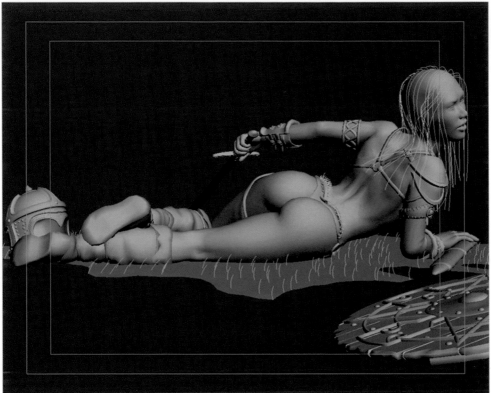

An alternative
pose

Color texture of the face

After the modeling of the character is completed and all the accessories are done, I can start applying materials to the surface.

For the skin, I again use photos. The image on the left shows the color and texture for the face. Fine creases and pores are created with a bump texture. It calculates the brightness values of the pixels only. The brighter the applied image is, the higher it appears to rise above the surface. This is just a visual shading effect and does not change the course of the 3D surface.

The bump texture for the face

The following image shows the result after applying the textures. The finished textured character can be seen on page 34.

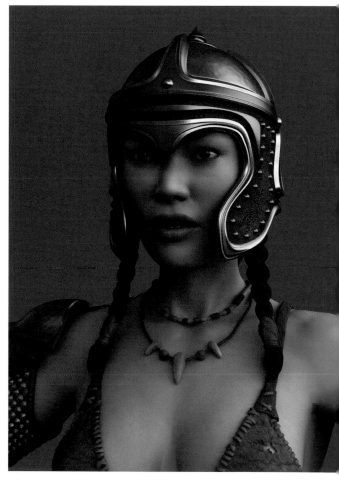

Close-up after applying the texture

A reflection texture

Finally, I use a reflection texture that determines, by means of its brightness, how much the face reacts to the lighting. This especially affects the highlight properties of the skin. Generally, the nose and forehead are shinier than, for example, the cheeks.

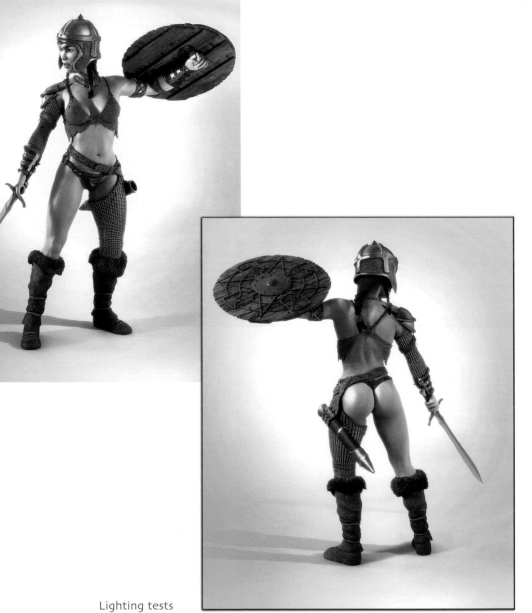

Lighting tests

Beside the actual look of the character, a large part of the appearance depends on the light sources. The use of colored lights can color the character, making it fit better into the environment of the scene.

It is clearly visible how the highlights, in connection with the red and bluish lights, bring the character to life. This kind of warm/cold contrast accommodates the way we see and lets objects appear more vivid.

Vampirella

My 3D character Vampirella is currently my favorite, even though I notice things I would do differently now.

I think she is one of my most successful organic models, especially because I reverted to ZBrush in order to loosen the symmetry of the figure. Little irregularities in the symmetry, especially of the face, bring you further along the path to a more realistic look. This is because no creature is 100% symmetrical.

I modeled the character in Studio Max using polygons and subdivision surfaces. ZBrush was used to put details on the surface and to texture it. Photoshop was also involved. Finally the character was rendered with V-Ray.

I modeled the face and body after the same pattern as the warrior. As for the pose, I was inspired by old comics. I wanted to give her a classical, but at the same time modern, look. I took an easy approach to some areas, as seen in the wireframe images.

Piece by piece I added the costume, bracelets, and earrings. The vampire fangs are separate objects also and were put into the mouth. The eyes are simple sphere objects that later received realistic eye textures and reflective properties.

Wireframe: One kind of visualization of 3D objects where the polygons remain invisible. Only the edges of the polygons are shown. This better shows the structure of the object, as because of the missing polygons, the otherwise hidden areas can be seen.

I placed the ears at the sides of the head, without extruding them directly out of the head. Nor are they connected to the head. This is sufficient since the ears will be covered, in large part, by the hair.

At this point I export the character to ZBrush for further editing. The big advantage of ZBrush is that objects can be finely subdivided and, with the help of painting tools, additional changes can be made to the surface. Often this can be done in real time, making it feel like modeling with clay.

Real time: In connection with 3D objects, it means that the result of a manipulation is instantly visible. You don't have to wait for the calculation of an action, like the deformation of the surface, and the result can be seen instantaneously.

Within ZBrush, fine details such as the crease on boots or clothing or irregularities of the symmetry can be created. These changes can then be saved as bump, normal, or displacement texture.

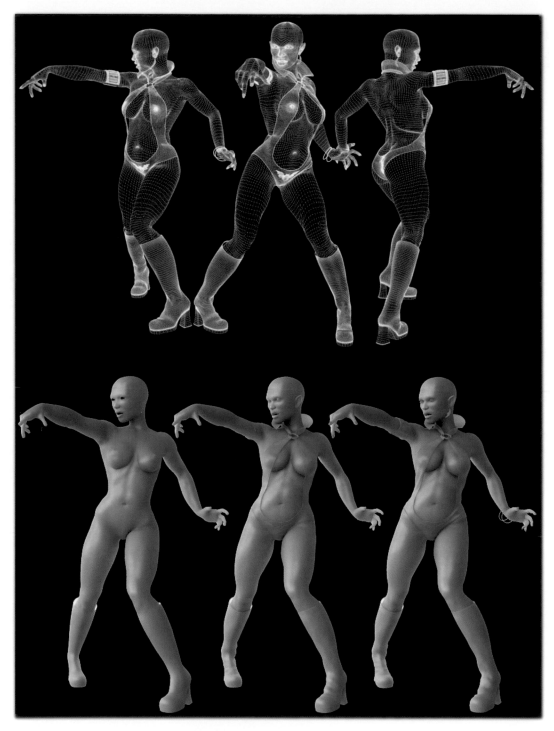

Formation phases of the Vampirella character

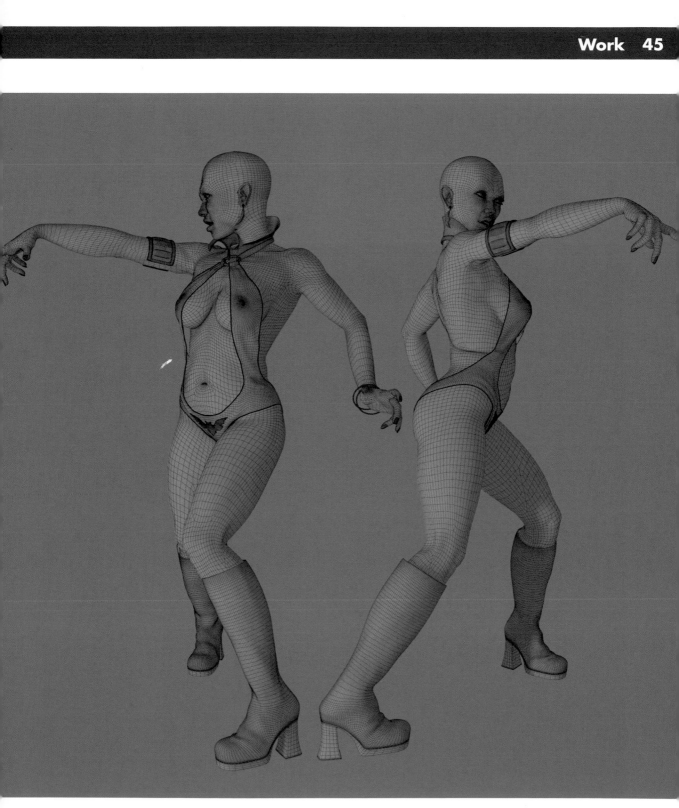

Vampirella within the ZBrush environment

Normal texture: The alignment of the surface can be coded as a color image. That way, the fine details of a highly subdivided object can be realistically transferred to an object with fewer faces. This technique is used mostly in computer games.

Displacement: This is the movement of the polygon corner points in order to deform the surface. This effect is controlled by a grayscale image. That way, details can simply be painted, which is much easier than modeling the details.

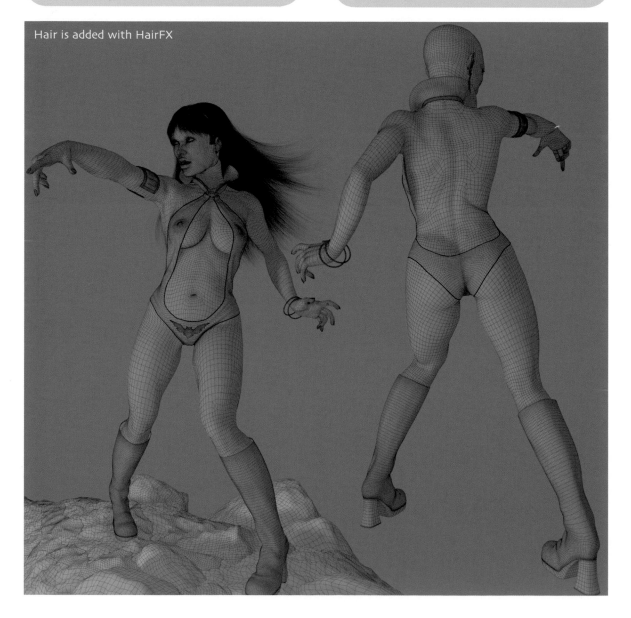

Hair is added with HairFX

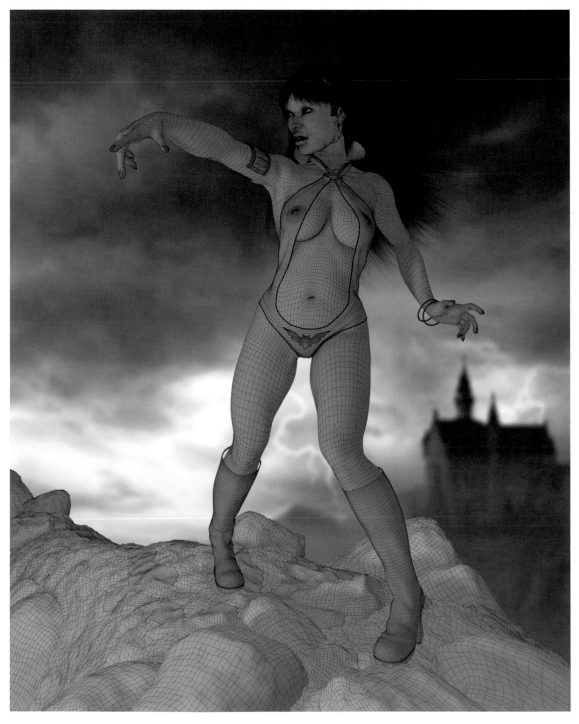

A background image created in Photoshop is combined with the character

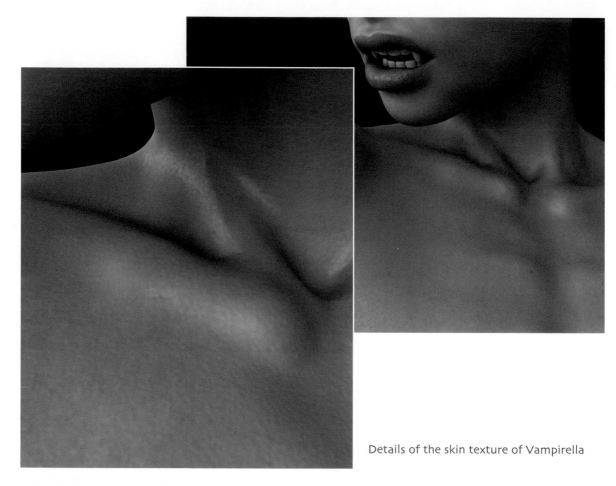

Details of the skin texture of Vampirella

After the creation of additional elements, such as the rock and the background image, the objects are textured. The skin consists of several layers of noise shaders. They are responsible for the color variations on the surface and for the subtle network of veins under the skin.

Shader: These are patterns or surface properties that are implemented into the 3D software. Often no images are necessary in order to create surfaces. The advantage of the shader, in comparison to images, is less use of disk space and the fact it is resolution independent. A surface textured with a shader, therefore, doesn't appear pixilated, even close-up or enlarged, as is common with enlarged pixel images. There are countless shaders that generate, for example, metal, wood, or fabric automatically.

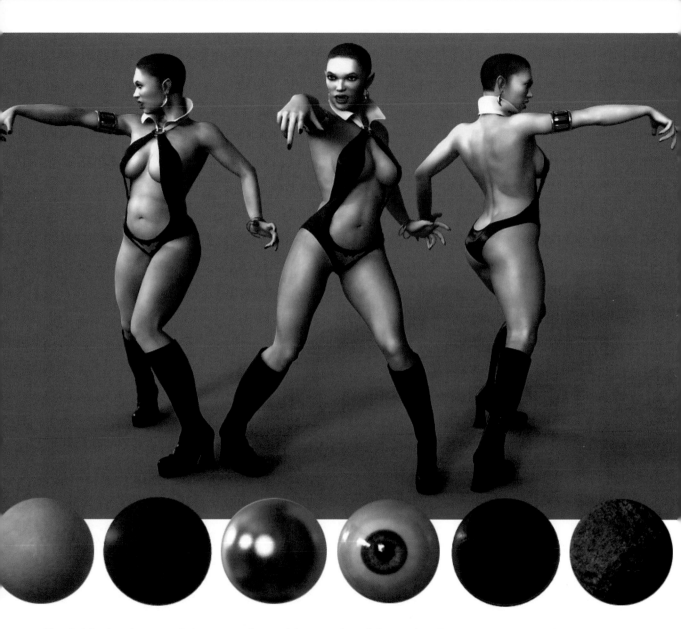

The finished and textured character, along with examples of the used surfaces

After all materials were applied, different lighting tests were done to test, for example, the highlight properties of the skin.

I first used HairFX for the hair, but currently I am testing Hair and Fur in Studio Max v7. These first tests are promising.

Finally, I rendered all elements of the scene separately and combined them in Photoshop. This makes it easier to adjust the color of the separate rock, character, and background elements and the controlled addition of depth of field.

The main advantage of using ZBrush in this workflow is, in my opinion, the wide range of possible detail levels. This makes it possible to prepare the character for use in movies, computer games, or print.

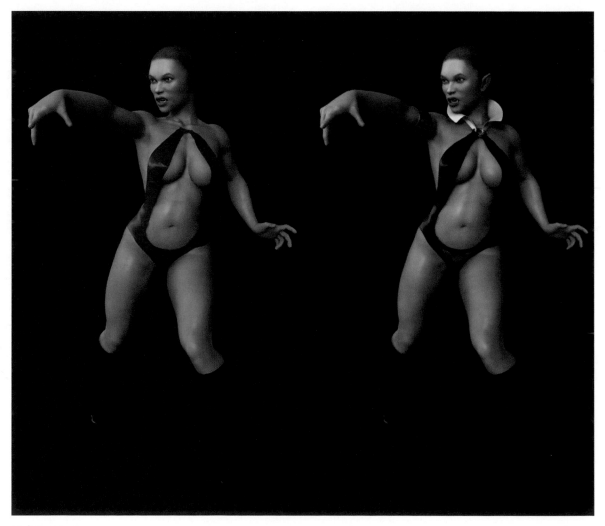

Lighting tests

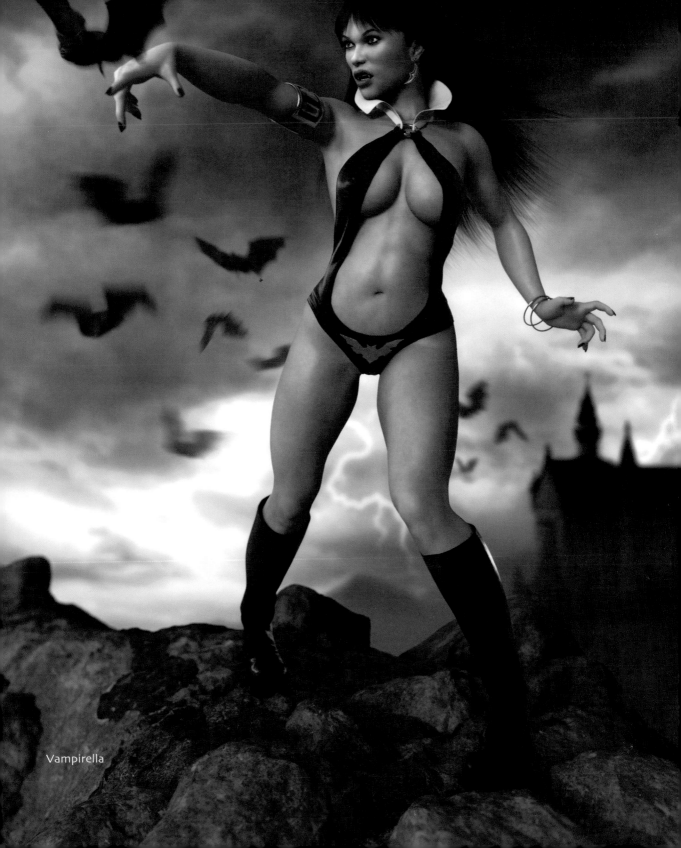
Vampirella

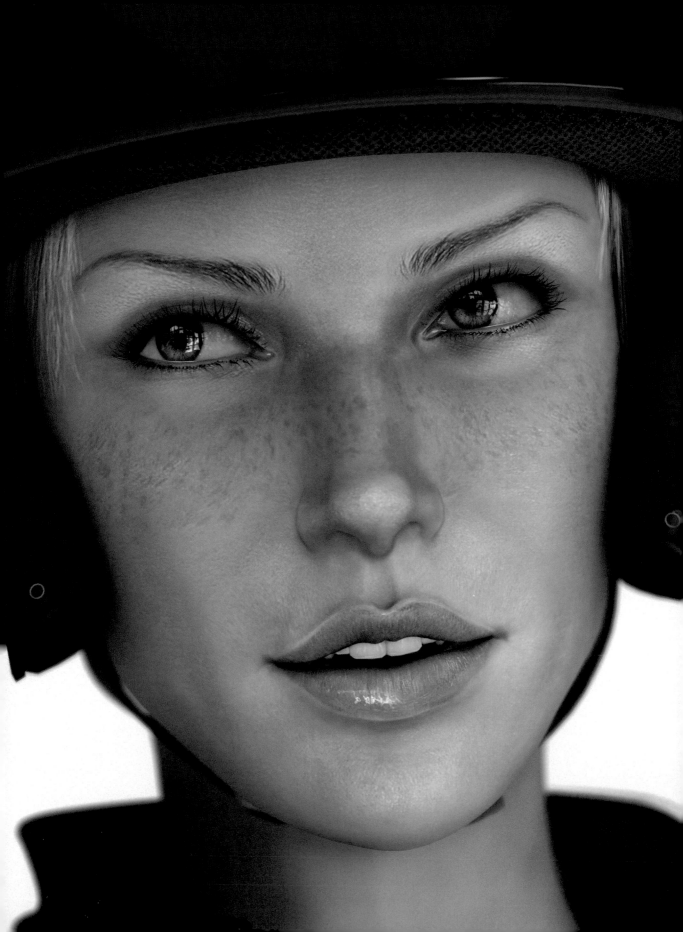

Andrea Bertaccini

>> I studied architecture at the University of Florence. The first time I came in contact with a computer I fell in love with the machine. I was thrilled about the prospect of bringing to life anything I could imagine.

After a short phase of testing and playing around, I started working with the architectural firm Studio Lucci & Biserne (www.studiolb.com). I soon discovered that my fascination with the computer could also be used to make a living.

We combined our forces and founded TREDISTUDIO (www.tredistudio.com) in 2000. Our purpose is the integration of different areas such as graphic design, industry and furniture design, communication, Web design, and event management. However, our main focus is 3D graphics, including postproduction.

My work with 3D graphics started with the software Studio Max, which I still use today. Of course, I also looked into other programs such as Rhino, Maya, Lightwave, and Cinema 4D. I think it is impossible to master several programs perfectly. I, therefore, concentrate on being proficient in one program, rather than being mediocre in multiple ones. <<

Biker Eyes

The idea to create a virtual model has been with me for several years now. It should be beautiful and expressive. Under no circumstance did I want to create one of these "puppets."

During the hunt for the right reference material, I searched through photos of actresses and models, such as Jennifer Connelly and Linda Evangelista, whose eyes I was fascinated with.

Elisha Cuthbert and Charlize Theron inspired me because of the shape of their lips and the expression of their faces. The result is supposed to be desirable, yet at the same time aggressive, looking biker.

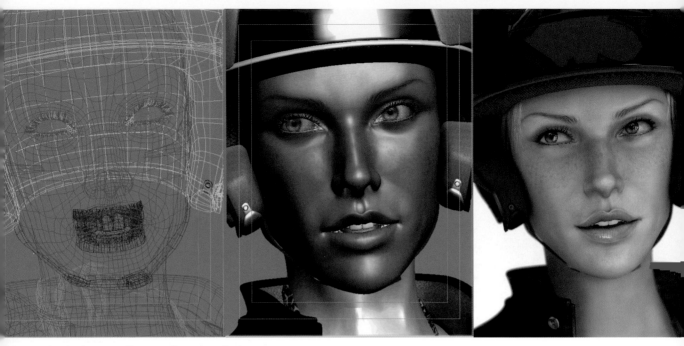

Wireframe, editor, and rendered views

The lips and eyes are for me the most important elements of a face, so it is clear that I need to concentrate on these areas. Unfortunately, they can only be created through great effort because of their wet and partly reflective surfaces.

Modeling of the Head

The following steps were produced in Studio Max 8, but could have also been produced in any other 3D program.

I start modeling the basic shape of the head by using a sphere. One half of the sphere can be deleted since this missing half will be added later by mirroring the existing half symmetrically. The eyelids, nose, and mouth are roughly estimated and the proportions are adjusted to each other.

With the help of the Cut Modifier and the rest of the Edit Poly group, I add additional edges and faces to the areas where I want to create more details. This is especially the case around the eyes and lips. The base of the neck is created by extruding the lower face spheres.

In the area where the eye is supposed to be placed, I delete the faces and extrude the edges of the opening slightly toward the inside of the head. This will give the eyelids some volume and thickness later.

Because the character will wear a helmet, the ears and the back of the head can be neglected.

Little by little the complexity of the model increases. Points are moved and new edges are added. It is important to create additional cuts only when all possibilities have been

exhausted and further details cannot be created with the existing faces.

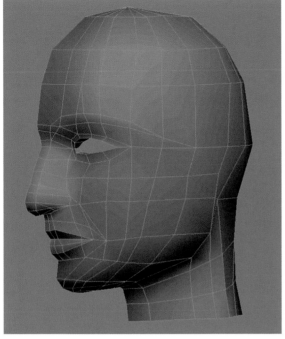

Roughly modeled head from a sphere

Additional subdivisions are created with cuts through the faces

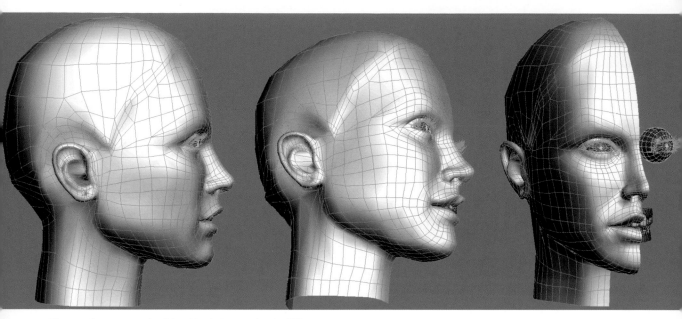

The surface smoothed by Mesh Smooth Modifier

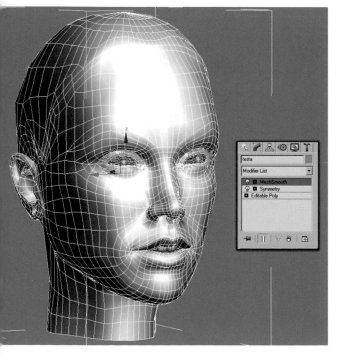

Added half of the face with Symmetry Modifier

When I am happy with the look of the face, I use the Symmetry Modifier in order to duplicate the existing half of the face and mirror it. The head can now be seen as a whole for the first time.

To smooth the existing polygons of the face I use Mesh Smooth Modifier. The modifier creates additional polygons within the existing surface and adjusts their position so that visible edges are smoothed.

Using the same principle I create the gum and teeth. I don't create a whole set of teeth, just a short section that is visible between the slightly opened lips.

After the modeling of the face is done, I look for a suitable camera position and change the location of the model so that the right head pose is achieved.

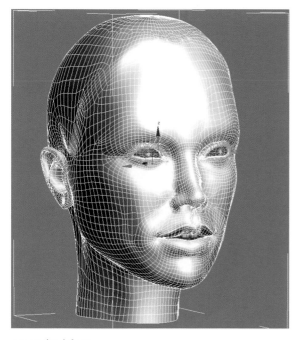

Smoothed face

Materials

I use the Unwrap Modifier to unwrap the UV coordinates of the head model onto a plane. Then I cover this newly created plane with previously prepared images in Photoshop. These images are combinations of photos and painted elements.

I use five different textures for the material of the face. The most complex is the color texture. Repainted variations of this texture are used for the bump map, highlights, and reflections.

Bump: Height information of the surface encoded as a grayscale image. It is used for influencing the surface shading.

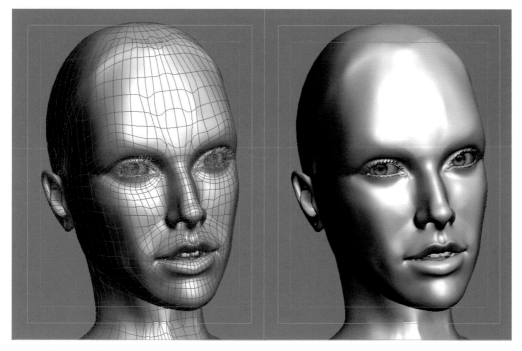

Poses of the model

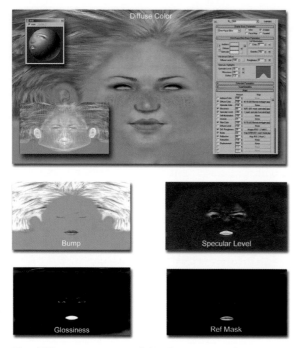

The different textures of the face material

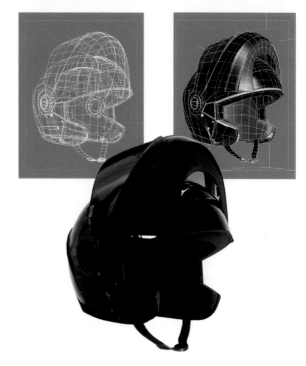

The modeling of the helmet

The fitted motorcycle helmet is then created using the same principle as the modeling of the face. I use my own helmet as reference.

Finally, the helmet has to be adjusted to the size of the head and its pose.

Eyes

As I mentioned in the beginning, the expression of the eyes is especially important. Therefore, I will explain my procedure in greater detail.

It won't surprise anyone when I start with a sphere. The sphere should be rotated so the pole faces forward. The order of the faces and the circular edges around the pole will make it easier to form the pupil and the cornea later.

In Edit Poly mode the sphere is converted into a polygon object. Then I select the rear half of the sphere and delete these faces.

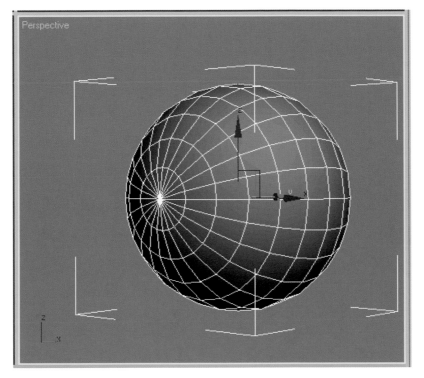

A sphere as the start object

This leaves the front half of the eye remaining. This rids us of unnecessary polygons since the rear of the eye will never be visible.

The half sphere of the eye will then be duplicated and the size of the duplicate slightly reduced. The size of the duplicate is now 99% of the original size.

Then select all faces of the smaller half sphere that directly border on the front pole point. The pupil should be created in this area.

Delete the selected faces and use the Cap Modifier. This closes the opening of the pole with a new face. The half sphere now looks like a slice was cut off at the pole.

Select this new pole face and use the Inset command in the Edit Polygons group. This duplicates the face and at the same time shrinks it within itself.

This new face can be used to create a kind of funnel that will represent the pupil. This is not anatomically correct since the pupil actually bulges outward because of the pressure of the lens behind it. However, this funnel shape creates a better result when rendered. The eye has better depth and expression.

The following images document the steps taken to this point.

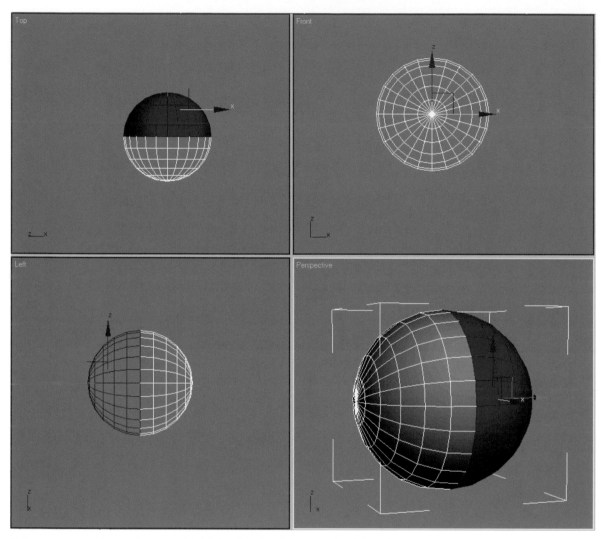

Sphere converted to polygons with highlighted polygons to be deleted

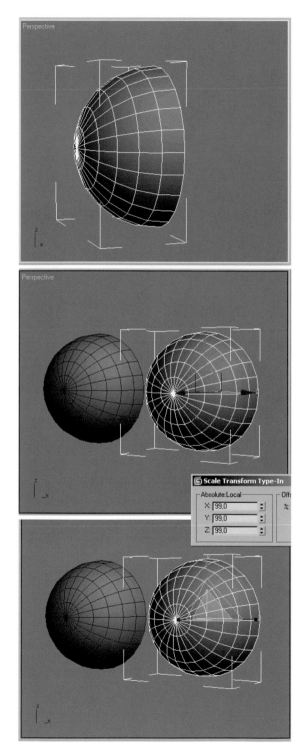

Duplicating and scaling
of the half sphere

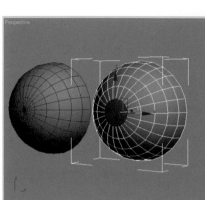

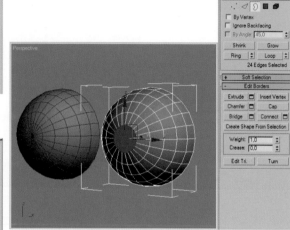

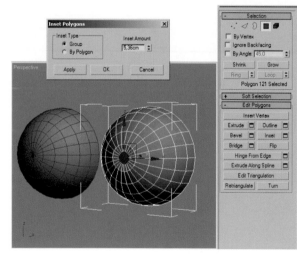

Restructuring of the front pole faces and inset
polygons at the newly closed opening

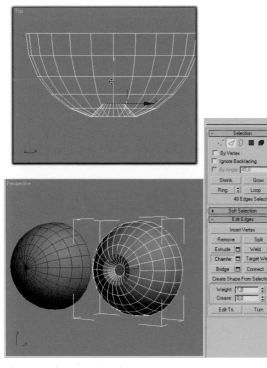

Shaping the pupil and iris

The polygon located in the center of the former pole will now be moved into the eye. This creates a small funnel.

With the help of the Chamfer command an additional subdivision will be added to the funnel wall. By scaling and moving this newly created edge ring, the funnel is rounded along its length.

This creates a soft surface shading in the funnel that will later portray the iris. In order to soften the still rough subdivision of the iris funnel, apply a Smoothing Group with a higher phong angle to the side faces of the funnel. The face in the center is excluded from this group so that the edge is still visible. A phong angle of 45° should be enough to smooth the funnel walls perfectly.

The following images show this step and show the effect of the phong angle on the surface shading.

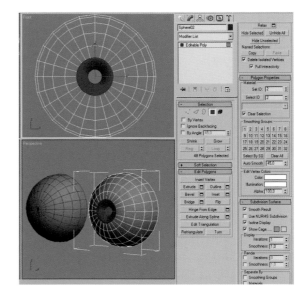

Assigning a smoothing group to the side walls of the funnel

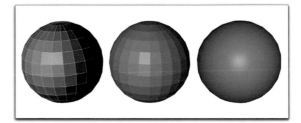

Effect of the phong angle

On the far left you can see a sphere and the structure of the polygons that form the surface. In the center image it is especially clear that the faces with a phong angle remain visible since the angle is smaller than the angle between the faces.

When the phong angle is increased, the shading no longer recognizes face differences below this angle. The surface appears to be perfectly smooth, even though the number of faces was not increased. This is only a visual effect, as seen at the slightly angular contour of the sphere on the right.

Outer Eye

This concludes the modeling of the inner eye, and now we can work with the slightly larger half sphere. Later this will encase the smaller eye model completely and depict the cornea and the reflective surface of the eye.

This splitting of the eye into two different objects is necessary since the eye is not spherical in the front, but rather bulges outward over the pupil.

This bulge appears like an attached lens. The characteristic highlights and reflections caused by this curvature of the surface are also important for a realistic appearance of the eye.

Thus, select the front pole point of the larger of the two half spheres and pull the point slightly forward, away from the center of the half sphere. A small peak at the pole emerges. Select the edges originating from this point and part them, with two additional segments, as shown in the following image.

Pull the two new circular edge loops slightly forward and scale them so the peak now becomes a smooth dome. The result is the previously mentioned bulge of the cornea on top of the pupil.

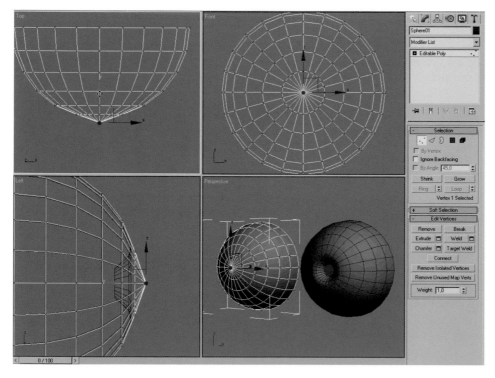

Pulling the pole point forward

The modeling of the eye is now complete. Place the two separate objects on top of each other if you haven't done so already.

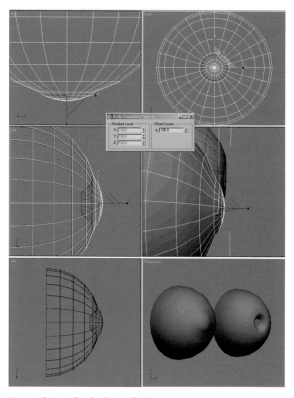

Smoothing the bulge of the cornea

Modeling of the Eyelashes

The basic shape of the eyelashes is not straight. Instead, they follow a slight curve from the base out to the tip. I use a simple linear spline with four points, as can be seen in the accompanying figure.

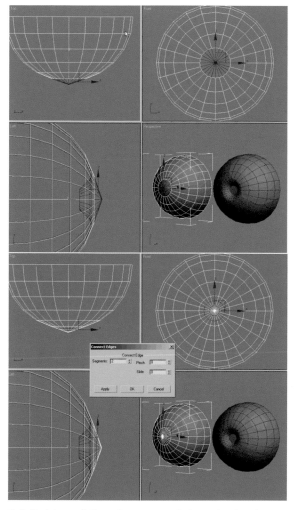

Subdivision of the edges around the raised point

Modeling of an eyelash

Spline: This is a curve or path. There are several interpolations for spline curves, which determine how the curve reacts between the set points. The simplest kind of spline is a linear spline. The set points are connected by straight lines.

Other spline types use tangents to be able to control the curve between the set points. Similar functions are also available in two-dimensional (2D) programs to define drawing paths or clipping paths.

Splines can be used for several functions, such as defining the shape of objects, supplying animation paths, or to control the behavior of parameters over time during animations.

Spline converted to polygons

The spline shape is then converted to a polygon object with the help of the Edit Poly tool. A triangular profile is enough for this shape since the lashes are very small in comparison to the whole scene.

One thing that shouldn't be skipped is the tip of the lash. Therefore, I select the three points at the front, upwards bent end of the lash and combine them into one point that forms the tip.

The bent shape of the lash is still a bit too angular. We will use the Chamfer tool to smooth the two middle profiles of the lash. This will convert the three parts into five segments. The lash now appears to be sufficiently rounded in its course.

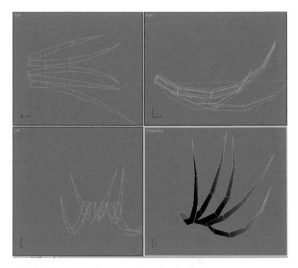

Multiplying and grouping the lashes

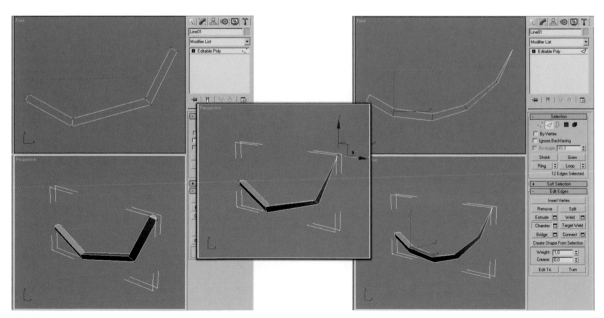

Shaping the lash

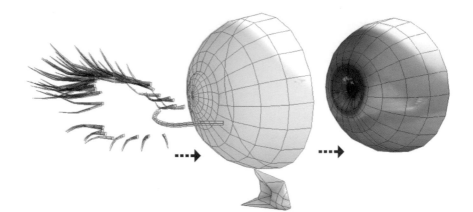

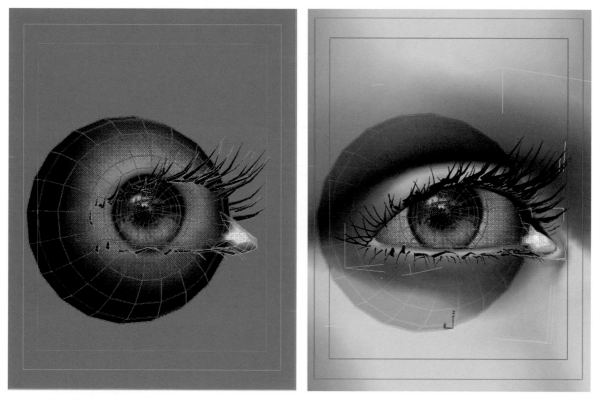

Connecting the separate parts

The lash is then duplicated multiple times, and size and direction varied so that a believable number of lashes are created for the upper and lower eyelid.

An additional hose-shaped object follows the contour of the surface just above the edge of the lower lid. This object will simulate, together with an appropriate material, the liquid collecting at the lower eyelid.

Materials of the Eye

Let us get to the surfaces of the eye objects. I will mainly use photographs, for which I pulled any available person I could get a hold of in front of my camera.

From these photos I created collages in Photoshop until I had reproduced the complete visible part of the eye. A copy of this color image is then converted into grayscales and modified in order to show the brightness of the eye. Under normal lighting conditions, a shaded area caused by the lashes of the upper lid will appear.

Integrating effects such as this one directly into the material can save a lot of work later when fine tuning the lighting.

In the lower figure you can see how I used the image of the eye and the aforementioned grayscale image in the material. The images on the following two pages show the remaining materials portraying the highlight and reflective properties of the cornea, the tear film, and the tear duct.

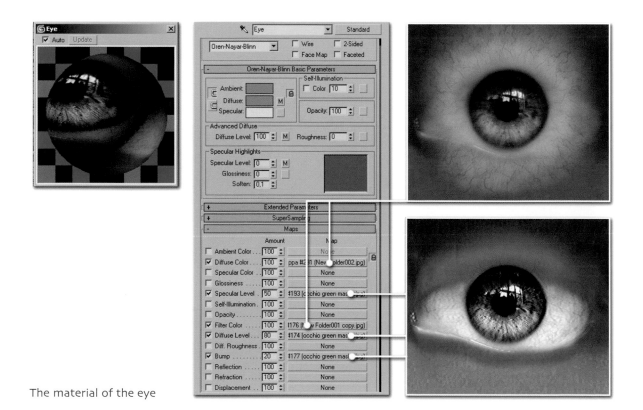

The material of the eye

The material of the cornea

The material of the tear duct

The material of the
tear film at the lower
edge of the lid

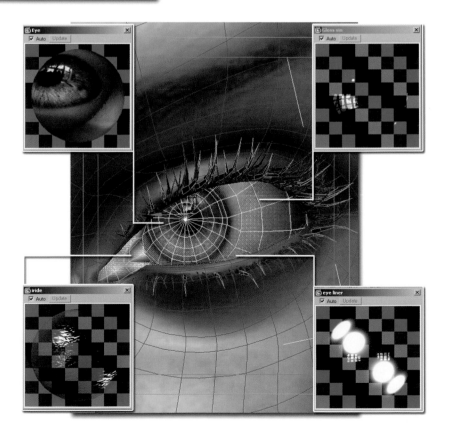

The allocation of the
materials to the objects

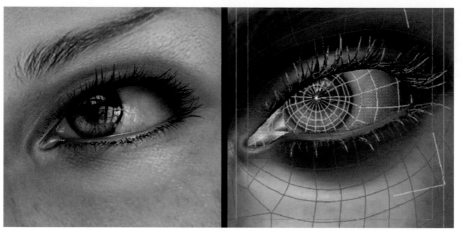

The finished textured eye

Strand of Hair

A strand of hair is poking out from under the side of the helmet. It is meant to soften the otherwise hard line between the helmet and the face. This hair consists of only a simple plane with an opacity map. The map causes parts of the plane to be transparent in areas where the opacity map is black. The rest of the area is white and gets the desired hair color by using a separate texture. In combination with highlight properties, which can be controlled in the material, the illusion is perfect. Generally this technique can be used for individual hair strands since only a few polygons are needed and the hairs can be calculated much quicker than more complex solutions.

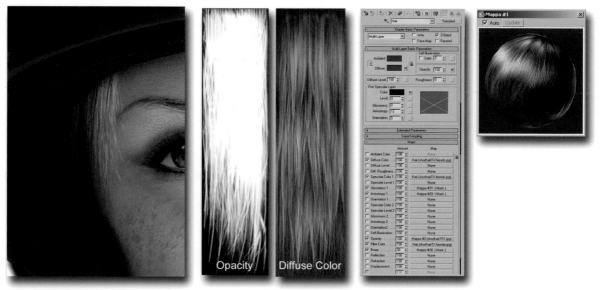

Opacity Diffuse Color

The structure of the hair strand

Lighting and Effects

The scene was lit mainly with the standard light sources of Studio Max. A MAXScript called E_light from Ronnie Olsthoorn helped me with that (http://home.wanadoo.nl/r.j.o/ skyraider/e-light.htm). It simulates ambient lighting that is usually created with intense radiosity and GI calculations.

Radiosity: This is a calculation method for 3D scenes where the light is to reflect off faces and encounter other objects multiple times. The light is scattered and simulates the natural behavior of light. Scenes calculated in this manner appear very natural but need, depending on the settings, much longer to calculate. This technique therefore is used mainly for still images and less for animations.

GI: This is the further development of radiosity, where light not only radiates from light sources but could also come from objects. Applied materials could simulate, for example, the light from the sky shining onto the landscape by using a sky panorama applied to a half sphere as a light source. Often GI is used together with the already mentioned HDRI images to create a reproduction of natural color and brightness values.

The scene is then calculated in several passes and assembled into the final result in Combustion.

Passes: This means the splitting of the image into an array of elements like the highlights or the bump channel. That way the depth of field or the color values can be edited without having to render the image again in the 3D program.

In this manner a blurred image is also integrated into the background and the sharpness of the face is manipulated depending on the distance from the virtual camera.

For the import into Combustion, I use the RPF format in order to directly transfer the depth mask and alpha masks for several objects, and render identifications from Studio Max.

Depth information of the scene and the background image

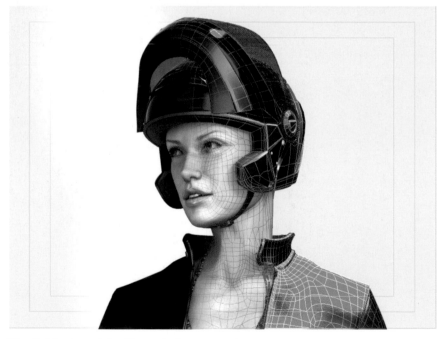

The finished model with a wireframe overlay

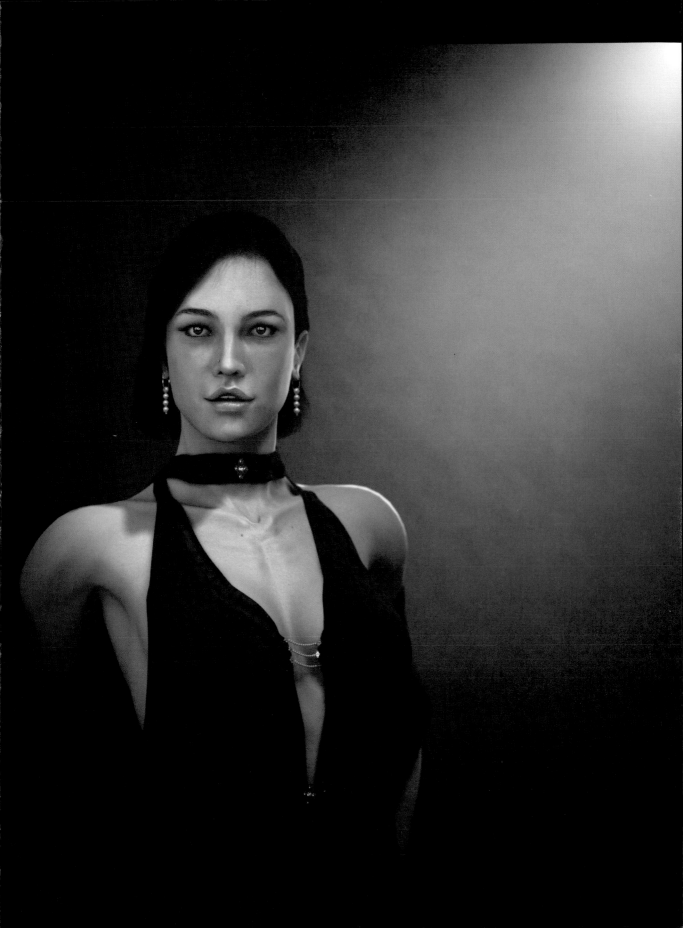

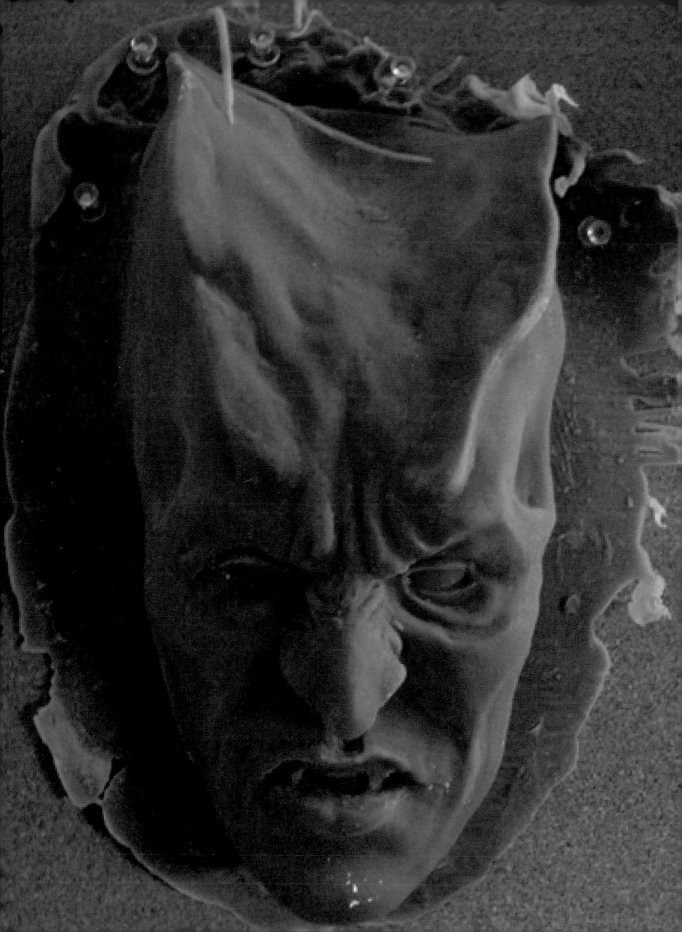

Sze Jones

Sze Jones is a character modeler at the well-known Blur Studios in California (www.blur.com). She has taken part in many projects, such as the modeling and texturing of characters in sequences of the computer games "Everquest 2," "Hellgate: London," "Fight Club," "Aeon Flux," "Bloodraven," and "Warhammer." Her story gives you an insight as to what kind of people are behind these fantastic images and movies that fascinate us so much. Let us hear what she has to say.

>> One of my biggest passions since early childhood has been art. I was raised in Hong Kong where Manga and Anime had a large influence on me. Often I saved my lunch money to go to the local Manga shop where I would buy a Manga and a large candy bar.

My grandmother and mother are both artists but in different areas. My grandmother likes to play Hawaiian music on the organ and my mother studied fashion design in the 1960s.

Ever since I can remember I have played video games with my brother, practiced violin and piano, and have drawn crazy things. We told each other fantasy stories and built model kits and sold them later to the students in our school. We did creative things all day long.

My mother is an open-minded person and let us be. She even supported us and registered us in a special class for art and crafts. Until today she has been one of the people who most influenced and supported me.

Then in 1986 I was honored for the first time in an art contest in school. From that time on I practically never stopped drawing and won an additional six art contests in Hong Kong.

I can remember well spending hours covering every blank spot in my schoolbooks with drawings while listening to 1980s music.

Pencil sketch by Sze Jones

Then I registered at a special art school in Hong Kong and lived on campus for two years. My life was all about art, before, during, and after school. On the weekends I learned even more with my neighbor who was a teacher at the University of Chinese Art.

Education

It has been a long time since I have had the opportunity to remember my life in Hong Kong. I have been in the United States for 13 years, originally having left my family to study in Canada. Since then my life has changed a lot.

The cultural differences made it difficult at first to find friends to laugh with and to share daily life with. At that time I went often to the movies, listened to music, and continued to draw to replace the missing social environment. I became very quiet and serious, all of which must sound a bit pathetic nowadays.

Besides these problems, the cultural differences also inspired me a lot and improved my art skills.

It was very inspiring to work with my teacher who had an incredible passion for art.

At the end of the semester I received a letter from him that encouraged and supported me. I still honor this letter because it inspired me to follow the taken path.

In 1993 I continued my graphic design education in the United States. At that time Adobe Illustrator and Photoshop were my preferred tools. Back then I didn't have any

contact with 3D graphics, because this field was still in its infancy.

In the second year of school I took a course about movie and television graphics. This was when I fell in love with the magic of film and developed a fascination for the team of artists that creates such effects.

At this time I also came in contact with computer graphics for the first time and was lucky enough to get a spot in such a popular course.

Pencil sketch by Sze Jones

Pencil sketch by Sze Jones

I remember how thrilled I was. I didn't miss any classes, got there first in the morning, and was the last to leave in order to spend as much time as possible on the computer.

I worked my way through the software manuals from the first to the last page to learn as much as possible about the software.

The first system I used was called Wavefront 3130. My first model was supposed to be a table lamp, but I failed miserably.

This didn't stop me though. I devoured several magazines and books about the subject. Of course, there weren't any online forums at that time.

Obviously I couldn't afford the hardware and software. An SGI was about $15,000 and to work with Unix commands is not for everyone. Remember, all this was a while ago.

Wavefront evolved into Alias/Wavefront and then to Power Animator. I learned to work with NURBS at school. At night I took additional courses at the Joe Kubert Art Center. I completed my master's of art in computer animation at William Patterson University.

During these four years I learned a lot about art and its history in the Western world, and I spent many hours drawing and 3D modeling. Much was done by trial and error as I learned to use the computer as a tool for creating art.

The computer helps me to live out my passion for colors, to model shapes, to animate things, to combine images with sounds and music and—most importantly—I can always use the undo command or Ctrl Z. What more do you want? All imaginable media are combined inside a machine and can be controlled and arranged with your hand. «

Practical Work

Right after I finished school I found my first job at a local computer game studio. I created characters and Full-Motion Videos (FMVs) for games. As a child I loved to play video games. Back then I was already inspired by the game "Final Fantasy" to create something along the same lines. I recorded the course of the game and the FMVs on video in order to analyze the technical structure.

My favorite FMVs at that time were "Tekken," "Final Fantasy," "Resident Evil," "Metal Gear Solid," "Parasite Eve," and "Grand Tourismo." Still the greatest thing for me is to complete a level or whole game and then to be rewarded with an impressive FMV.

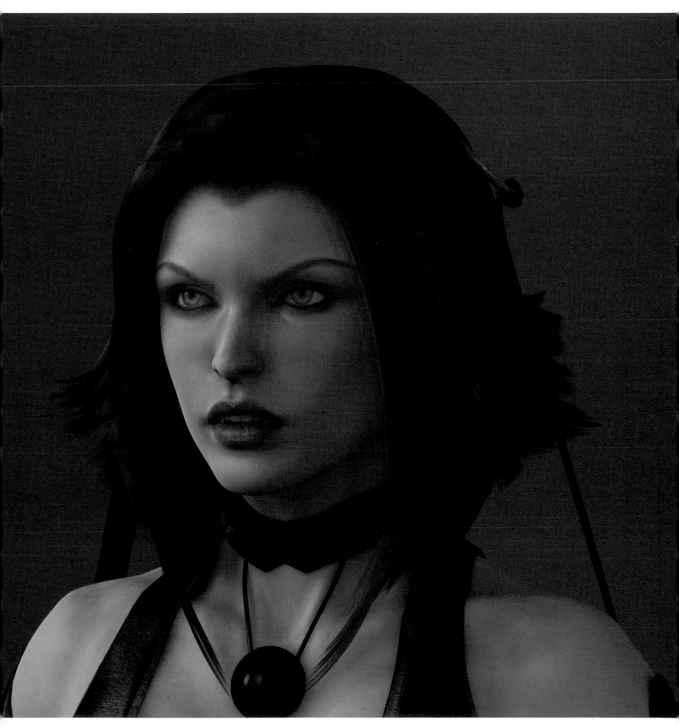

"Blood Rayne," Majesco

I will always remember the moment when the first game I was a part of appeared on the shelf with my artwork on the cover.

One year later I accepted an offer from Viewpoint, a well-known company that offers 3D objects online. There I learned to model objects, to texture them, and to create scripts for their online presentation. I gained an insight into all the rather technical backgrounds that have to do with 3D models. This also included the optimizing of 3D data and the scanning of real objects.

Even though I learned a lot about these things at Viewpoint, an inner voice told me to pursue the more artistic side. Thus, I quit after two years.

At the moment I work as a character modeler at Blur Studios for game FMVs. I oversee games like "Blood Rayne" from Majesco and the female templar knight in the game "Hellgate: London" from Flagship Studios.

All employees at Blur are alike in that each has a big passion for his or her work. Everybody tries to give 110% in order to create the best image and to be the best artist possible.

Over the years I have been in contact with artists from all over the world and we have become a strong team. Every morning when I get to the studio, a day starts that is full of fun and creative work, together with friends and people whom I respect.

I've been there now for four years and this is a dream come true for me. There is nothing better than to work in harmony with a team and to have a shared passion with others.

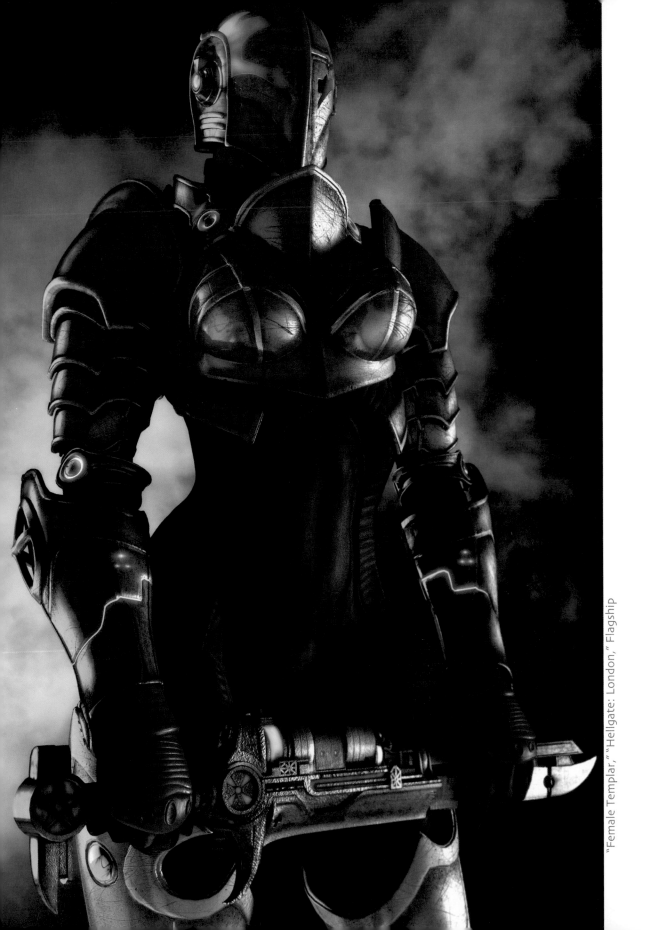

"Female Templar," "Hellgate: London," Flagship

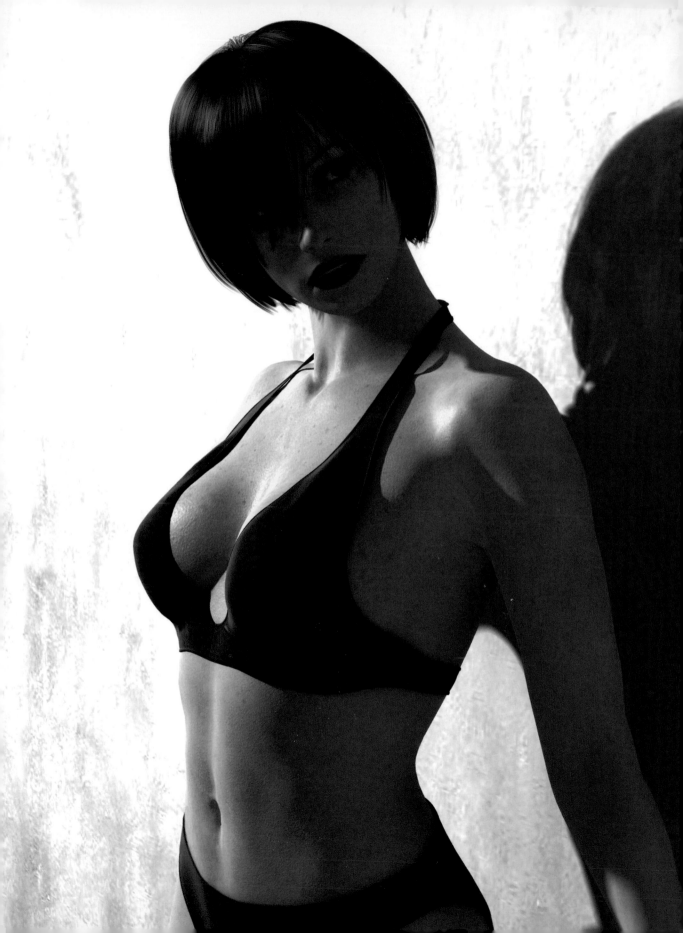

Liam Kemp

First known only by insiders, Liam Kemp's pictures should also have captured the attention of general magazine readers by now. His hyper-realistic women appear, for example, in advertising campaigns of Autodesk and in the magazine Maxim.

But there is more behind this than just the perfection of the characters. The basic shape of his female characters goes back to the year 2001 when he started the project "This Wonderful Life." It tells the melancholic but beautifully created story of a woman who finds an orphaned baby on a river.

This film was created with much patience on, according to current standards, a very old computer within 23 months.

This project has been shown at several festivals and has won several awards. More information about this and other projects can be found on the website of Liam Kemp at www.this-wonderful-life.com.

» I am 33 years old and live in Derby, England. After school I began studying at a university, with my main focus on illustration. Until I got there I went through a real odyssey. I was rejected by more than a dozen universities throughout the country because they couldn't categorize my photorealistic approach.

Toward the end of my study I began to experiment with stop-motion animations. I built characters and sets out of anything that was at hand at the moment. In this manner I created a few short films.

After my degree I again had more difficulties, this time in finding a job. I had to cope with more than 30 rejections, again mainly because of me leaning toward realism in illustrations.

After I had spent three years trying to find a job, I decided to learn more about the subject

of computers. I got my hands on a low-priced license of Studio Max and an old PC and taught myself how to use them. I had neither access to the Internet nor any friends who could have helped me. The familiarization with the software and the subject of 3D had to be learned the hard way.

Over time I gained ground in this area and even taught some courses about the software. I found a job in the game industry

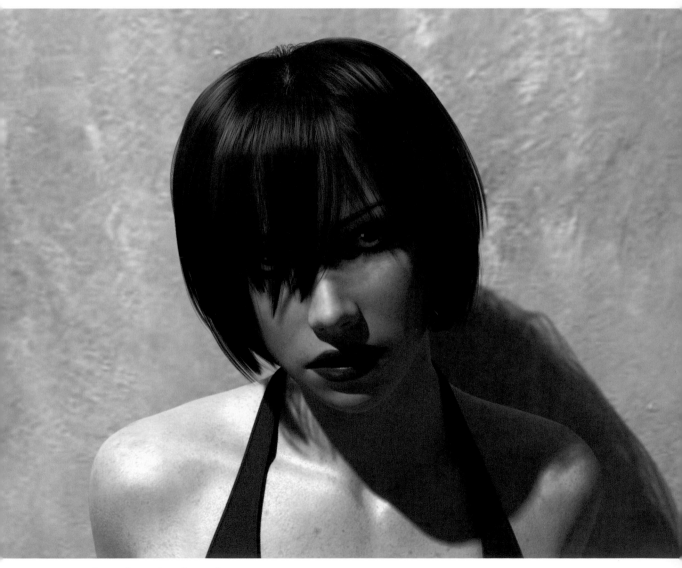

Image from the series photo shoot

and animated FMVs for the well-known computer games of the Worms series.

After several years I worked at Core Design in the area of modeling and texturing. My latest job is with a new game company called Circle Studio.

At the moment I work on a new animation with the title "The Normals." This is a project that I am financing myself and that I work on in my free time. I have already worked on it for 18 months and plan to complete it in the next 6 months. Then it will be shown at several festivals and sent to TV stations. I hope that this work will serve as a base for a new series. It has always been my dream to be able to present my work to a broader audience.

Both works, "This Wonderful Life" and "The Normals," mean a lot to me. I have always felt that images and projects born from my own ideas are much more fulfilling and help my creativity.

As for my hardware and software, I still work with 3DS Max for modeling and I use Brazil for rendering. Additionally I use several plug-ins for simulating hair and clothing, and I utilize Photoshop for texturing. «

Insights into a Work Sample

In October 2004 the Belgian magazine MAXIM included a contest for readers to select the most attractive virtual creature. The following images give an insight into my project that I submitted for the contest.

I started with the modeling of the eyes. My technique is to create two high-resolution spheres where one is slightly larger than the other. The outer sphere will later portray the white of the eye and the curvature of the cornea. The inner sphere simulates the pupil, including the iris.

First I activate the larger sphere and select the front pole point. This selection is then widened with the Soft Selection function of 3DS Max so that a soft transition to the surrounding points is created.

Two deformed spheres shape the eye

When the pole point is pulled forward the neighboring points will follow and automatically create the soft curvature of the cornea.

I do the same to the inner sphere but push the pole point inward. The upper

image shows the result. This concludes the modeling part.

As for the mapping of the textures, I project the material, using the shrink map method, where it is directed toward the front pole point. Additionally I use a plane projection for the inner sphere in order to control the width of the iris.

For the actual textures of the eye I create four images. These control the color, bump effect, reflection, and transparency.

Parts of the different textures for the eye

I start with determining the color of the iris. I often use the airbrush tool to create a base coloring. On this layer I can create striped variations that radiate from the pupil. For this I also like to use the airbrush tool.

As for the colors to use, it can be helpful to use a mirror that will show the color distribution in your own eye. When your own eye color is too different from the one the 3D model is supposed to have, then different references have to be found. Make sure you use references, since different eye colors have certain color patterns at, for example, the frame of the iris.

A copy of the color map, converted to a grayscale image, can be used to generate a bump map. Here the contrast should be increased and the brightness can be adjusted. Otherwise, no other details have to be added.

A map for the highlight properties of the pupil doesn't need to be created. Just make sure that the surface receives and reflects enough light later.

When these textures are complete I start with the maps of the outer spheres. Here, I start again with the color map and draw the fine blood vessels on a light background. In the center where the iris is located I create a dark gray circle. The edge of this circle will later create the circular shading around the iris.

For the bump map I create a subtle structure containing several noises in Photoshop. These are supposed to show fine irregularities on the object. Make sure to leave out the area on top of the pupil. There I use a uniform gray tone.

The character in its pose

Lastly, I create the map for the transparency or translucency of the outer sphere. This map is simply a white area with a blurred black circle in the center where the bulge of the cornea is located. This area will then be transparent and allow the iris underneath to show through.

I activate additional reflective properties of 20% in the material itself for the outer sphere. This makes sure that the environment is reflected in the eye. However, the effect is subtle enough to still keep the color properties of the eye visible.

The eyes are then inserted into the head of the character and links are created so the direction of the eyes can be easily controlled.

In the lower image of the figure on page 89, the two reference points for the eyes are shown as green cubes.

The distance between the target objects has to be chosen in a manner to be determined, so that the eyes are neither cross-eyed nor drifting apart.

In addition, the proper axis for the eyes has to be selected in order to align the pupils to the target objects and not, for example, to the rear of the eyes.

Beside these help objects and the camera, you can also see in the image how I set up the lighting. I base it on classic studio lighting.

The main light source is located to the right behind the camera. This light takes care of the base lighting, the highlights in the eye, and the side of the character.

A second light source is located across from the first one and behind the character. This light is much weaker and simulates the ambient light of the studio environment reflected onto the character. Also, the coloring of this light source is warmer and adjusted to the reddish color that is planned for the background.

Both light sources cast shadows onto the character and the railing, an additional accessory in the scene.

The third light source is positioned high above the character and has a red color. This color gives the skin a more natural coloring and creates additional highlights on, for example, the lips.

As can easily be seen in the previous images, I use a complex hair simulation, made of single strands, in order to show the variations of the hairstyle.

The images on the following pages show other shaded views of the scene including the final composition and pose. The resulting image is right at the beginning of the following gallery of my works. More examples can be found at www.this-wonderful-life.com.

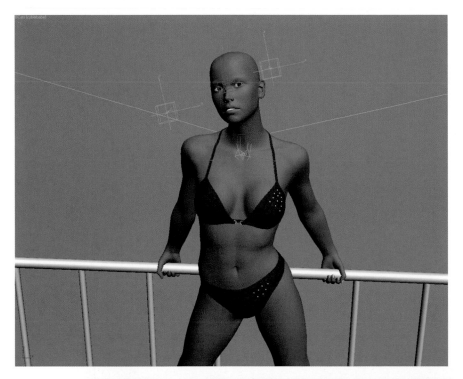

Editor views of the scene

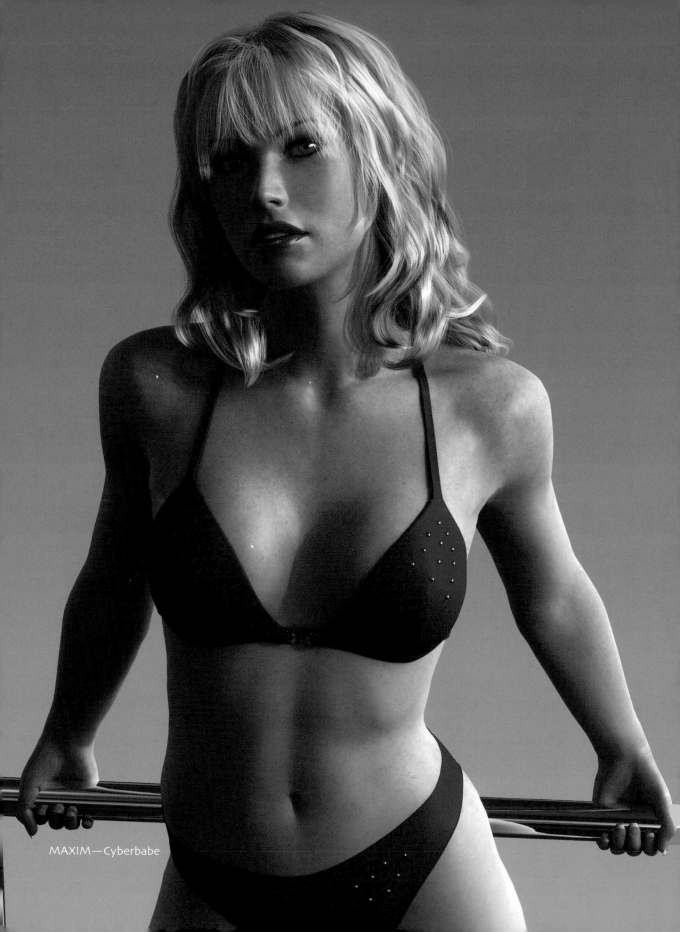
MAXIM—Cyberbabe

Image from the series photo shoot

Image from the series photo shoot

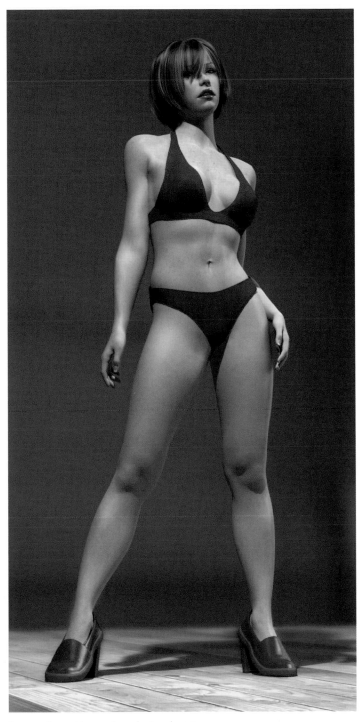

Image from the series photo shoot

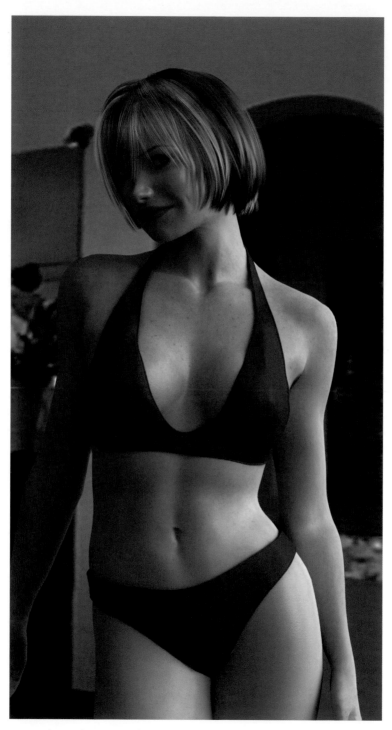

Image from the series photo shoot

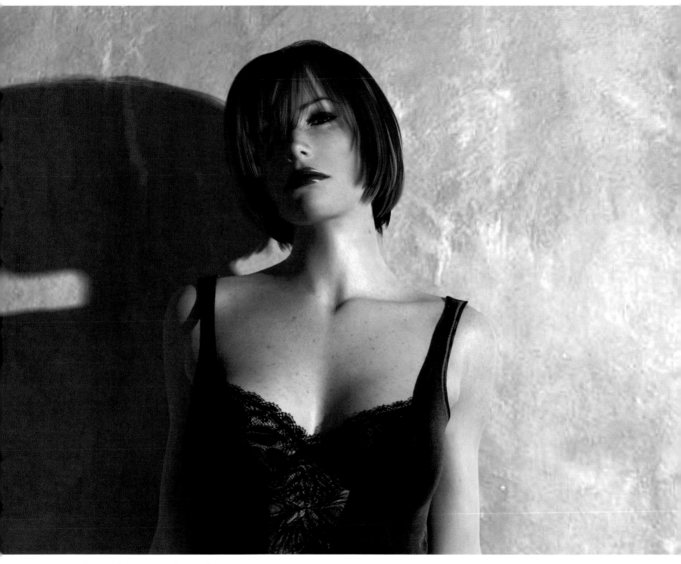

Image from the series photo shoot

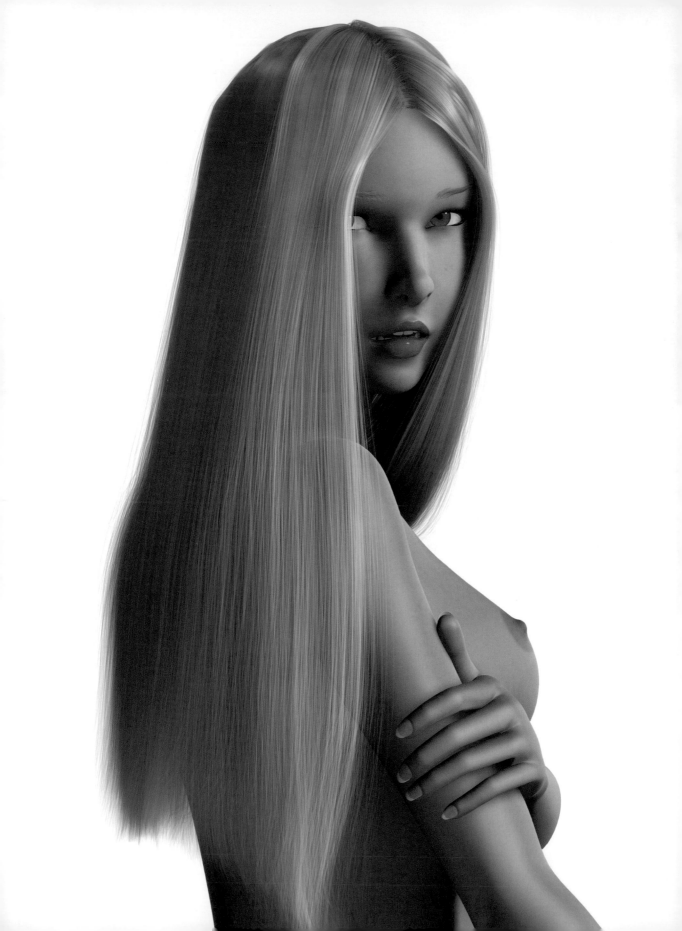

Francois de Swardt

It is not always the goal to achieve a result as realistic as possible. The variety of possible techniques and styles accounts for the diversity of 3D images.

In my view the works of Francois de Swardt, from South Africa, reside between comic characters and modern Barbie puppets. Let him talk about himself and his work.

» I am 33 years old, a designer, and come from Pretoria, South Africa. 3D graphics is more of a hobby to me than a job.

For as long as I can remember I have liked drawing. But I was also interested in 3D graphics. The origin of this passion was an Australian TV documentary I saw in 1989 called "Beyond 2000." It was about the subject of 3D animations.

This documentary assumed that even a halfway realistic reproduction of humans would be impossible to achieve, because there would never be enough computing power. How fast the world, and especially the technical possibilities, can change.

Aside from a couple of 3D-like vector images that I created in 1989 on my XT computer, I first started in 1995 to create real 3D graphics with CorelDREAM 3D and CorelMOTION 3D.

The animation possibilities were still very limited and the modeling was restricted to a combination of several primitive objects like cube, sphere, or cylinder, and 3D text. Additionally, the render times of my 486 AT computer were so high that there was no way to create an animation, let alone to try and create 3D characters.

In the following years, I worked with Ray Dream Studio 5 and Poser 3 (www.e-frontier.com) but wasn't happy with either of them. Ray Dream Studio wasn't really made for modeling organic objects or characters, and Poser characters were of good quality, but somehow they all looked the same. The possibility of individualizing the characters was missing.

As a result I looked for alternative software that was designed more for organic modeling. At the same time, I have to confess that I wasn't especially talented in 3D modeling, and all that was just a hobby for me. Therefore, I wasn't ready to spend a lot of money on software.

I researched the Internet for days and found the software Hash's Animation Master (www.hash.com), which was also affordable.

At first I was overwhelmed by the number of functions and the complex workflow that accompanies the modeling of a character. I tried to get tips from other Animation Master users, but only a few tried to achieve realism. Rather, the majority worked on caricatures and comic characters. As a result I had to teach myself.

Back then I worked on the first version of my Angelique character, even though I wasn't happy with the result. My goal was to use Angelique in a music video that I was to compose and produce myself.

I gave myself half a year, which was very naive in retrospect. Of course I neither managed in that time to finish modeling the character nor to animate it. I didn't know at that time that it would be a project that could take several years.

This discouraged me so much that I left the work alone for several months. Then in mid-2004 I found my motivation for 3D again and decided to change the software I use. This time I got Cinema 4D (www.maxoncomputer.com). The many available plug-ins and a very good connection to the animation software Alias Motionbuilder (www.autodesk.com/alias) made this decision easy.

In order to save myself some work, I used the geometry of the character from Animation Master and imported it into Cinema 4D. Now I had the possibility of animating clothes and hair with, for example, Joe Alter's Shave and a Haircut plug-in (www.joealter.com).

Fabian Rosenkranz, who also programs plug-ins for Cinema 4D, helped me with the preparation of rigging the character with bone deformers. For the first time I could animate my Angelique character.

One day I came across the works and demo reel of Steven Stahlberg (www.androidblues.com). I knew that I still had a long way to go before I would achieve this quality, if ever. This experience led me to delete my character and to start again from scratch.

The current version of the character is now the third one and won't be the last, for sure. ≪

Insights into a Work Sample

Splitting the work between different programs proved to be the most efficient way for me to work. Currently I use Cinema 4D for modeling, the preparation for the animation, texturing, lighting, and rendering.

I use Animation Master for all still images and to pose the character for the animation. Because of the open GL display, it is also possible to work with more complex characters in real time.

The software Blender is used to simulate liquids. It is unbelievable what this free software can accomplish (www.blender.org).

PhotoImpact is used for the postproduction of images and the editing of textures. For editing movies I use Mediastudio Pro.

When working in 3D is just a hobby, like it is for me, I would recommend downloading finished objects from the Internet to build your scenes. Many objects are free or can be purchased for a small fee directly from the 3D artist. There are also several vendors, like Turbosquid (www.turbosquid.com), 3D Export (www.3dexport.com), or the classic 3D Café (www.3dcafe.com), which offer objects.

Always be careful where you use the objects, because not all of them can be used in commercial projects. When you are not sure, directly contact the 3D artist who offered the object.

With this example I did just that because I needed a modern motorcycle for this scene.

You can imagine how time consuming its modeling would be, especially when it is to be used only as an extra or prop. Consequently, I found and purchased a suitable object from the 3D artist Jamie Hamel Smith.

Creating and Preparing the Character

I can't place enough emphasis on the importance of using the right reference material before starting to model the character. This could be images or sketches.

Photos are generally preferred since the proportions of body parts in sketches could be slightly off. This would then be transferred onto the character and often you realize too late that there is something wrong with the character's proportions.

The Internet is filled with useful images, while references prepared especially for modeling could cost some money. If you have a certain pose in mind, it would be ideal to take photos of a real person yourself.

I think the shape of the female body is one of the most difficult, yet most fascinating, challenges to model. The face, bosom, and bottom are especially difficult to get right. Often there are nuances that, if not handled properly, can result in an unnatural-looking shape.

The body could be modeled perfectly, but when the 3D face has weak areas, or even looks too masculine, then the overall impression is ruined. Therefore, the same

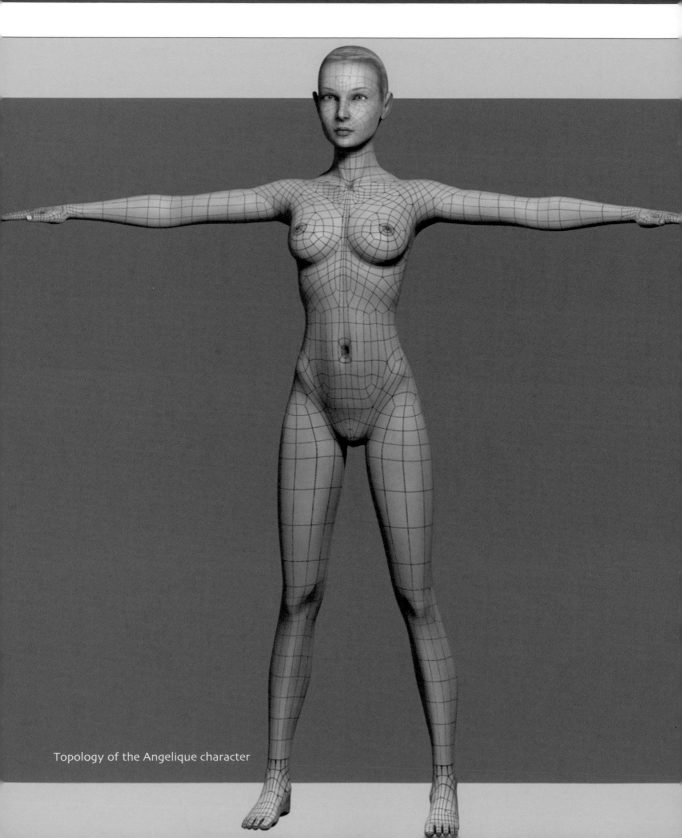

Topology of the Angelique character

care should be exercised for all body parts. The eyes are especially important.

I merged 12 different photos of women's faces into a new one, and used it as reference for Angelique's face. Later, I made some more changes to get even closer to my idea of beauty.

The topology, which is the number and position of polygons on the 3D surface of the character, should be planned in an early stage. In a later stage it could be more time consuming to rearrange polygons than to build the model from scratch. As far as I know there is no perfect topology, but there are methods that work better than others.

The reason for a good topology should be to arrange the polygons so that the deformation of the surface looks natural. This is especially important in the area of larger joints, like the knees or the shoulders, and also around the eyes and mouth.

As you can see in the last image, the areas around the large joints have a higher subdivision so they can be easily reshaped with a deformer.

For texturing I like to use images that I put directly onto the geometry. The software necessary for this step, Bodypaint 3D, is already included in my version of Cinema 4D. That way, I can work on this part without having to switch programs.

First, I place textures with the most important skin tones, and add the missing or covered areas with the Clone Brush tool.

Finally, I add a special shader that simulates the light scattering on deeper layers of the skin, and that also simulates slight fuzz

on the skin. The latter gives the skin an additional softness and tenderness. This effect can also be nicely simulated with the fresnel shader.

Fresnel: This term describes the calculation of the slant of the surface in relation to the line of sight. Surfaces that are facing the camera can be calculated differently from the ones that are angled away from the camera. This effect can be tested when standing in front of a window and looking straight ahead. Ideally, the window becomes invisible and the objects behind the glass become more apparent. But when looking parallel to the window or in a flat angle, then the glass looks more like a mirror and the items can hardly be seen behind the glass.

This effect can be used in 3D programs for many reasons. It could be used to control the relation between transparency and reflection as explained in the example of a window. Additionally, the brightness of an object can be controlled so that the contours of a model are brighter than the front faces. This gives the illusion of the surface being covered by fine fuzz or hairs capturing additional light. This effect is also useful when simulating fabrics like velvet or wool.

Then I prepare the character for the animation. This preparation is also necessary when only a still image is the goal, since the character was modeled in the neutral T-pose. This pose makes it easier to texture the character and to prepare it for animation.

I pull the necessary bone objects into the character and assign areas of the surface to each bone, which then are supposed to follow the movement of the bone.

For the simulation of the clothes I first duplicate the character. This makes sure that

the clothing and the character react similarly when deformed, since the subdivisions of each object are at the same place. This also makes it easier to texture the clothing since the UV coordinates of the character can also be used for the clothing.

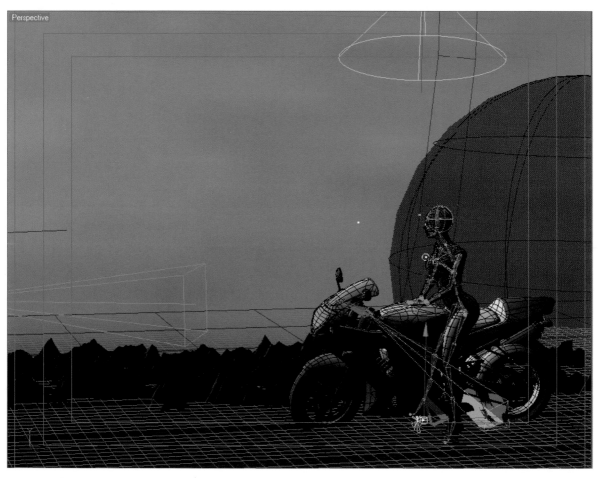

Setup of the scene

Hair Simulation

Since a module for creating and simulating hairs is included in Cinema 4D, the creation of hair is much easier.

The software takes over the dynamic simulation so that I only have to worry about the shape and color of the hair. This is especially important with the Angelique character since she has quite long hair.

I usually leave the character in the neutral pose and add hairs when necessary. When

this is finished, I animate the character into the desired pose. Because of the dynamic properties of the hair, it follows the animation of the character and deflects from the body and clothing in a natural manner. When the character has achieved its final end position, the hair looks very natural, just as if I had placed it in the desired shape.

Generally, I try to keep the scenes simple so the attention of the viewer is not diverted from the character. This also makes the work easier for me, since I focus all my

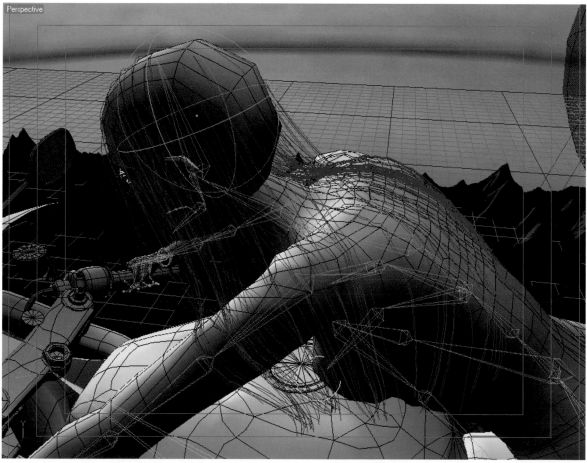

Close-up of the hair simulation

attention on Angelique in order to put the spotlight on her.

Since the scene with the motorcycle is planned to be an animation, I export the motorcycle and the character to Motionbuilder. In order to have control over the movement of the handlebar, I also added a few bones to the motorcycle.

Because the image is supposed to be a combination of two themes, I thought it would be a good idea to just create two animations in Motionbuilder and to extract two images from them.

Therefore, I exported the animated objects again, from Motionbuilder to Cinema 4D, and positioned a camera and additional light sources. Furthermore, I added simple objects like rocks and a sky to give the scene an environment. Here my rule is "less is more" in order to keep the render times down.

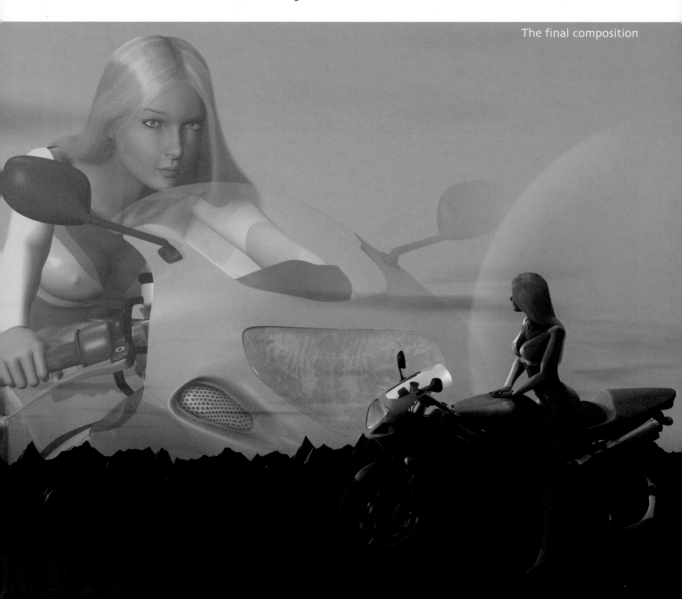

The final composition

Since my scenes generally contain simulations, such as the long hair and the clothes simulation, I have become used to a certain workflow.

I always start by rendering the clothing separately. Since there are no layered clothes in this scene, I need only one pass. Otherwise, the pieces of cloth would have to be rendered from the inside out so that the collision recognition still works. When the clothes are tight, I try to get by without using any dynamic simulations. In this case, the fabric can be deformed along with the character.

The hairs are the last part of the simulation. This is so they can interact with the clothing pieces. Clothing and hair can then be additionally affected by turbulence and wind. This prevents them from looking static during the animation. The final composition can be seen in the figure on page 106.

Angelique

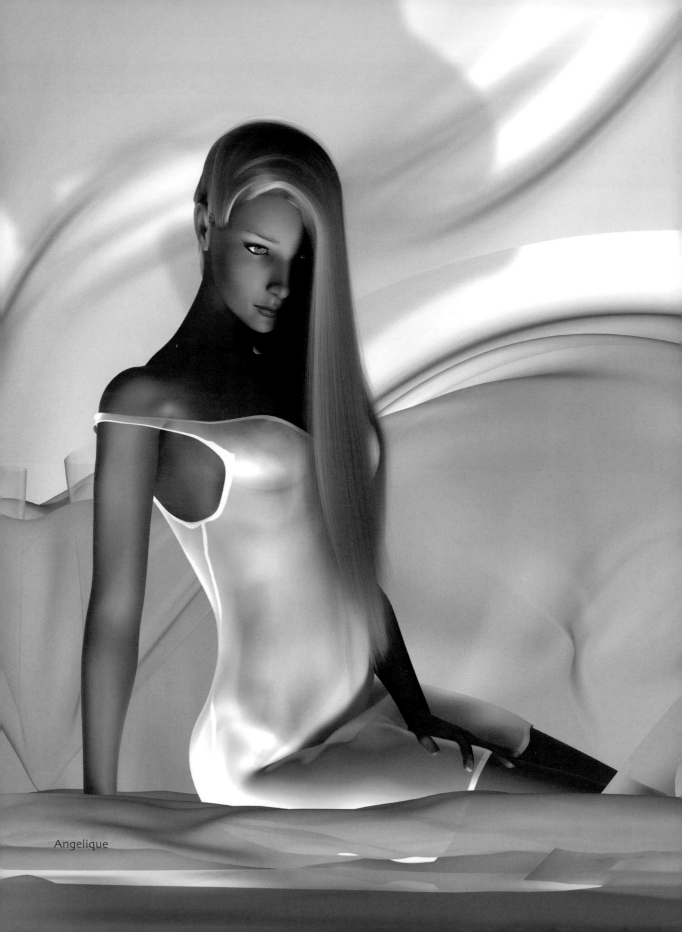

Angelique

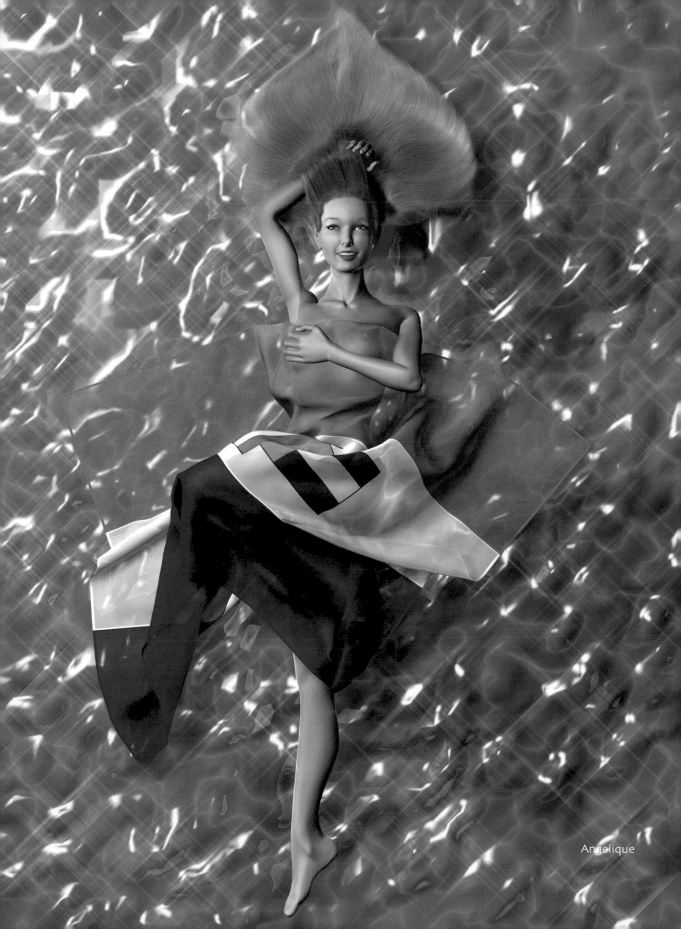

Angelique

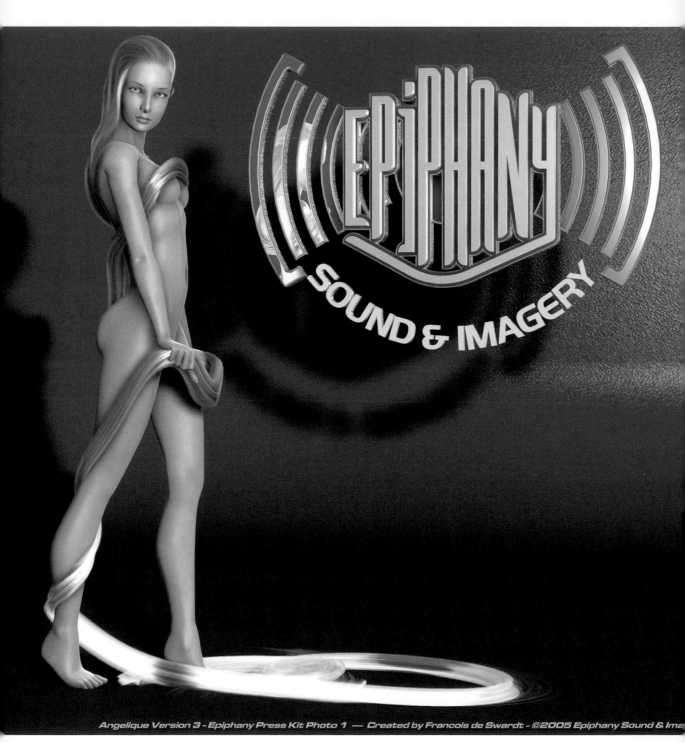

Angelique Version 3 - Epiphany Press Kit Photo 1 — Created by Francois de Swardt - ©2005 Epiphany Sound & Ima

Angelique

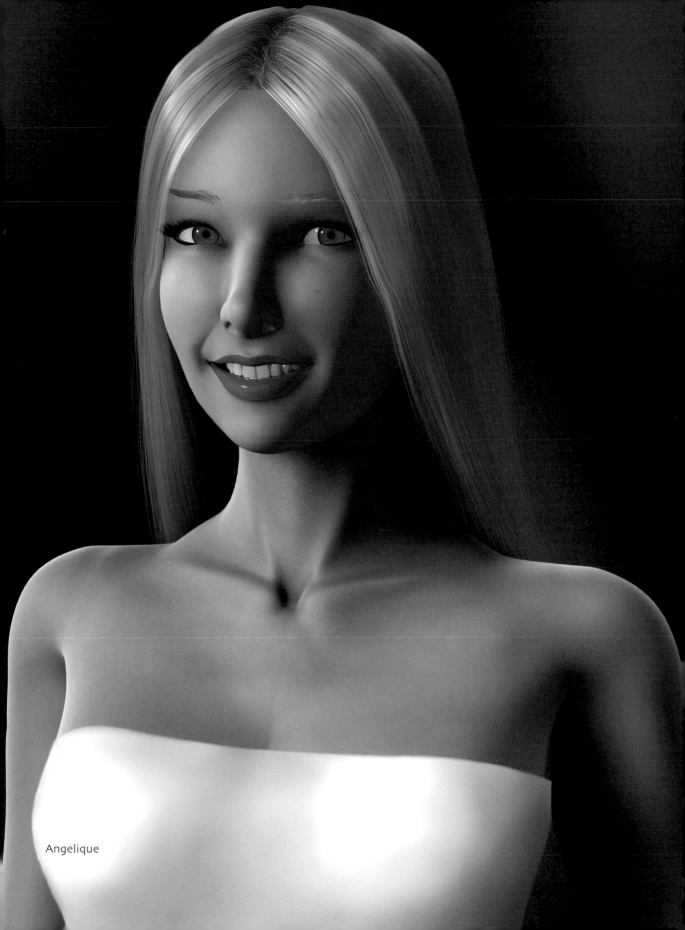

Angelique

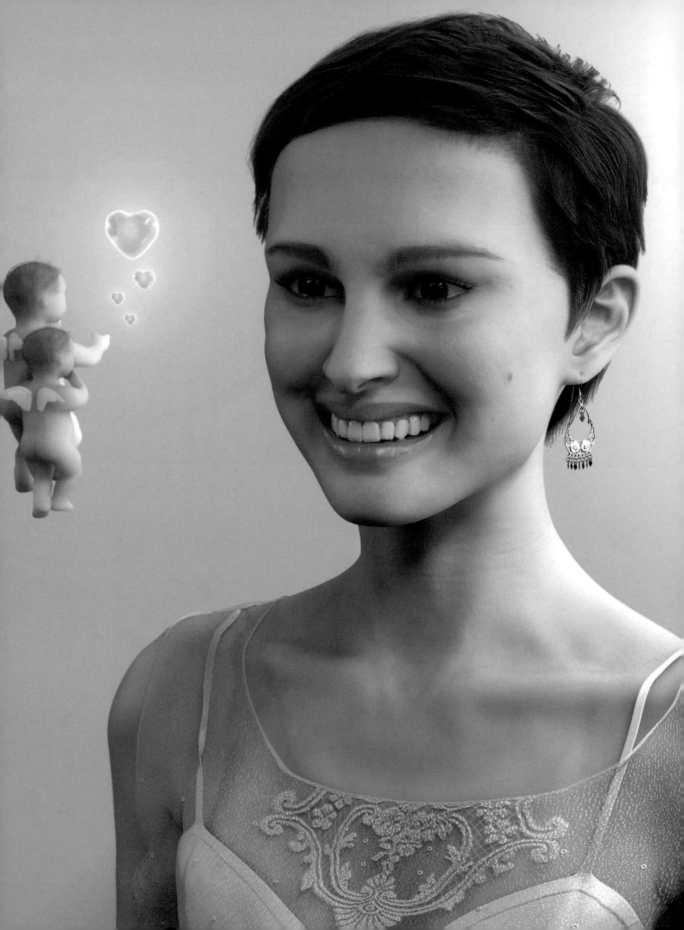

Max Edwin Wahyudi

Not only commercial artists have fallen for the appeal of modeling 3D characters. Representative of the many so-called hobby users and students, I'd like to introduce Max Edwin Wahyudi. His works inspired me instantly when I saw them.

He works mainly on the reconstruction of well-known Hollywood stars like Natalie Portman, Angelina Jolie, and Brad Pitt. It could be seen simply as fan art, but that would not do justice to the perfection of his models. Let us see what he has to say.

» I am 23 years old and come from Indonesia. Two years ago I came in contact with 3D programs for the first time and was instantly fascinated by their possibilities. I cannot pinpoint any specific reason for that. Maybe it is the fact that I've always liked to draw and to work with images.

As for using the programs, I learned exclusively by means of the manuals. Also, the accompanying tutorials and examples that can be found on the Internet helped me a great deal.

In this manner I learned 3ds Max and Photoshop. The latest software I have learned is ZBrush. This program, with its intuitive tools for 3D modeling and surface sculpting, reminds me of working with clay or Play-Doh.

ZBrush finally gave me the possibility to achieve the level of details I desired. The method of working within this program is very similar to the process of traditional drawing.

As for my plans for the future, I am currently looking for a suitable school where I can learn more about 3D graphics and modeling. «

Natalie Portman

In this short workshop I would like to provide an insight into the development of the Natalie Portman model. The modeling was done exclusively in ZBrush. The texturing, addition of the hair, and the rendering were then done in Studio Max.

For all of you who don't know ZBrush yet, I'll give an overview on how the modeling is handled.

Working with ZBrush

Generally, there are two possible ways to start the modeling process. My preference is also the most common method: to create a low-resolution model in another 3D software. The idea is to create the basic form of the object with just a few polygons. Be sure to use rectangular polygons whenever possible since they work better with the subdivision algorithms of ZBrush.

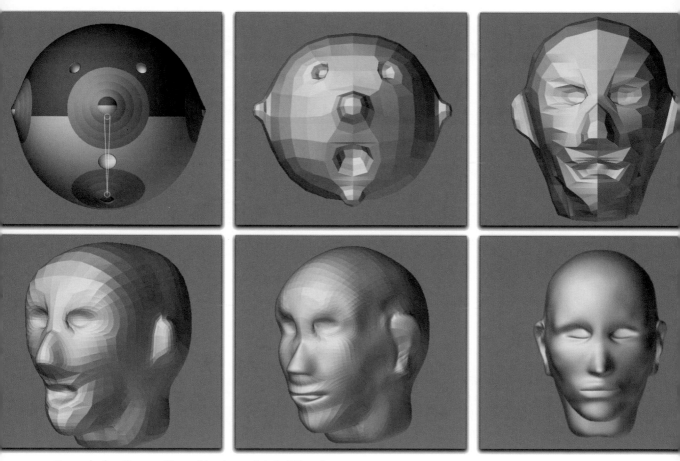

Example for the creation of basic models in ZBrush

If possible, the UV coordinates of this model should be unwrapped at the same time. These can then be immediately imported into ZBrush. The program can generate UV coordinates by itself, but they are not suitable for further editing in other 3D programs.

The prepared object is then imported into ZBrush, preferably in OBJ format.

The second method begins directly in ZBrush, where a stylized shape is created by using so-called Z Spheres. Starting with a sphere, multiple sphere chains can be created that represent, for example, arms and legs. As for the head, the Z Spheres can also be moved into each other to create holes and cavities.

This technique can be used for creating eye sockets and the mouth. The previous figure shows such a Z Sphere arrangement, in the top left image, as it is used for a head.

These sphere chains can then be covered by a polygon hull that can be moved and distorted using magnetlike tools. The images in the first row on page 115 show how quickly the basic shape of a head can be created.

Now the model has to be subdivided in order to add more details using the numerous tools available.

Because of the intuitive use of the paint tools, forms can be created very quickly. However, I still recommend creating the low-resolution model in another 3D software.

Working with image templates and creating individual loops is still accomplished more comfortably there. However, when it comes to detailed modeling, ZBrush is again ahead of the game. The simple head in the last image series, which was modeled in just a few minutes, demonstrates this.

As shown in the series of images, when I started the modeling process of Natalie Portman, I still worked with Z Spheres. For reference I used numerous images that could be found on the Internet. By continuously comparing the model to the images, the shape was refined until the model looked almost like the actress.

After the basic shape was completed, I subdivided the object further. I did this in order to model the fine details, such as the

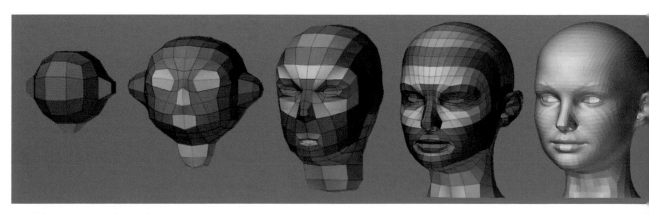

Modeling steps with Z Spheres

creases around the eyes and on the lips, and the slight elevation of moles.

details that otherwise could be achieved by bump maps.

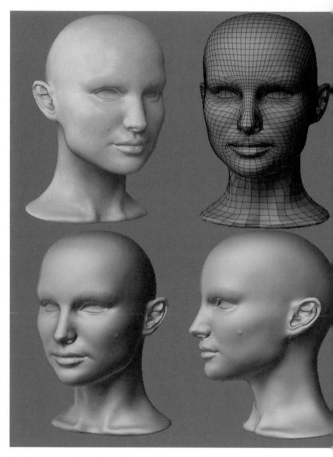

Adding further details

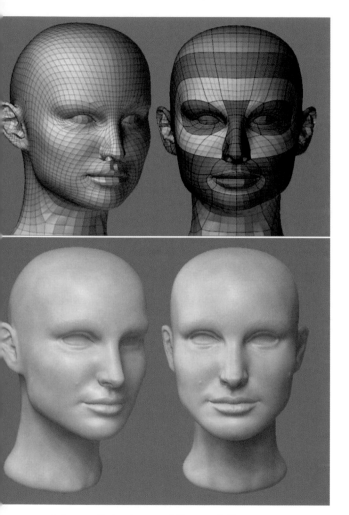

Intermediate stages of the modeling

Adding Fine Details

It is possible to work on objects containing one or two million polygons without any problems. However, it is tempting to use this high-density information to create

Therefore, I continue to model fine details, like the pores and other fine structures of the skin, with stamp tools and brushes.

The series of images above also shows how I slowly expanded the head toward the upper body. This allows me to have more creative freedom with the composition later.

Generally, the brush shapes and brush patterns provided by ZBrush are enough

to shape the skin. Often, the creases can be created with fine crossed lines and pores can be accomplished by using spheres pushed into the skin.

In this manner, layer by layer, more details are added. This is done until the object, as seen here, cannot show any more details because of its polygon density.

At this point, the subdivision has to be increased by one level and the work can continue. When the refresh rate becomes too sluggish to work in real time, then a special tool called Projection Master is available. With its help, the current content can be frozen and further edited as an image. This is of course much faster than moving the polygons directly.

When enough details have been painted, the Projection Master is exited and the image information is applied to the 3D object. As a result, colors and changes on the surface can be applied at the same time.

If you have not previously worked with ZBrush, you might be amazed by the number of polygons. This large quantity makes it very difficult to further edit or to use the model in an animation in another program.

The main advantage to ZBrush is that all changes and subdivisions can be changed into a displacement, bump, or normal map. These can then be applied to a low-resolution object in another 3D software. The displacement is then activated when the object is rendered.

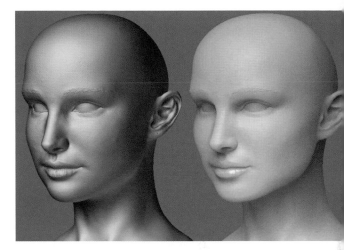

Eyebrows and lips get finer details

This allows us to work with low-resolution objects in the editor or in animations, and to achieve the look of a high-resolution model in the rendering.

The fascinating part is that because of the existing UV coordinates, the displacement and all the previously modeled details in ZBrush can be moved and deformed realistically when animating the low-resolution object.

When the lips are deformed to a smile and the cheeks are moved closer to the eyes, the creases realistically move along as well.

My experiments don't go that far yet. Because of my not-so-advanced computer I restrict myself to creating still images.

As can be seen in the images above and the ones following, I first create the desired level of details, and then I start to add colors. This, however, can also be done directly in ZBrush.

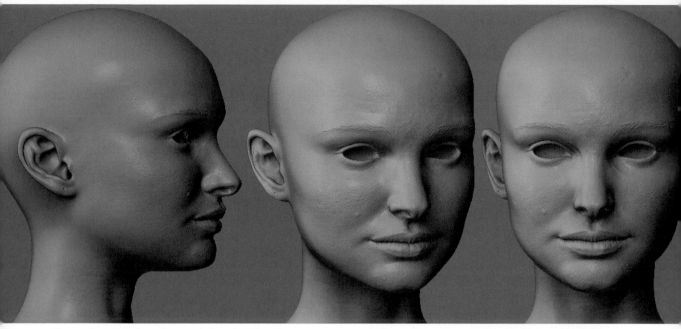

The end stage after the modeling in ZBrush

First, determine the desired pixel size of the texture. Then begin applying numerous colors and patterns using the diverse brush tools available. Also, here the Projection Master is helpful when working with high-resolution objects.

Beside the skin structures, which are interesting for close-ups and detailed views, more time can be spent on other areas as well. For example, I have tried to create the inner structure of the ears to be as close as possible to reality. It is more difficult to find decent reference images since hair is in the way most of the time. However, in the end I did find some useful images to use.

To the right are some of these references and the corresponding views of the 3D model.

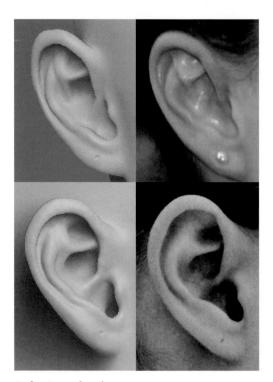

References for the ear

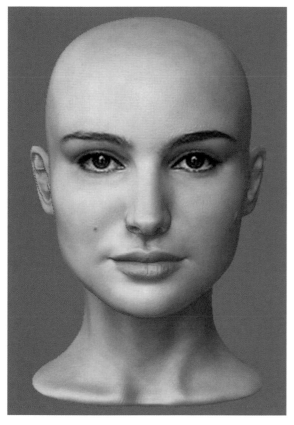

Eyes added as a projection

Eyes

When I was finally happy with the shape of the head, I applied a unified skin tone. At that point, I wasn't sure how I should create the eyes. First attempts were to project simple images into the area of the eyes.

This would greatly restrict the movement of the eyes; however, they would look realistic without much effort.

As shown in the upper image, it appears like it may be a good solution. This proved to be problematic though, since almost all the eye images already had definite lighting. For

the most part, they had strong highlights or shadows. It is also difficult to find images in the appropriate size and of good quality.

Lastly, I decided to take a different approach and used image collages that I produced myself. These had the right size and detail depth, but appeared to be flat and lifeless when lit.

The problem is that the human eye achieves its appearance from highlights and reflections. Also, the shadows cast by eyelashes and the slight overlap of the eyelids gives the eyes a certain depth.

There seems to be only one real solution, and that would be to model the eyes. This way, a realistic look can be achieved when lighting is added.

I accomplished this in 3ds Max and built the eye out of two objects: the outer transparent cornea and the inner eye with the iris, along with the white portion that contains thin blood vessels. This allows me to concentrate completely on the color of the iris. The reflections and highlights will be added automatically by the lighting.

The color in my first experiments was too bright, and the eyes appeared too cool and flat. Photos that are taken under studio conditions and with perfect lighting can be deceiving.

Under natural lighting, the pupils appear very dark while the whites of the eyes appear to be a rather dark gray with a slight yellow and red tint. It helps, therefore, to sample the color values of this area from photos. It is surprising how dark these colors actually are, even though the eyes in the photo appear very bright and gleaming.

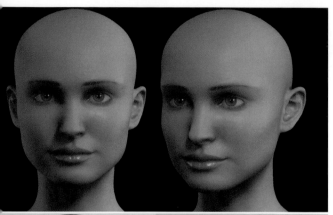

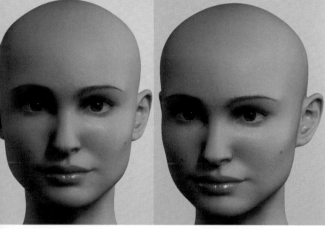

Variations of the eye color and brightness

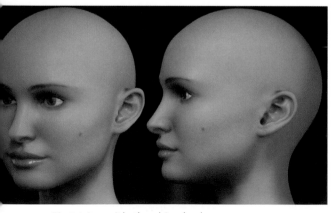

First tries with the skin shader

This is caused by the contrast to often darker skin and black eyelashes. With women, makeup amplifies this effect even more.

As can be seen in the images to the left, the iris has a much more natural appearance since brown eyes should be darker and have more depth.

In order to frame the eyes appropriately, we have to add the eyebrows and eyelashes. There are different techniques to accomplish that. Eyelashes can be modeled piece by piece out of bent cylinders and splines. This has an advantage in that the exact position, size, and curvature of every eyelash can be individually determined.

I chose a different method and used a hair simulation. I also used splines, which are curves with supporting points. They can be "combed" with special tools and can be controlled easily, even in larger groups.

It sometimes is enough to use just a few control splines to cover large areas with hair or fur. The hairstyle is then determined by an interpolation of the existing spline curves. This way, it isn't necessary to create and edit each hair by hand, like in the previously mentioned method. Instead, it is enough to use only a few control splines to create, in the case of the eyelashes, just the beginning and end of the eyelash row on the eyelid, and one more in-between position in the center of the lid.

The total number of lashes to be created can then be easily set. The lower image shows the result on the eyelids and brows.

Skin

As for the depiction of skin, a simple color texture is not enough.

As demonstrated by the red glow of ears when they are lit from behind, light penetrates skin. It even passes through at thin spots, such as the side of the nose and the tips of the ears. At the fingers this effect can also be seen.

In 3D programs, this effect is the so-called subsurface scattering (SSS). This term describes all effects where light seemingly penetrates the object, is scattered, and then exits the object again at other places. The light doesn't merely hit the surface and reflect back into the direction of the camera, as is common with metals.

Generally speaking, the majority of materials would benefit from SSS, resulting in more realism. Even stones and wood absorb light and redirect it internally. But this effect requires highly intensive calculations and is used only with objects that are intended to be especially realistic looking.

In order to keep the render time within a usable range, simplified models are used and are often integrated as shaders into the 3D software. Their different penetration depths can be assigned to several images. This depth is controlled by numerical values and is dependent on the angle of incoming light to the surface. Light that hits the surface at a flat angle is reflected more than light hitting the surface at a vertical angle.

The latter can penetrate deeper and take on more color information of the deeper skin layers before it emerges again in another location. Because the tissue under the skin

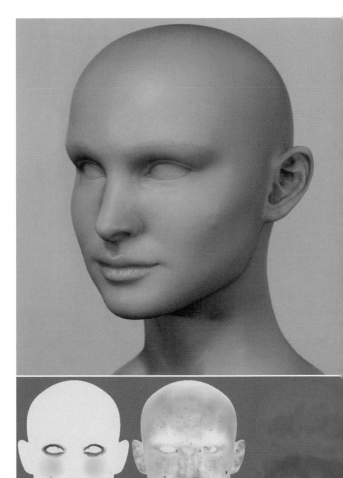

Structure of the skin texture

contains many blood vessels, the light passing through to this point takes on a red color. That's why ears lit from behind or fingertips held in front of a flashlight glow red.

The coloring of the skin layers should depend on their distance to the bones underneath. The skull, which is relatively close to the skin in the area under the eyes, prevents a deeper penetration and scattering of the light,

whereas the tip of the nose is comprised of only soft cartilage.

Therefore, I created three different textures that I painted directly onto the head and then exported to 3ds Max.

The first texture represents the outermost skin layer with distinctive discolorations, like moles and makeup.

The second layer controls where and how deep the light penetrates the skin. A simple grayscale image, with its brightness values, is enough for controlling this effect.

The third image depicts the coloring and intensity of the deeper areas. I especially emphasized the cheek and nose in darker red tones.

When these images are loaded into the SSS shader and the intensity and penetration depths of the light are adjusted, a very natural-looking skin can be simulated. In addition to these textures, the effect also depends strongly on the position of the light sources. It should be certain that lights seen from the virtual camera are placed above and behind the object.

Only in that way can the light be transported through the virtual tissue and achieve the desired effect. It is important not to overdo this effect, otherwise the surface looks too much like wax. Lastly, this effect should only be used as an addition and be supportive of the normal surface shading.

The following image shows the final result with the skin material and appropriate lighting.

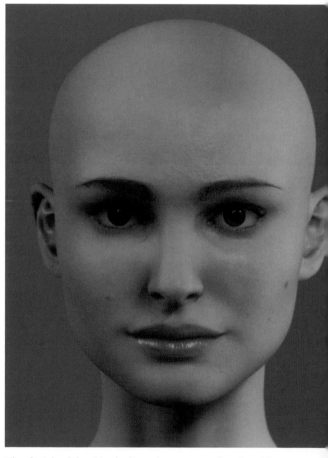

The finished face including the texture for the skin

Hair

Just like the eyelashes, there are different solutions for the longer hairs on the head. Textures with alpha maps on simple layers can be used to simulate simple hair strands. This can work very well when several layers are built on top of each other to give the hairstyle a certain density and volume.

It is often faster, more realistic, and more suitable for animations to take advantage of special hair shaders that are used in combination with hair simulations. I used Hair & Fur, which is a part of the 3D software 3ds Max.

My procedure was that I divided the hairstyle into several segments. This could be done at the place visible at the parting of the hair, or at the hairline.

For every one of these segments I have created a copy of the head model and adjusted the selection of this area. That way I can edit the different hair directions and styles separately from each other. The series of images below shows roughly how I built the hairstyle.

The larger hair groups are to the left and right of the parted hair. Then I have added shorter and more curled hair at the hair line and at the temples. Additional hair groups are added when necessary to increase the volume or to fill gaps.

It is important to find a believable thickness at the roots of the hair. On the one hand the hair should be dense. On the other, it shouldn't appear so massive that skin is no longer visible. The same is true for the quantity of hair, which can simply be determined by numbers.

Only the render time and the memory have to be watched, since they depend directly on the number of hairs. If the computer does not have enough memory, the hairstyle has to be rendered in several passes. In this manner, one at a time, different portions of the hair are rendered and combined later into one image.

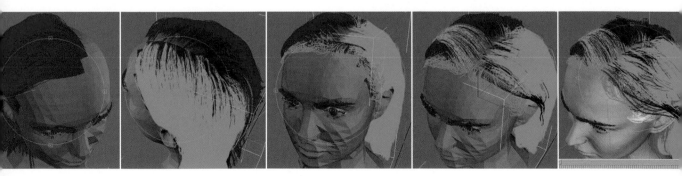

Phases of the hair simulation

Finally, the right color and highlight properties have to be defined. Often, many test renderings are necessary to find the correct values. Therefore, the hair should be added after the modeling, texturing, and lighting of the model. Then, the appearance

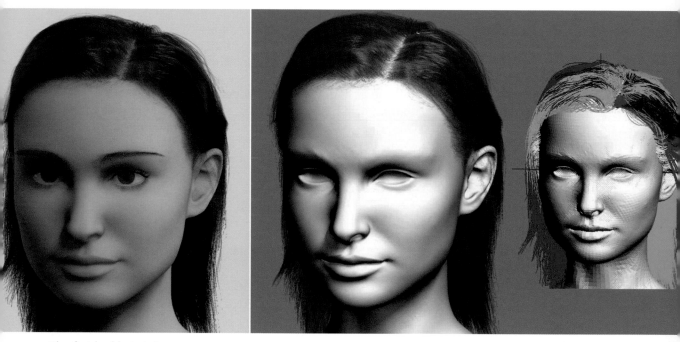

The finished hairstyle

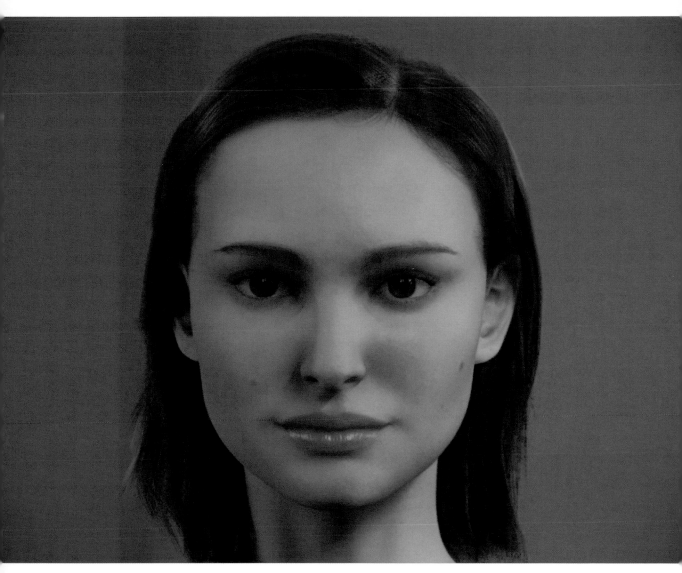

The finished scene

of the hair can be adjusted to the lighting situation and skin tone.

A New Scene

Encouraged by a very realistic display, I wanted to try a different pose. By now I have collected enough image reference material.

Because of the previously mentioned anchoring of the materials to the UV coordinates, I just needed to adjust the textures slightly in ZBrush to the new pose. Creases were emphasized or new ones added.

The lower-resolution object was previously placed into a new pose in 3ds Max. The goal was to show Natalie Portman with a smile. As a result I had to add the teeth, which did not exist before. The upper body also had to be elongated slightly and the top of the arms had to be added.

During the model changes, I took some advice from others who criticized the fake "Hollywood smile" in earlier stages. The mouth showed a wide and open smile, but the eyes remained almost unaffected by it.

I needed to incorporate the area of the eyes by adding more laugh crinkles under the eyes, at the transition to the cheek.

I also altered the shape of the teeth and loosened the position of the lower lip a bit to make the laugh appear more relaxed. Finally, I exchanged the hairstyle to make it look like the photo in front of me. Actors, with their constantly changing appearances, don't make it easy for us, do they?

The final touches are the small accessories, like the ear ring and the half-transparent dress. The series of images below shows several phases of remodeling, while the last image shows the finished version.

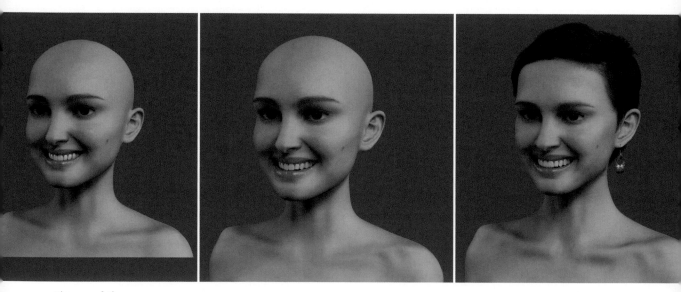

Phases of the new pose

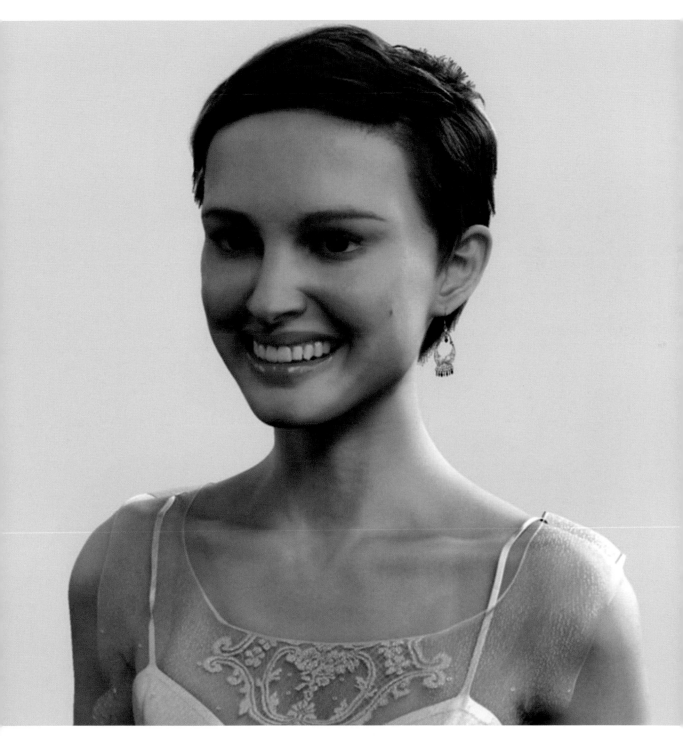

The new pose

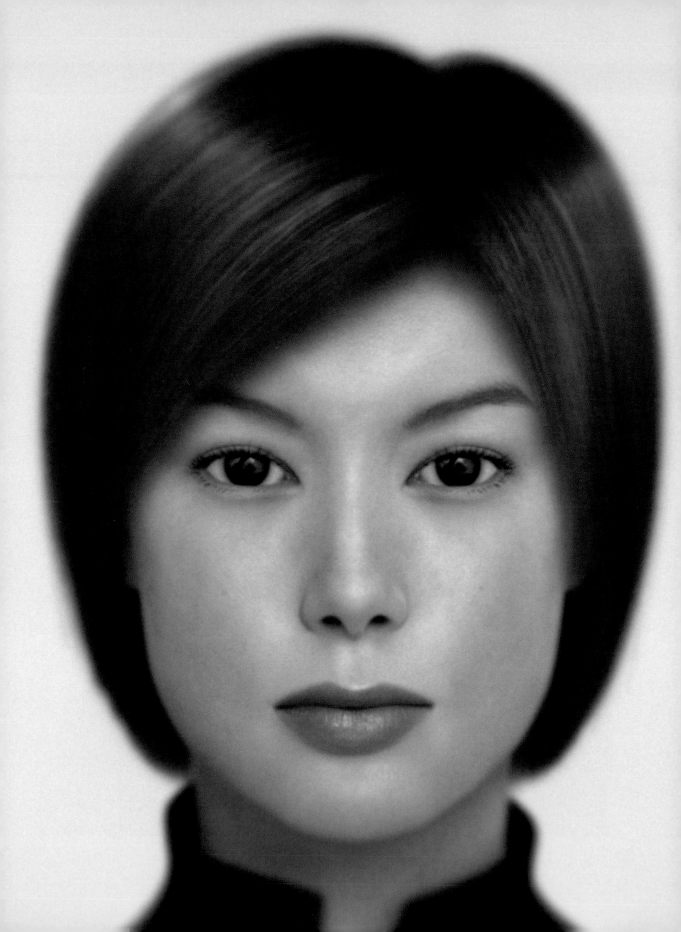

K. C. Lee

It is always inspiring for me personally to take a look at 3D artists from Asia. There is a much closer relationship between Mangas, Anime movies, and the work of 3D artists, whereas a wider gap exists between similar genres in Western culture.

Partly we notice an extreme addiction to, what is for us, tacky colors and shapes, but that always carry emotions and are never boring.

K. C. Lee is working in Hong Kong, and therefore is affected by Western and Eastern influences. This also fascinates me about his works.

>> As for my education, I received a degree in computer science at the University of Otago in New Zealand. Then I started working as a programmer in Hong Kong.

I discovered relatively quickly my enthusiasm for computer graphics and animation. I tried to learn about the subject in my free time and to get as much practice as possible.

As luck would have it, I was offered the opportunity to work as an animator at Centro Digital Pictures. This is one of the largest postproduction companies in Hong Kong.

It's funny that I was hired as an animator, but hardly came in contact with the subject during my four years in the company. I dealt mainly with modeling, texturing, shading, lighting, and rendering. This also included compositing jobs.

In my leisure time I continued to program for my own pleasure, which often proved beneficial. As a result, some valuable help routines were created that I could use for my 3D work.

For a year I have been working as a freelancer, mostly on commercials for TV or effects for movies. I still take much pleasure in 3D graphics and especially in 3D characters, where I have a special fondness for renderings that are as realistic as possible.

Since my early days in kindergarten I have been fascinated by Japanese Mangas and Animes. From them I still receive inspiration for when I visualize robots, machines, or a new character. The abundance of ideas and fantastic shapes is almost infinite, with new stories and images being published on a daily basis.

I create my work using Lightwave and Photoshop, or After Effects with animations.

More information and work examples can be seen at my homepage www.gumfx.com. «

Insights into a Work Sample

In this example I would like to present my actual project, which is a portrait of a young Chinese woman.

I start with the modeling of the eye. Several images are used for the texturing of the surface, especially for the fine blood vessels.

Different photos are used as reference for the modeling of the head, that can be seen in the image on page 128. I mainly concentrate on the face, since this part will be seen in close-up later on.

Because the portrait will be front facing later, it is important to be sure of the proper

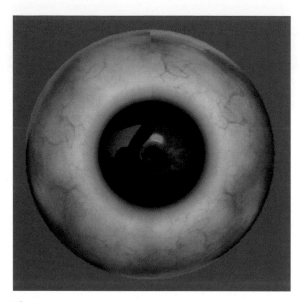

The eye

proportions. Also, the lighting will play an important role so the face doesn't lose volume and details even with this restricted perspective. Most important are the eyes, which will provide the face with life by way of their reflections. Therefore, I work with High Dynamic Range (HDR) images. They will provide the virtual environment for the scene and partly take over the lighting of the object.

The texture of the skin is a mix of composed images and elements made by hand. This will make it easier to adjust the color of the makeup.

I wasn't sure about the hair style when I started the project, and therefore modeled the ears completely. The image on page 131 shows a view of one finished ear. As it turns out, they will hardly be visible.

The ear

After applying the textures, I start working on the hairstyle and the individual hairs. I build them in levels, starting with a helmetlike shape. The hair guides start at the parting of the hair above the left eye, run to the left and right, and down in a soft bend to the chin.

The hair simulation will automatically create the hair around and between the guides. Even though this is very handy, it also looks fake, since the course of all the hairs is more or less parallel to each other. Therefore, we should make the effort to create several layers of hair guides that are moved slightly and varied along the course of the guides.

The merging of several hairs to a single strand plays a special role. In particular, at the tips, the hairs merge together into smaller groups.

The following images give you an impression of the development of the hair style and my buildup of the different hair layers.

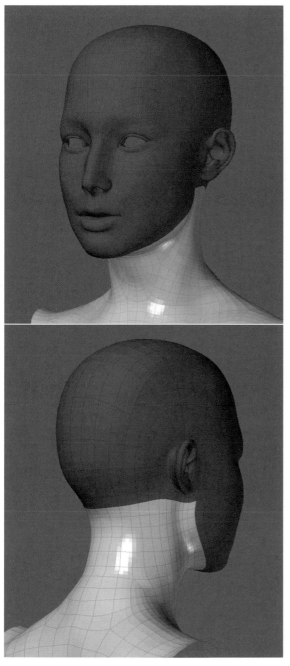

The model of the head

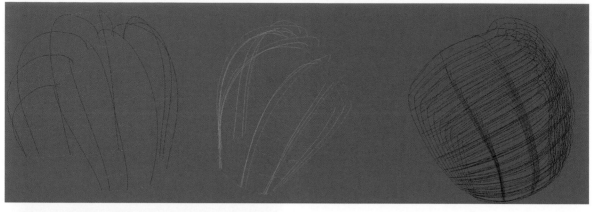

Buildup of the hairstyle

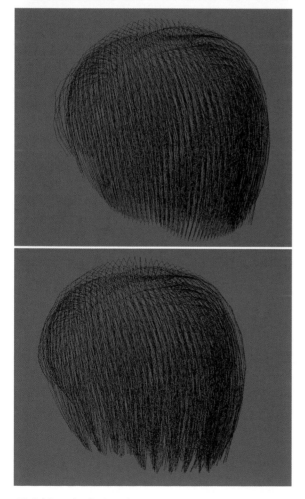

In these images, you can see on the left the buildup of the outermost guide layer. As you will notice, the guides run from the parting of the hair, around the head, and span the surface indicated by the pink lines.

Under this layer I placed separate guide setups for each side of the head. This is shown by the example of one half of the head, in the center of the image above.

In the lowest layer, several short guide setups are defined that run like stair steps down each side of the head. This will give the hairstyle a more voluminous look and will cover skin that might show through the hair.

In the last step, I bundle irregular groups of hairs at their tips. You can see the difference in the adjoining image. The top image shows the initial state, and the bottom image shows the final result.

Lighting

For the lighting I use two area lights, which can be seen in the previous image as green frames. I restrict these lights so that one is showing all the light while the other one

Finishing the hairstyle

Setup for the lighting

shows only the diffuse lighting. This way I can comfortably control these two properties separately from each other. In the center of these two area lights there is an additional spotlight that creates highlights only. With this light I create the very important highlight in the eyes. Another spotlight is located across from the camera, behind the head, and takes care of lighting of the hair from behind. The whole scene is enclosed by a large sphere that has an HDR image applied to it to simulate the environment. I use this sphere as a reflector for the radiosity calculation.

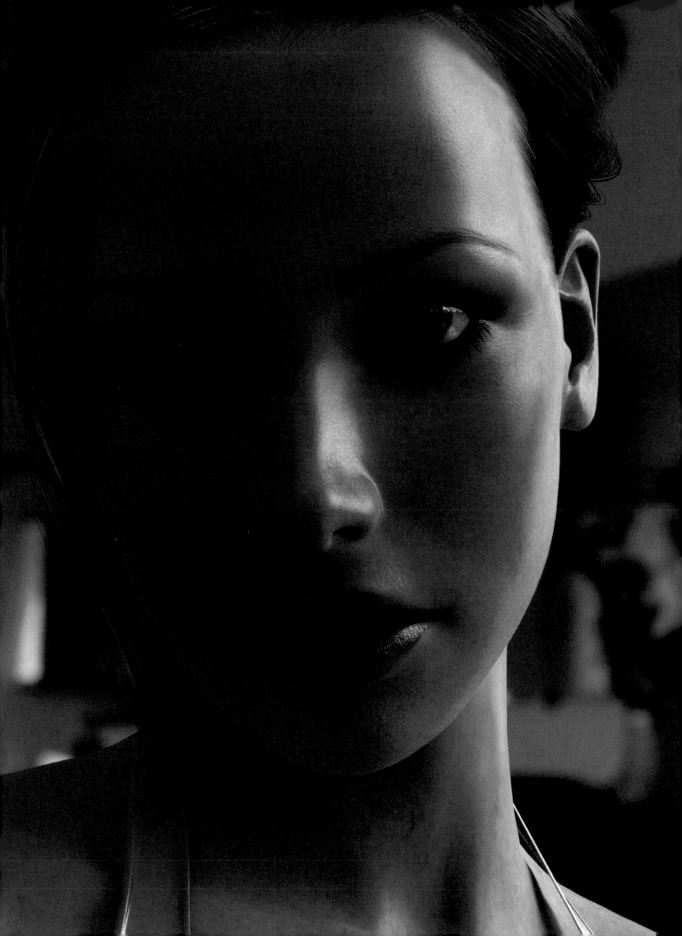

From Head to Toe: Continuous Workshops for Modeling Virtual Characters

Creating and Preparing Templates

Regardless of the fact you already may have experience modeling characters and organic models, or that you want to know more about this subject, the first step should always be preparation of the proper templates.

These could be photographs, small models, toys, or sketches. Templates that were saved or created on a computer are preferred since all 3D programs allow the display of images in the work environment. The modeling can be done directly on top of the image, making it much easier to keep the proportions and allow the exact transfer of the template.

Before we start with the actual modeling of the character, I would like to introduce two methods of creating suitable image templates. The first allows a more open method of working, which will be especially interesting for artists with drawing skills. The second technique includes the use of photographs as references and is therefore better suited for real and existing characters.

Mixing these two methods is also possible, for example when an alien with a humanlike face is to be modeled.

1.1 Drawn Templates

The drawing of individual templates has the advantage of being able to work completely freehand. Shapes and characters can be developed that neither exist in reality nor are realistic. In the latter category are, for example, all comic figures.

When a realistic figure is to be designed, a hand-drawn image can be helpful because it is easy to create poses and themes. That way, the look and feel of the character can be tested on a simple piece of paper.

You don't have to be a skilled artist. Often a few strokes are enough to sketch a mood or facial expression. As the various renowned 3D artists in this book have demonstrated, most of them work this way.

When we look at a sketch of a head, it is helpful to know that certain mathematical rules apply. The eyes are always positioned in the middle of the head. From the front the head is about five eyes wide, including an imaginary eye that would fill the space between the real ones.

Rules such as this make it easier to sketch a standard head that can then be further individualized. We will therefore take a closer look at the creation of such sketches.

All you need is a pen, ruler, and piece of paper. In order to use the sketch at the computer later, it would be helpful to use a drawing program. The ideal situation would be to use an additional graphics tablet, which, compared with using a mouse, allows for a more natural way of drawing. This also makes it easier to apply a texture to the object.

Texturing: This term defines the application of properties to the surface of a 3D object. These properties determine the look of the object and influence, for example, the shininess, bumpiness, transparency, reflections, and, of course, color.

Figure 1.1: Work space with guides

1.1.1 Preparing the Work Space

In the following steps I will use Adobe Photoshop for creating the sketches. Since we need to draw only simple guides, you can use any other drawing program you like.

Start with the creation of a new, white work space. The aspect ratio should be 8:6, for example, an area of 800 × 600 pixels.

At the start of a project, nothing can be worse than a white sheet of paper. We will now change that and add four guides to the work space. In order to easily remove them later, they should be on their own layer.

Measure 300 pixels horizontally starting from the ruler origin and place a vertical guide at that spot. Place another guide at 600 pixels.

Add two horizontal guides at 300 and 450 pixels on the vertical ruler. Figure 1.1 shows the result.

1.1.2 Drawing Contours

These few guidelines are enough to draw an anatomically correct shape of the head.

Start by connecting the two verticals, which are crossed by the horizontal center line, with a large U as shown in Figure 1.2. This is the line that proceeds from the ear down the jaw bone to the front of the chin and then upward to the bridge of the nose. Because we want to sketch a female head, the line flows in a soft arc from the ear to the chin. The further the line from the ear gets pulled down before it curves to the chin, the more masculine the face will be later on.

Figure 1.2: Jaw bone and lower half of the face

In this and in all future steps, do not try to draw a line all at once. Hardly any beginner will be able to do that. Instead, it is easier to create a line by connecting shorter strokes.

In addition, create a new layer for each new segment. This will make it easier to correct parts of the drawing or to mirror them, which is what will be done with the ears and eyes.

In the next step, add a half circle on the left side to form the rear part of the head. In the upper portion, continue the half circle over the forehead and down to the previously drawn lower part of the face. Now the basic shape of the head is complete. Do not be alarmed by the extreme protrusion of the back of the head. We have drawn the skull itself, which will later be covered by the structure of the neck.

This can be corrected easily by a soft curve going from the back of the head down the neck. Also add a transition behind the chin, under the jaw line, to the front of the neck. The way you draw this line depends on how fleshy the character is supposed to be.

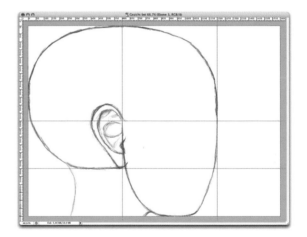

Figure 1.4: Added ear and beginning of neck

Since there are many different sizes and shapes, the ear in Figure 1.4 cannot be used as a general guide. Instead, the two horizontal lines should be used as orientation guides. The places where they are crossed by the left vertical guideline are the starting points of the ear, where the ear is attached to the head.

Figure 1.3: Drawing the upper head

The structure of the inner ear does not necessarily have to be drawn. Photos can often be used later to model this part. Sketches like this one are used primarily to develop the character and to determine its most important features.

1.1.3 Mouth and Nose

On the right side we now add the nose between the two horizontal guides. Draw the tip of the nose above the lower horizontal guide so it looks like a snub nose. As of now this represents the current ideal of beauty.

Be sure that the side of the nose is drawn mostly outside the face area. Figure 1.5 shows a possible result.

When you like the way the nose looks, add two guidelines. One runs from the bridge of the nose (where the upper horizontal guide enters the forehead) downward past the side of the nostril. It will later border the corner of the mouth.

The second guideline connects the chin and the tip of the nose. This will be used later to draw the outer curve of the lips.

Remember to create the guidelines on a separate layer. This will ensure that you get a clean result at the end, ready for export.

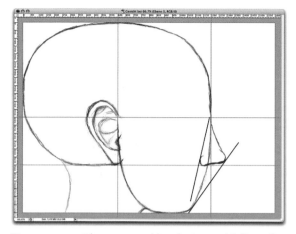

Figure 1.5: The nose and bordering guidelines for the construction of the mouth

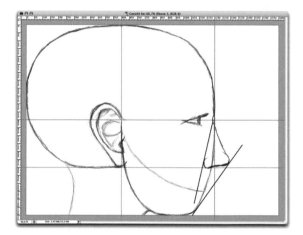

Figure 1.6: Cheek and eye

Now imagine a horizontal guideline that splits the area between the nose and the chin in the middle. At the point where this line crosses the face is the location of the lower lip. A soft curve starting from this spot up to the ear marks the edge of the cheek. Figure 1.6 shows this lightly drawn curve between lip and ear.

As already explained, the eyes are located exactly in the middle of the head and therefore along the upper horizontal guide.

Unfortunately, the precise depth of the eyes within the head cannot be clearly determined by guidelines. In this case, relying on your visual judgment is required. An appropriate placement is shown in Figure 1.6.

In the next step we will draw the lips (Figure 1.7). All necessary guidelines are already there. Note that the upper lip protrudes farther than the lower lip when the face is relaxed. This protrusion is determined by the guideline running from the nose to the chin.

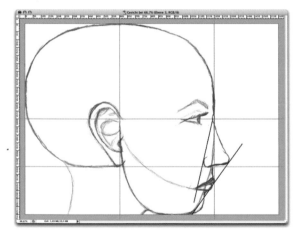

Figure 1.7: Construction of the lips

The guideline, which starts at the bridge of the nose and borders the side of the nostril, also crosses the curve of the cheek. This spot determines the corner of the mouth when the face is relaxed.

Emphasize the line starting from this point to the right, to determine the edge of the lower lip. Expand the border of the lower lip out to the slanted guideline so that the lower lip slightly protrudes from the face.

Now draw the edge of the upper lip, starting again from the corner of the mouth, at an angle of about 45°. Extrude this line up to the right guideline past the edge of the face. As we have already learned, the upper lip automatically protrudes farther than the lower lip.

Determine a dividing line between the upper and lower lips, making sure that the lower lip has more volume than the upper lip.

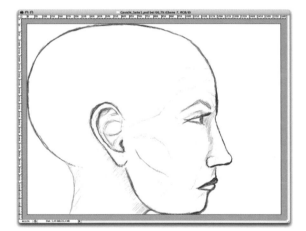

Figure 1.8: The complete side view after removing the guidelines

This almost completes the stylized side view. Add the eyebrow and some shading if necessary, to hint at the bulge of the cheek or above the eye.

Now delete all the layers containing the guidelines and erase overlapping lines. Figure 1.8 shows a possible result. Merge the remaining layers and save the image.

1.1.4 The Frontal View

The procedure for the construction of the front view is similar. We will again start with a new, empty document that will now be square, for example 650 × 650 pixels. The measurements are different from the side view since the ears expand the overall width of the head.

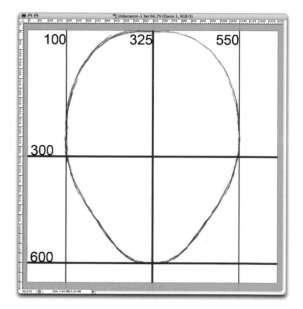

Figure 1.10: The outer shape of the head

Figure 1.9: Guidelines for the construction of the front view

On a new layer create guidelines that separate the work space horizontally at 300 and 600 pixels, and place one vertical guideline going down the middle. Figure 1.9 shows the positions of these guidelines.

Add two vertical guidelines to separate about 100 pixels on each side for the ears and draw an oval in the remaining four fields. The oval should be pointier on the bottom than on top.

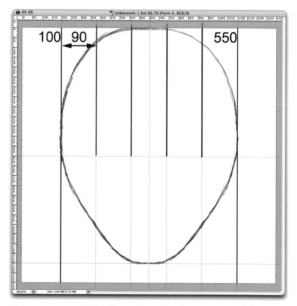

Figure 1.11: Guidelines for the placement of the eyes

As we know, the head is the width of about five eyes. Therefore, separate the width of the oval with four equally-spaced vertical guidelines. These guidelines should now be 90 pixels apart (Figure 1.11).

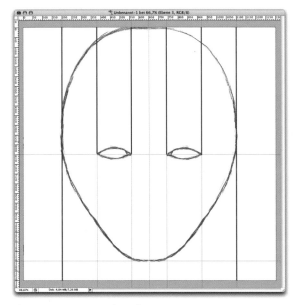

Figure 1.12: Drawing the eyes

Draw two almond shapes to determine the size and placement of the eyes as shown in Figure 1.12.

Note that the placement of the eyes is along the upper horizontal guideline, which determines the center of the head.

In order to be able to use the created sketches later within the 3D application, the size and position of both sketches have to be carefully aligned. The easiest way of doing this is to enlarge the side view and to copy the front view and place them both in a newly created space.

Then create guidelines on a new layer that determine the placement of the most important facial features like the height of the eyebrows, the upper edge of the ear, and the edges of the lips. This step is shown in Figure 1.13.

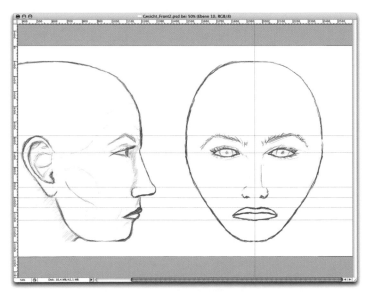

Figure 1.13: Aligning the side and front views

In this manner, both sketches can be aligned to each other. The width of the mouth is established by placing the corner of the mouth in line with the center of the pupil. The sides of the nostrils are within the triangle that can be created between the corners of the mouth and the bridge of the nose.

Just as we have done in the side view, the last step is to remove the guidelines and to add details, such as the eyelashes and the shading of the neck.

The advantage of such a constructed view, when compared to a photograph, is that it doesn't have perspective distortions. Since—apart from a few exceptions—all 3D modeling programs work with orthogonal views, it is easy to use these sketches.

Orthogonal: Objects can be seen without perspective distortions. Parallel lines on the object are actually parallel and the usual perspective distortion to a vanishing point does not apply.

Orthogonal views are used mainly in 3D programs to model and place objects without any distortion.

For the modeling we will do in the following chapters we will not use these sketches, but instead use photos. The following section explains what has to be taken into consideration when taking photos and what additional information can be used.

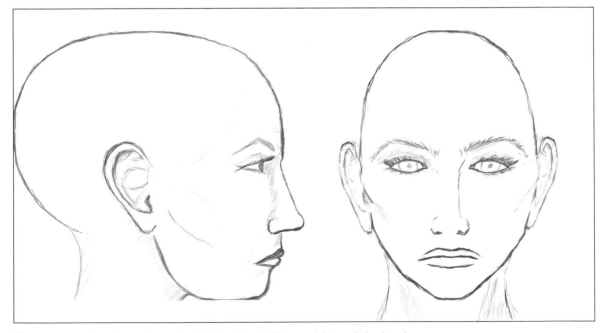

Figure 1.14: Complete views for the front and side modeling of the head

1.2 Creating and Editing Photo Templates

In order to work more realistically we will use photographs in the following chapters. Perhaps you already have photos you can use, or you can download them from the Internet.

There are many websites for 3D artists who look for references for their work. These range from nature and animal shots to detailed photos of body parts and clothing to whole body shots of clothed and nude people. One of the largest collections of this kind can be found at www.3d.sk. For a monthly fee you can download a few thousand images that are replaced every few days by new images. Free sources such as www.fineart.sk can also be found on the Internet. These sources are sufficient most of the time.

It shouldn't be a problem though to get photos without having to use commercial sources since almost everybody owns a camera cell phone or digital camera.

In this way the following images were taken. I would like to thank Dania Dobslaf for being the model.

Beside the actual perspectives for the modeling process, which should show at least the front and side views, perspective views like a three-quarter shot can also be helpful. They help us to better understand the dimensions of the shape. Often, details are only visible in an angled shot, such as the bulge of the cheekbone, which cannot be seen clearly either in the front or in the side view.

Thus, if you have the opportunity to take photos of a reference model, then take advantage of that and shoot as many photos as possible from different angles and distances. Even if the images can't be used for the modeling process, they might come in handy for the texturing or posing of the 3D model.

Besides the geometry and the textures, the lighting of the model can be useful later on as well. This is especially important when you want to model a character that is to be integrated into a photo, or the reverse, when the surroundings of the photo are to be integrated into the 3D scene.

For example, you can create images of a polished chrome sphere that reflects the surroundings of the photographer. That way, when these photos are unwrapped, they can be used as almost perfect panoramic images with little effort. This technique is often used for the creation of HDR images, where a series of exposure shots of the chrome sphere are taken and later combined into an HDR image.

HDR images: HDR is an abbreviation for high dynamic range and stands for images with a large range of values. Normally these images have 16- or 32-bit color information for each channel, compared to the usual 8 bit. These images could also be saved in a much higher color depth, but the color gain wouldn't be worth the much larger file size. Images with this increased color depth can be used in 3D programs, for example, to light objects and to simulate reflections to create an accurate simulation of environments. HDR images can be created in Photoshop by layering a series of different exposures of an image.

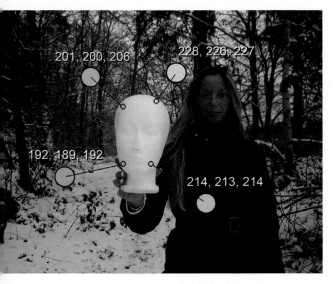

Figure 1.15: Recording the lighting

head. The displayed RGB color values show the different degrees of brightness and color of the light that shines onto the Styrofoam head from different directions.

These values can be helpful later when recreating the identical lighting situation within the 3D program.

The largest possible focal length should be used when the images for the standard views are taken so that the images have the least possible distortion. Compact cameras reach their limit in this case, since the lens is set for a wide angle in order to keep the camera compact.

When the current lighting is to be captured it is helpful to use a Styrofoam ball or, as in my case, a Styrofoam head. The brightness and color of the diffused light can easily be determined by using the color values in the photo. Figure 1.15 shows this in the example of four areas of the Styrofoam

Therefore, try to be as far away from the model as possible and to use the highest camera resolution possible. That way, details in the distance can be extracted in a high enough quality later on.

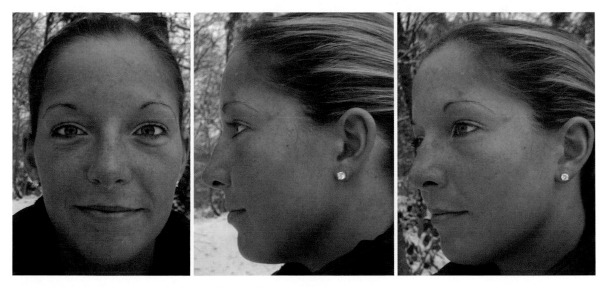

Figure 1.16: Commonly used standard views for modeling

Figure 1.16 shows a possible image series that includes all important facial features for modeling. Despite all efforts, the images still have a slight perspective distortion that has to be corrected when the face is modeled. We will talk about this later.

Generally, parts that are closer to the camera appear larger because of the wide angle, and distant parts appear smaller than normal.

Once all images have been taken, load them into an image editing program and adjust different components to each other. This corresponds to the alignment of the side and front sketches from the beginning of this chapter.

For example, place the front and side views of the head next to each other in a document and create horizontal guidelines across both images at important points. This way we can align and bring both images to the same size by scaling, rotating, and moving them.

Be sure that both images are taken at the proper angle as well. It often happens that, for example, the head is slightly tilted when the image is taken from the front, or that the chin is lower in the side view. This occurs when the model does not have a point to focus on. When taking the front view, the model normally focuses on the photographer, while in other views the model may look up or down. Therefore, this should be taken into consideration when taking the photos.

Figure 1.17 shows an example of the alignment of the different photos. Normally, a few guidelines are enough to adjust the position and size of the images to each other. The distance between the model and the photographer usually doesn't change much during the photo shoot.

Before these images are used within the 3D program, we should take some time to plan ahead. This will save us a lot of work later during the modeling and will result in a more natural look.

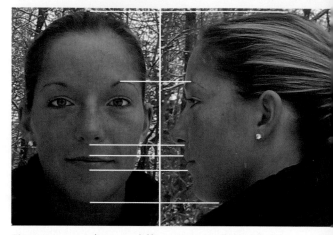

Figure 1.17: Adjusting different views of the model

Even though it isn't obvious at first, the face is covered with a complex network of muscles. This allows us to express a wide range of moods and feelings. The position and direction of the muscles also determines the development of creases in the face. Thus, it is very important that we adjust the 3D surface to the direction of the muscles.

For clarification I have drawn the position and direction of the most important facial muscles onto the photos, as can be seen in Figure 1.18.

Especially noticeable are the ring-shaped muscles around the eyes and mouth. These structures should be incorporated into the modeling. These closed structures are called

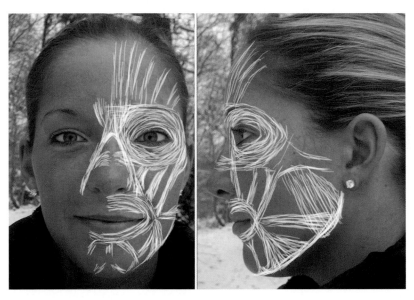

Figure 1.18: Sketched course of the facial muscles

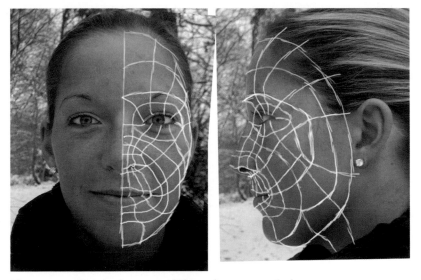

Figure 1.19: Sketched course of the polygons

loops. Loops consist of polygons that are grouped into closed shapes.

> Polygons: This term generally describes the smallest unit with which a surface is constructed in a 3D program. These are triangles and squares. There are also so-called N-gons that can contain any number of corner points.
>
> One common requirement of all kinds of polygons is that all corner points have to be on one plane. Otherwise it could result in unwanted changes of brightness when the surface is calculated. Because all polygons represent small surfaces, curved surfaces have to be assembled using multiple polygons. Thus, the modeling of organic shapes requires planning in order to use the least number of polygons possible.

Figure 1.21: The plane follows the direction of the force

Imagine a surface that is subdivided, perpendicular to the direction of deformation. Figure 1.20 shows an example. The red line represents the effect of a force to the surface. When the force is increased along the red line, the surface will be squeezed together and a crease appears (Figure 1.21).

Repeat this experiment on one plane that is subdivided in a direction different from the force applied to it (Figure 1.22).

Figure 1.20: Subdivided plane perpendicular to the deformation direction

This has advantages not only for the modeling process, but for the eventual following animations as well. A simple example shows the reason for this.

Figure 1.22: An even subdivision inconsistent to the direction of the force

Since, as we learned, polygons have to be located in one plane, this will result here in creases in the surface (Figure 1.23).

Figure 1.23: Creased surface

The loops help to make the creation of creases easier and make other typical features of the face using a fewer number of polygons.

Based on this theory, different concepts on how to construct a loop in the face can be developed. The complexity of the order depends on the age of the character. Toddlers and teens generally have smoother skin that can be modeled without the details of creases.

It also depends strongly on the expression. Even toddlers can have a pronounced crease between the side of the nose and the corner of the mouth when laughing, or a crease between the eyebrows when angry.

Many of these small creases, and also pimples, scars, or warts can be added later with surface properties and without having to actually model with polygons. Therefore, it should be determined if a certain detail really has to be modeled. This also depends on how large the object has to appear later on.

These thoughts can result in major changes later within the 3D environment. Thus, it is recommended to draw the course of the loops into the templates. Trying out different ways is much easier and faster. Figure 1.19 shows my draft of the basic polygon structure.

Upon closer examination you can see the ring-shaped loop around the eye and mouth that is a direct result of the direction of the muscle. You can already see how naturally the laugh-line is formed out of the direction of the polygons.

We will use this structure in the following modeling and enhance it in certain places. For example, the nose, ears, and eyelids need more faces to show more details realistically.

Let us come back to the templates. In addition to the standard views, there should be at least one image of the desired pose. This will make it easier to place the character later and gives us some information about, for example, how the clothing reacts. Therefore, Figure 1.24 is a photo of the desired pose.

Figure 1.24: The pose to be replicated in 3D

The Human Eye

In the first workshop we already created sketches and images that will be used as references in the following modeling. Thus, we can start directly in this chapter.

2.1 General Way of Working

With all the following steps, all techniques and tools chosen are easily replicated in all current 3D programs. That is also the reason why we use polygon modeling; we construct all objects from triangles and squares, which are the smallest units and are also available in all 3D programs.

The subsequent texturing, which means the definition of the surfaces, cannot be generalized. Each program uses a different approach that, optically speaking, can be completely different. Almost all systems are based on so-called nodes, which function as small mathematical units.

There are nodes that, for example, simply display a loaded image. Nodes can also function like Photoshop filters or units and can directly influence the samples of the raytracer; for example, the result could depend on the viewing angle of the surface.

Raytracer: This is probably the most frequently used calculation method that emits rays based on the position of the viewer. When one of these rays encounters an object in the scene, the raytracer can calculate the brightness at this point and combine it with the surface properties.

On transparent and reflective surfaces, additional rays are sent from this point to, for example, objects positioned behind the transparent object. This method is a good alternative to more precise, but slower methods like the ones that can incorporate diffuse light scattering and reflections. It results in high-quality images over a shorter period of time. The disadvantage of imprecise light simulations can, with a little experience, be compensated by the placement of additional light sources.

This is only a fraction of the possibilities and shows how complex this subject matter alone can be. Therefore, we will restrict ourselves to the general terms when we talk about the surfaces. This can then be transferred to the material system used by your software.

First, before we get to this, we will look at the human eye and how to create one in 3D. The eye is a mirror of the soul, as every poet knows, and we should therefore pay a great deal of attention to this object.

Luckily the outer shape of the eye is easy to create. The approximate diameter of the human eyeball is about 2.5 cm (1 inch).

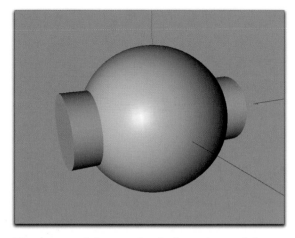

Figure 2.1: Sphere and cylinder as base of the modeling of the eye

2.2 Primitive Objects as a Base

Using these parameters, we get almost the exact shape needed when using a sphere of the approximate size. In these cases it is easiest to use so-called basic or primitive objects in your 3D software.

These are geometric basic shapes like cones, cylinders, or spheres. Thus, you don't have to construct these objects, but can use them instantly in any size.

Create a sphere with a radius of 1.25 cm (0.5 inch) and a cylinder with a radius of 0.6 cm (0.25 inch). Set the height so the cylinder pierces the sphere as shown in Figure 2. 1.

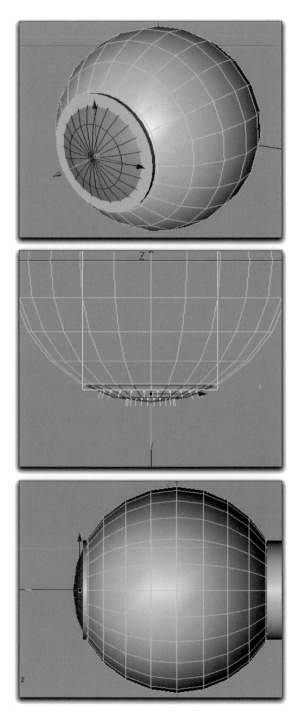

Figure 2.2: Modifying the sphere pole

The diameter of the cylinder comes about because the iris is covering about half the eye when seen from the front.

A polygon structure of a sphere looks the same in all 3D programs. There are two points from which the faces are spread in a circular manner across the sphere. This circular order of the faces is very helpful to us since the iris is also circular.

Since we want to model an anatomically correct eye, we also have to consider that the clear cornea over the iris and pupil bulges outward.

Make sure by rotating the sphere that both poles are positioned on the length axis of the cylinder, which means that the cylinder is centered and pierces the sphere at the poles.

Then create an additional edge ring where the cylinder pierces the sphere. This is only necessary where the iris will be located and not in the back of the eye.

Select the polygons positioned between the front pole point and the newly added edge ring as shown in Figure 2.2.

In order to construct the aforementioned bulge, we cannot simply move the faces forward. A lens should be formed. Thus, move the selected part slightly forward and add additional edge rings. These allow us to control this area further.

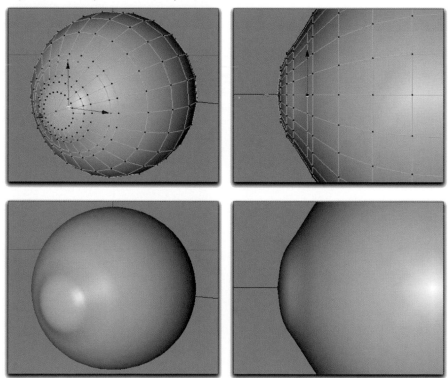

Figure 2.3: Bulge over the pupil

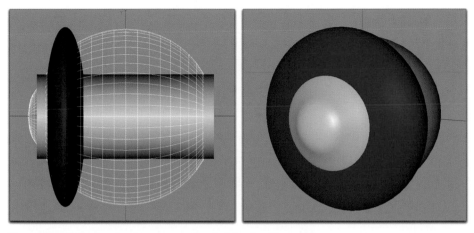

Figure 2.4: Squeezed sphere as a placeholder for the pupil

Figure 2.3 shows how this could look. As you can plainly see in the side views, the area around the pulled pole stays relatively flat. An added polygon ring creates the actual transition from the lens to the body of the eye. This effect can be seen especially well in the shaded object in Figure 2.3.

Lastly, this bulge will create the realistic highlights and reflections on the eye. Don't overdo it though so that the eyelids can be modeled close enough to the eye later on.

The outer hull of the eye is now complete and now we can concentrate on the iris including the pupil.

2.3 Pupil and the Iris

The iris is a circular muscle that has an opening in the center called the pupil. The size of this pupil can be controlled by the iris in order to regulate the amount of light reaching the inner eye. Behind the iris is a lens fixed by bands. This lens pushes the iris outward in the area of the pupil.

We will model this shape as described, but there are several other possibilities that simplify effective lighting of the eye. In the coming chapters you will find out how other artists handle this step. As always, many roads lead to Rome.

In order to provide the base for the modeling of the iris, we will start again with a basic sphere object. Resize it to the same size as the eye sphere and make sure that a pole point is positioned in the line of sight.

Then scale the sphere along the line of sight so that it is squeezed into the shape of a lens. Figure 2.4 shows the lens in red in two perspectives.

As we can also see in these images, the lens is moved toward the pupil until the part penetrating the eye sphere has the same size as the cylinder surface. The cylinder has done its job as a helping object and can be removed from the scene.

Delete the polygons of the lens located in the rear and outside the eye. Remaining is a flat bowl in the shape of a contact lens. By extruding the outer edge and the faces close to the pole a shape is created as shown in Figure 2.5.

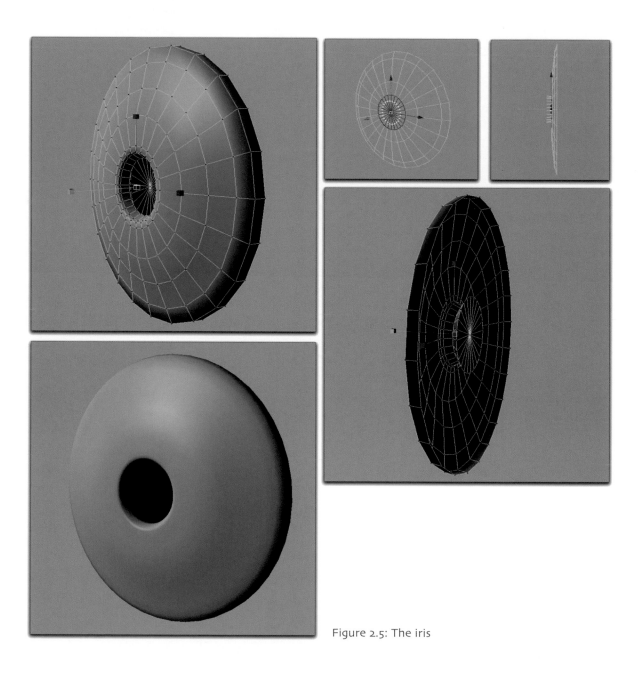

Figure 2.5: The iris

Extruding: This action moves selected edges or faces. At the same time, new faces are created at the edges of the moved elements. That way, thin objects can be thickened or, for example, bulges be created as we need them at the pupil.

Normally the black of the pupil is only created when we look through this opening into the inside of the eye. But very little light is deflected out of the eye again. Responsible for this is the muscle of the iris, which controls the pupil. Only in rare occasions, such as with the direct and unexpected lighting of a flashlight for example, is the red background of the eye visible.

Therefore, we save ourselves the time spent constructing the inner eye and create a baglike bulge behind the pupil. This area will later be colored in black and sufficiently simulates the inner eye.

The outer edge of the iris disc will be slightly extruded backwards. This creates better shading of the surface at the edges, which is important for us since the transition of the bulge of the iris to the body of the eye is supposed to be smooth.

Also make sure that the iris area around the pupil is rounded and moved slightly forward. This simulates the already mentioned pressure of the lens beneath. Add additional polygon rows if you have difficulties achieving this with the number of polygons available.

Figure 2.6: Doubled front of the eye

2.4 Working Double-walled

This concludes the modeling of the eye. But I would like to go one step further and double the front part of the eye. In my opinion this has the advantage that refraction will be more natural in this area.

Refraction: Deflection of the original direction of light in transparent materials. The strength of this effect can be controlled numerically with the refraction index. Air, for example, has an index of 1.0 at room temperature, liquid water about 1.33, and glass has an estimated refraction index of 1.6.

Just take the faces of the front part of the eye and copy them into a new object and scale it down slightly. The result can be seen in Figure 2.6.

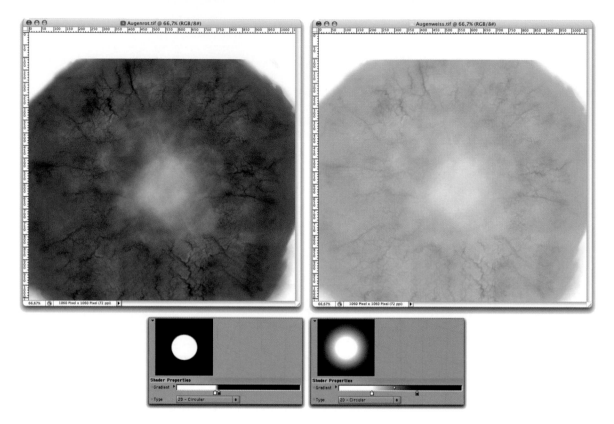

Figure 2.7: Image textures for the eye

2.5 Texturing of the Eye

For texturing objects, meaning the application of surface properties, there are several techniques available. All properties can be applied parametrical with the help of shaders. These are algorithms implemented in the 3D program that can create patterns and physical properties based on mathematical calculations.

More predictable is the use of images, but these have to be created beforehand with a great deal of effort. These images also have a fixed pixel size that can result in blurring or

pixilation when zoomed in. By comparison, shaders are mostly resolution-independent. Both methods have their advantages and disadvantages, so we will work with both shaders and images when texturing.

Let us start with the surface of the eye. I created a collage of different images of human eyes. Figure 2.7 shows two variants of this collage, one focused on the blood vessels and one, slightly desaturated, on the rather bright surface of the eye.

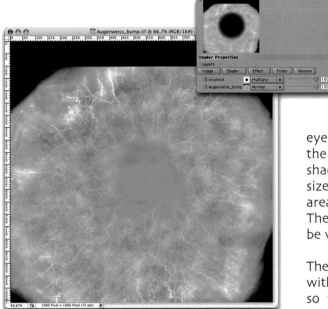

Figure 2.8: Bump map of the eye

It is important that highlights and shadows are removed when working with photographs. Otherwise there could be irregularities when using these images later, such as when the virtual 3D light comes from the left and the object has an image texture applied that has the light coming from the right. The image information should therefore only include the color values of the displayed object.

With the help of a circular gradient I mix the two images so that the color-intensive vessels and red tones are visible only at the edge of the eye. Such a color gradient could also be prepared as an image, but this would have the disadvantage that you never know exactly if the transition is smooth enough or if it starts at the right position. As a result, here I use a gradient shader that can be adjusted directly within the 3D software.

I use a similarly structured gradient shader to describe the transparency of the outer

eye. In the area where the shader is white the eye remains transparent. The darker the shader, the more the object is visible. The size of the circular gradient is set so that the area on top of the pupil iris is transparent. The transition to the white of the eye will be very narrow.

The transparency should also be combined with the already mentioned refraction index so that the light that shines through the cornea onto the lens is refracted realistically.

Because the eye is mainly filled with water we can use a refraction index of 1.33.

We also apply the bump map shown in Figure 2.8 to the eye. A bump map is a grayscale image or a shader where brightness is used to influence the shading of the object's surface. Light areas appear slightly raised while darker areas look depressed or grooved. This effect is purely optical and does not change the geometry of the object. Bump maps are used mainly for fine details where modeling would be too involved. This would be, for example, skin pores, pimples, or small wrinkles.

Figure 2.9 demonstrates this effect on a sphere. In the lower part of the figure it can be seen that the effect is an optical illusion. The contours of the sphere stay identical even with a bump map applied. The bump map for the blood vessels was created by increasing the contrast of a colored vessel image and a subsequent desaturation.

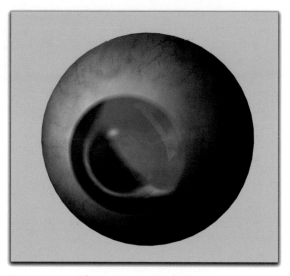

Figure 2.10: The outer eye including texture

Figure 2.9: The bump effect

Here a circular gradient is used again that controls the intensity of the bump map being multiplied with it. That way, the transparent cornea above the pupil remains unaffected by the bump map. This is especially important because bump maps also change the look of highlights and reflections. The front of the eyes should show nice round highlights.

Finally, a slight shininess is activated and the material is applied to the outer eye. In this case I project the material to the front of the eye. This results in distortions at the edge of the sphere; however, this will not matter since this part will never be visible anyway.

Adjust the circular gradients if necessary so that the transparency is visible only above the pupil and that the bump effect is visible only on the white of the eye.

As you can see in Figure 2.10 I have added a landscape image to check the intensity of the reflection and the refraction of the lens. Such an image can be applied, for example, to a very large sphere in order to simulate reflections on the surface.

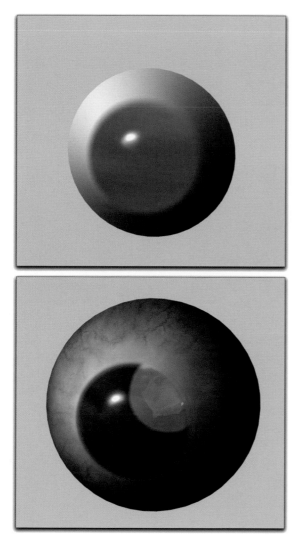

Figure 2.11: Additionally textured lens

2.5.1 Lens

Duplicate the material of the outer eye and exchange the color in the copy for a bright yellow. We do not need the reflection and bump effect, but we do need to increase the highlights. The transparency and the refraction index can be kept the same.

Apply this new material to the object that represents the doubled wall of the cornea. The upper image in Figure 2.11 shows the effect of the material.

In the lower image of the figure you can see the further calculated outer eye. Only at first sight does it appear that there is no change. The change becomes apparent when comparing the transparent area of the lens with the previous image of the eye without the double-walled effect. The light refraction appears completely different. Also, the highlight was increased and, because of the two surfaces, it has more depth and variation.

Let us get to the last missing part—the iris. Its surface appears very complex close up. Diverse color variations are possible, with the fibrous structure creating different mixture ratios of these colors when the iris is changed.

The simplest way of texturing is the use of adequate photos. These are not easy to come by since the eye is partly hidden by the eyelids when relaxed. In addition there are the previously mentioned disruptive influences such as reflections, shadows, or highlights, which often cannot be completely removed from the images.

Masking

Overlay

Figure 2.12: Shader combinations for the surface of the pupil

2.5.2 Pupil

Thus, I would like to create the surface of the iris with shaders. Figure 2.12 provides a guideline.

I start with the creation of a slightly striped structure with gray and blue tones. A good shader for this would be so-called noise shaders, which can create different patterns with any color values. The result of this shader is then multiplied with a vertical gradient. These two shaders can be found above at the letter A.

A similarly structured noise shader with bluish and orange colored structures is also

multiplied with the gradient, but this time it creates a chaotic color mix.

Only the outer right edge, which will later cover the outer edge of the iris, remains black. These shaders can be found at the letter B.

The gradient shown in the center is used for the blending of the results of A and B.

Basically this is equal to an alpha mask in Photoshop. Here the result of the B shader is put above the result of the A shader and displayed according to the masking gradient.

At the places where the masking remains black, the B result is visible. Lighter areas let the A result shine through. That way, different color combinations and mixing values can be tested without having to work with images.

Generally we have to make sure that the iris is darker toward the outer edge. Many people even have a clearly visible dark edge.

In order to create even more variations, I multiply a noise shader with yellow and green color areas with a gradient. This will create a slim vertical stripe with low brightness and frayed edges.

The result of these shaders, shown in the lower part of Figure 2.12, is mixed with the already created material as an overlay. The result is shown in Figure 2.14.

Besides this color material, we should also take a look at the surface structure. Therefore, I used a noise shader with a bubbly structure and overlaid it with horizontal lines. Figure 2.13 shows this structure on one level. In the

Figure 2.13: Bump structure of the iris

lower part is the same shader combination applied to a disc. Because of the curvature, the desired effect is visible, showing the frayed radial fibers of the pupil.

This effect will be applied to the bump channel of the material. In addition, a weak and broad highlight is activated so that the surface doesn't appear as dry and rough.

Finally, all objects can be made visible again to see the entire result. Figure 2.14 shows the full result of the iris and the complete eye after completing the texture.

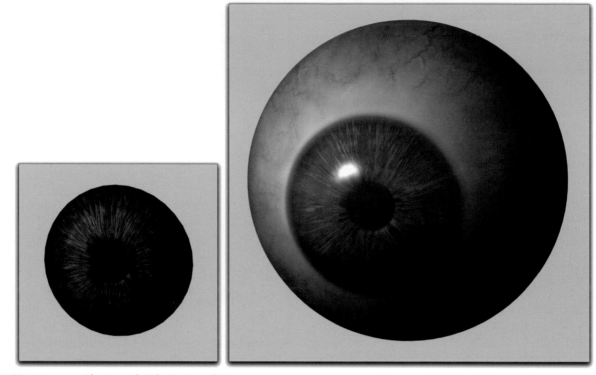

Figure 2.14: The completely textured eye

2.6 Preparations for the Modeling of the Face

The reason why we modeled and textured the eye first is that it can serve us as a guide for modeling the face, which follows.

Because we begin with the area around the eyes, we can instantly adjust the polygons to the eyes and make sure the eyelids are positioned correctly.

Also, the distance between the eyes and their size determines the proportions of the whole head, as we have already seen in the first workshop.

Open your 3D application and load the image, with the two views of the head, which we prepared in the first workshop.

Depending on how you usually use image templates within the program, you can display the image as a background or applied as a texture to two planes.

The important part is that both images create an angle of 90° between them in 3D space.

It also makes sense to put the image with the front view into the XY plane, or front view, and the side view image into the ZY plane, or side view.

Figure 2.15: Importing the image templates into the 3D space

This could look like Figure 2.15. When you have saved both views within one image, then aligning the images is not necessary. We did this earlier in Photoshop.

You just have to project the image onto an appropriately scaled 3D plane and make a copy of the plane. Then rotate the copy vertically by 90° and move both planes so that you can see the corresponding head in both the front and side editor views.

Duplicate the eye and move the copy horizontally to the other side of the head in the front view. It is helpful to move the symmetry axis of the face to the origin of the Y axis of your 3D coordinate system.

That way, objects in one half of the face can easily be moved to the correct position in the other half by using numerical values. The left eye, for example, could be positioned at an X position of 150.0. The simple changing of the sign of this coordinate then moves the eye to the other side of the face.

Figure 2.16: Positioning the eye

Figure 2.16 shows a good position of the eye objects. In the next workshop we will start with modeling the head.

Modeling the Head

We are set with the two eye models and the reference images from the previous workshops, and the work can now start.

In this chapter we will go through all steps that are necessary to model a human head. The demonstrated way is flexible enough to create either men or women. We will get to the differences between the two head shapes at the end of the chapter.

We will model exclusively with polygons. These are available in every 3D program and can be smoothed by subdivision surfaces. This function is named differently in every program but is always similar. The existing polygons will automatically be subdivided in detail. New polygons are created within the existing faces. These new polygons don't only lie in the same plane as the old polygons, but are also positioned so that the original shape of the object is smoothed. The finer the subdivision is, the rounder the object appears.

Another tool often used when modeling characters is the reflection or symmetry function. It automatically adds the missing half of, for example, a head. This makes it so only one half of the face has to be worked on. We will also use this function in order to save time.

3.1 Eye and Cheek

To start with the area around the eyes, we will orientate ourselves on the loops sketched into the templates as previously discussed in an earlier workshop.

Figure 3.1: A polygon disk as the start object

In order to not start from scratch, you can use basic polygon objects if they are available in your software. As you can see in Figure 3.1, I selected a disk from the nine segments and placed it in front of the eye. These points and polygons are easily created by hand if you don't have such objects available to you.

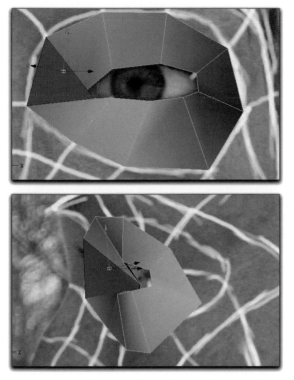

Figure 3.2: Adjusting the polygon shape to the image template

Use the point-moving tool to adjust the inner points of the disk to the edges of the eyelid. The points of the disk can be directly positioned onto the corresponding lines in the front view, depending upon how exact the loops were drawn.

Change to the side view and correct the position of the points along the third axis. Some imagination is needed here since the eyeball covers the inner corner of the eye. As a basic rule it might help to know that the inner corner of the eye is not embedded as deeply as the outer corner, as can be seen in Figure 3.2.

Continue by moving the outer point circle of the disk. These points are positioned on top at about the base of the brow bone and on the bottom at the point where most people have a small crease between the lower lid and the cheek.

On the nose, about half of the distance between the tear duct and the bridge of the nose is covered.

When working with the drawn loops we prepared in the first workshop, don't get nervous about both views having different looks. These were not aligned, but rather are just freehand drawings. In my case, I just follow the drawing in the front view and adjust the point position in the side view without forcing the points onto the loops. Ultimately it doesn't matter which of the two loop drawings you use. Just make sure you stick with one view and don't switch back and forth.

Also, don't be bothered by the size and rough look of the polygons and the fact that many details are covered up. Details like eyelids or creases will be added later when at least the basic shape of the head exists. Otherwise, we would have to deal with too many points, edges, and polygons. The clever placement of the polygon loops will save us a large part of this work.

In the next step select the loop ring that borders the lids at the eye and extrude it slightly toward the head. The depth of this extrusion determines the thickness of the eyelids later.

New polygons are created at the previously open edge that will then be moved inwards.

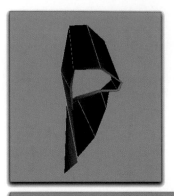

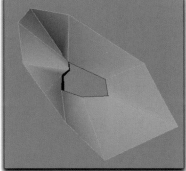

The depth of the extrusion is not so important. It is only crucial that these faces exist. This area will later be adjusted to the shape of the eye.

In this early stage of the modeling we can already see what affect this little fold has on the surface. The two bottom images in Figure 3.3 show this on the smoothed model.

The edges of the eyelids are not as sharp-edged as they used to be. Because bordering faces are included in the smoothing of the polygon subdivision, the curvature of the whole area changes and appears more organic. If your software gives you the option, switch between the original model and the smoothed version to check on the smoothed surface.

Because of the whole principle, the rounded version is always slightly smaller than the original. This is because the rounded surface doesn't pass through the points of the existing polygons.

This difference is smaller when the points are set closer to each other in the lower resolution original. Therefore, make sure that the points at the creases and at sudden changes of direction on the surface are closer together. This ensures that the smoothed version doesn't have room for sizable deviations.

Figure 3.3: Extruded edge ring and smoothed display

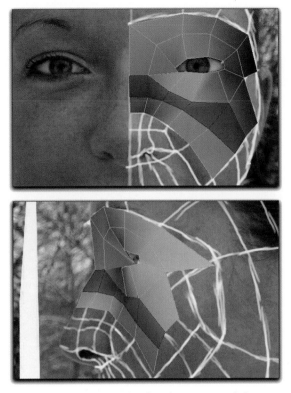

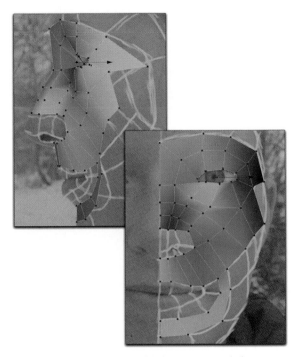

Figure 3.5: Extending the loops toward the nose and cheek

Figure 3.4: Continuing the shape toward the nose and cheek

Add more polygon rows in the next step, above and below the eye, as shown in Figure 3.4. Make sure that the points, which are at the middle of the head, have a uniform X coordinate. These points are later positioned exactly on the symmetry axis of the head and exist twice after mirroring the head.

When all points are at exactly the same coordinate, optimizing the face is easier to accomplish since both halves of the face are combined into one at the end.

The coloring of the points and polygons in the images only serves the purpose of making it easier to see the progress in each view.

Piece by piece, or polygon by polygon, we extend the existing structures along the drawn loops in the front view. In this manner we quickly close the gap between the base of the nose and upper lip. The first advance toward the chin already gives us a glimpse of the dimensions of the head.

Remember to save the model at regular intervals and to name each save individually. This makes it much easier to correct a modeling mistake later by loading a previous version.

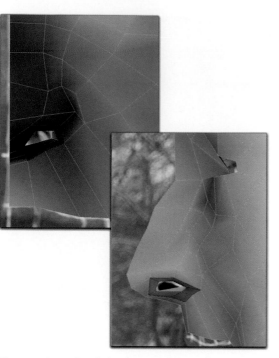

Figure 3.6: Tip of the nose and nostril

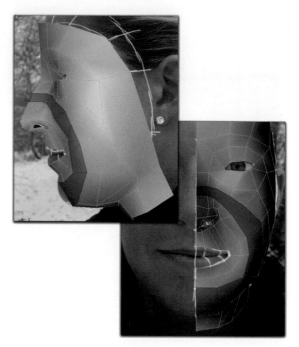

Figure 3.7: The chin

3.2 Lower Half of the Face

Let us get to the more difficult parts. So far all polygons were positioned more or less in the front view. This will change when we model the nose and later when we add the back of the head.

We will start with the open tip of the nose. Figure 3.6 shows how the faces should be positioned. Especially important is the correct placement of the opening of the nostril and the transition of the polygon flow from the dorsum, or back, of the nose into the loops toward the mouth and chin.

For the dorsum of the nose we can rely on the side view template and place the points directly onto the image.

Starting from the faces on the dorsum, create a half-circle polygon loop across the cheek, past the corner of the mouth, under the lower lip, and over the chin up to the symmetry plane.

Add polygons above the eye at the forehead and extend them past the side of the face. Just before the ear, the loop curves along the jaw and ends at the chin. For the first time the face now appears as one unit, except for the missing mouth.

On the bottom, extend the chin by one or two polygons to form the beginning of the neck in the front. Figure 3.7 shows the current state of the model and highlights one of the polygon loops very well.

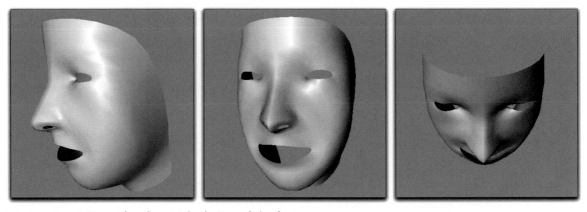

Figure 3.8: Mirrored and smoothed view of the face

3.2.1 Examination of the Model and Interim Result

Now is the time to examine the current state of the model, before we continue with the back of the head. Therefore, create the missing half of the face and smooth the result. The upper series of images shows different views of the current model.

It makes sense at this point to make sure that we have achieved the best possible quality with the faces used. The goal of each modeling should be to create the desired result by using the least number of polygons possible. This will make it considerably easier to texture and animate the model.

Noticeable on our model is the sharpness of the tip of the nose and of the ridge along the slope of the nose. There is also a lack of definition around the eyes. Neither the eyelids nor the bulges around the eyes and cheeks, caused by the bones right beneath, are defined clearly enough.

The reason at this moment is the low number of faces, and therefore cannot be fixed at this time. Restrict yourself to the remaining areas and try to sharpen the course of the loops by moving single points or faces to correct existing bulges or depressions.

It helps tremendously to leave the standard views and to work in a perspective view for a while. The templates will not be helpful right now, but by rotating the perspective view we can see the model from different directions.

Irregularities, such as the sharp ridge on the slope of the nose or the wedge-shaped forehead, can often be noticed only in this view. These mistakes should be corrected as early as possible since the surface can still be manipulated in its current stage by moving just a few points.

The more points and faces are added, the more difficult it becomes to make space-restricted changes without influencing bordering areas negatively.

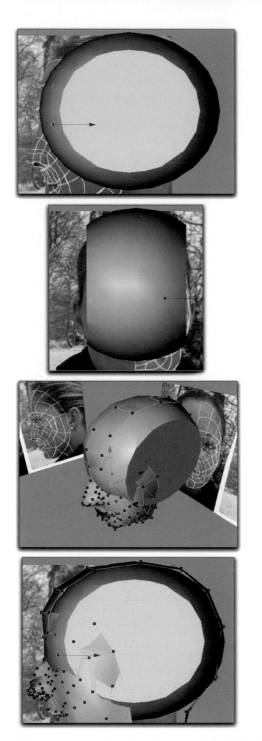

Figure 3.9: Help object for the back of the head

3.3 Back of the Head

Regardless of how well the photo templates were created, in most cases the hair covers the actual shape of the head. This is especially true for women with long hair.

Therefore, I work with a simple trick to obtain a template for the modeling of the skull. This procedure also has the advantage that a real three-dimensional object can be used as reference.

Create a sphere, which can be taken from the basic objects. Place the sphere vertically slightly above the eyes in the side view, and horizontally in the center of the head.

Then squeeze the sphere along its height until the upper curvature matches the upper curve of the skull in the images.

Then cut off the two poles of the sphere in the front view. Now you have a rough template for the shape of the skull. A similar model is used by illustrators to achieve the basic shape of the head.

The series of images in Figure 3.9 show the development of the skull reference and, in the bottom image, its use for modeling. As can be seen there, the top edge of the polygon on the bridge of the nose is extruded repeatedly and guided along the skull reference, first up and back, and then down again at the back of the head. Be sure that the new inner points remain on the symmetry axis so mirroring of the head will work later on.

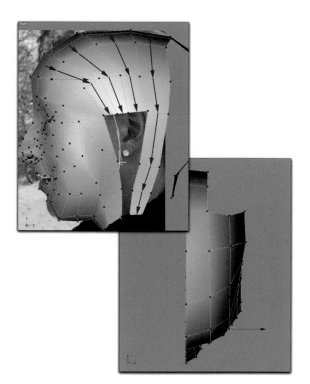

Figure 3.10: Modeling the sides of the skull

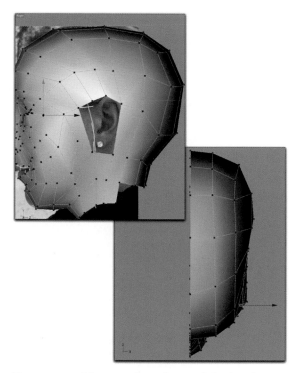

Figure 3.11: The complete shape of the head

When the outer border of the skull is pulled down to the neck, new polygons can be extruded laterally from this polygon strip. These stripes are continued in the direction of the ear where they end.

Only when the starting position allows extending the strip behind the ear can it be continued down to the neck.

The upper figures show these steps from two perspectives and indicate the extrusion with arrows.

Note that the skull is not round in the top view but appears squarer. Compare this with the reference sphere from which we deleted the pole caps.

Figure 3.11 shows how the polygon strip, which passes behind the ear, continues forward in the lower part in the direction of the chin. This allows us to create, by using just two polygons, a connection under the ear opening to the polygons of the face.

The back of the head and the neck are closed in the same way. Then the reference sphere can be deleted, for we don't need it anymore.

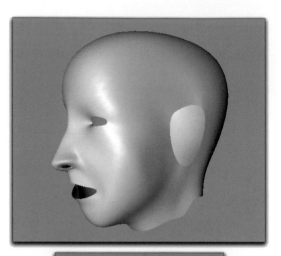

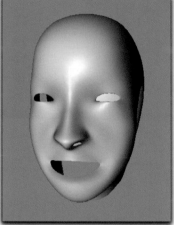

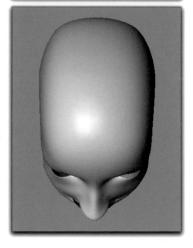

Figure 3.12: The mirrored and smoothed model

An opening for the ear remains at the side of the head. We will model the ear separately and later connect it with the head.

This is a good opportunity to take a look at the mirrored and smoothed model, since the head is almost completed. It is especially important during this phase to check the shape of the skull in the area of the forehead and the transition through the bridge of the nose.

Because of the restricted perspective when working in the front and side views, it can be overlooked how flat the face actually is and how it suddenly curves toward the ear at the cheeks.

Figure 3.12 should therefore serve as a guideline, even though the face still looks more like a mask because of the missing details.

Besides the afore mentioned deficits at the bridge and dorsum of the nose and around the eyes, details are also missing from the cheeks. The face also appears too wide in the lower half.

Before we add these details in the next step, check again if the path of the loops around the eyes and mouth are as clean as possible. The polygon strips should merge organically into each other and naturally follow the topography of the face.

Figure 3.13 show this by highlighting some polygon rows. Then we will start to apply cuts to some of the polygon rows. This has the advantage that on the one hand new points, and therefore new manipulation possibilities, are created within these faces, while on the other hand the surrounding faces are not affected.

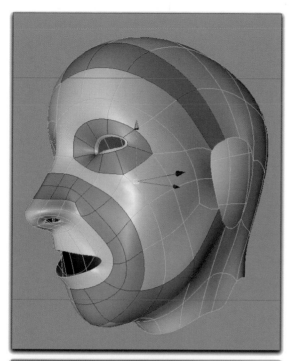

3.4 Adding Details

We start by subdividing the loop under the nose up to the ear opening. Depending on which tools are at your disposal, create new points manually on the existing edges or use the cut function, which automatically recognizes polygon structures and allows them to be cut along their length in the middle.

Create a similar subdivision at the polygon strip that starts at the corner of the mouth. Both actions are shown in Figure 3.14.

At the end of the strips are faces with more than four corner points, so-called N-gons. Since it is our goal to model an object mostly from quadrangles, we will make some changes in this area.

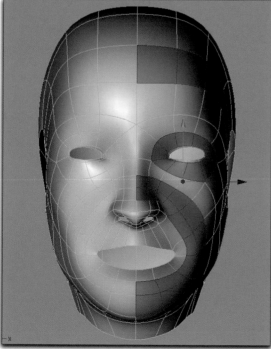

Figure 3.13: Checking the course of the loops

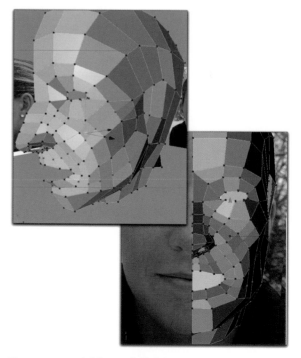

Figure 3.14: Adding subdivisions

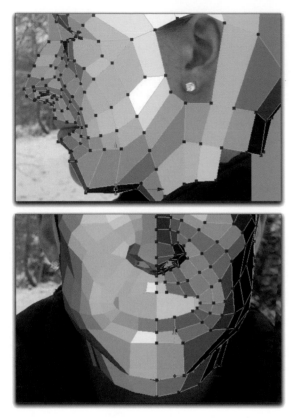

Figure 3.15: Use of the new faces

Figure 3.15 also shows how to integrate the ends of the loop cuts into the existing mesh.

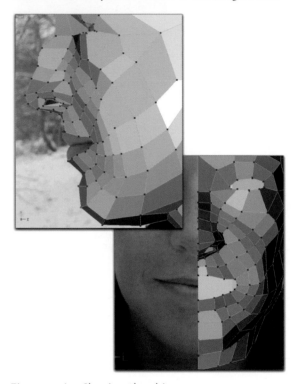

Figure 3.16: Shaping the chin

The subdivision only creates new faces, but they alone don't have a use yet. The new points have to be moved sensibly in order to create more details.

Use the points under the nose and at the side of the upper cheek to define the area above the upper lip and under the eye. Especially try to define the cheekbone, positioned laterally under the eye.

The new points at the corner of the mouth can be used to shape the chin and to narrow the side of the cheek. Between the jawbone and the cheekbone, the cheek should curve slightly toward the mouth area.

Use the same technique to part the loop running from the dorsum of the nose, across the cheek, and down to the chin. We don't have to worry about the ends of this cut since both points are located on the symmetry plane and therefore at the open edge of the face.

Use the new points to shape the chin, give a hint of a laugh line, and to refine the dorsum and bridge of the nose.

Here the end result is captured in Figure 3.16.

With the next action we finally remove the pointy dorsum/bridge of the nose and at the

same time the weakly defined bulge above the eye.

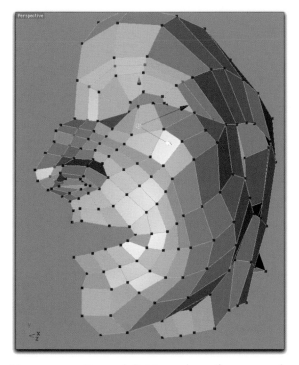

Figure 3.17: New subdivisions along the nose and above the eye

Therefore, part the polygon row along the dorsum and bridge of the nose. Start the cut at the nostril; continue along the nose upwards and in a half circle above the eye. The cut ends next to the outer corner of the eye, as can be seen in Figure 3.17.

Pull the new points above the eye and at the dorsum of the nose forward in order to round this area. Generally, every new point should be at least slightly moved to ensure that no flat areas are created where several points are positioned on one plane. Otherwise, this would result in unnatural-looking areas when the face is smoothed.

Don't put too much trust into the smoothing, but rather try to shape an organic surface with just a few polygons.

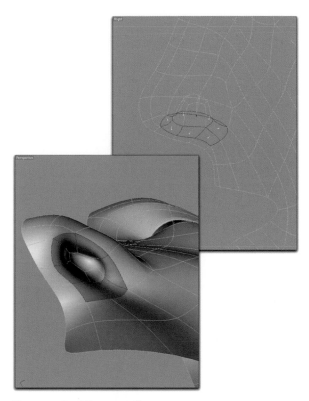

Figure 3.18: The nostril

3.4.1 Nostrils

The amount of detail depends on how the character will be used later. Should the character be animated and be able to talk? Then the inside of the mouth and the teeth need to be added.

This also pertains to all the other parts of the object. Generally only the parts that will be visible later should be modeled. As for the nose, this also includes a part of the inside.

The nostril shouldn't remain as open on the inside, but instead extended a short way into the nose. Figure 3.18 shows how this might look.

together force the smoothed surface to be closer to the original object.

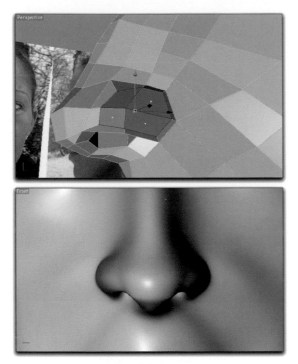

Figure 3.19: The side of the nose

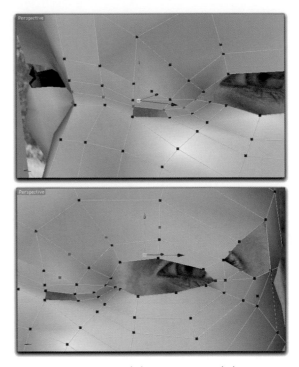

Figure 3.20: More subdivisions around the eyes

3.4.2 Side of the Nose

In order to refine the nose, it helps to extrude the sides of the nose and to shrink them slightly.

As it is shown in Figure 3.19, I have done this with the four connected faces at the side of the tip of the nose. As a result, the characteristic lines are built that separate the tip of the nose from the nostril, as can be seen in the smoothed view in the figure.

The second advantage is that the crease at the transition between the side of the nostril and the cheek is more defined. As mentioned a few times already, points positioned closely

3.4.3 The Polygon Flow Around the Eyes

The important contours around the eyes are still missing. In the first step, the subdivisions of the faces around the eyes are increased selectively to optimize the polygon flow.

In order to better model the transition of the upper lid to the nose, add a cut that starts at the bridge of the nose and ends at the inner corner of the eye. Then create a new subdivision at the upper lid as it is shown in Figure 3.20.

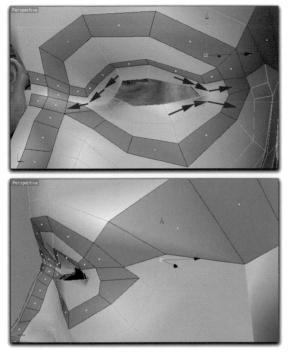

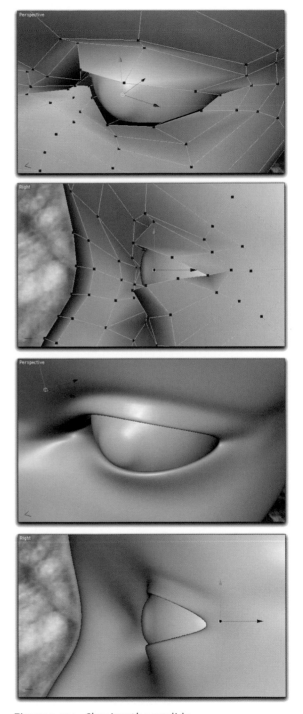

Figure 3.21: Polygon flow around the eyes

After the new points and edges are connected harmoniously with the surrounding faces, the image looks like Figure 3.21. As an example, a few polygon loops are highlighted. In addition, arrows point out the desired polygon flow.

There are two basic polygon directions. Generally, the polygons run in a circular manner around the eye. To achieve the creases at the corners of the eye, the polygons at those spots have to branch off to the outside.

The branched-off loops are close to the eyelids, while the course of the round loops is farther outside.

Use the new points to shape the eyelids. Figure 3.22 shows an example.

Figure 3.22: Shaping the eyelids

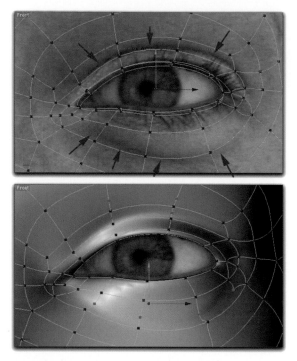

Figure 3.23: Creating additional subdivisions

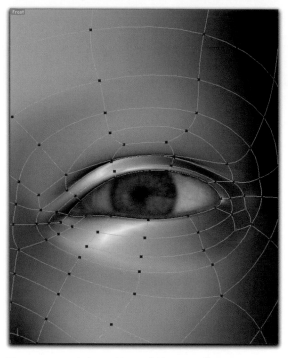

Figure 3.24: Integration of the new faces

As well as the edges of the eyelids, we also have to take care of the wrinkles in the area of the eye.

Under the lower eyelid is a distinctive line that runs from the inner corner of the eye in the direction of the cheek bone. The skin folds above the upper eyelid partly overlap the upper lid when the eye is open. Both areas are marked with arrows in Figure 3.23.

The lower image in Figure 3.23 shows which points have to be added in order to get a sufficient number of points for modeling.

Remember that there should be only quadrangular faces, if at all possible. Therefore, cuts have to be made so that the ends of the split loops can be connected nicely with the existing faces.

In Figure 3.24 the critical areas are marked in red. There it can be seen how all the loops end with quadrangular faces.

As described before, it is helpful, especially in the area of the corners of the eye, to not only have radial loops around the eye but also to branch them outwards.

Often the mesh can be simplified further by making relatively small changes without losing any details. The colored points show an example of which points could be merged to eliminate a face completely.

Move the new points of the lower eyelid slightly down and inward. This movement should go deeper at the inner corner of the eye than at the outer corner so the crease at the outer corner ends softly.

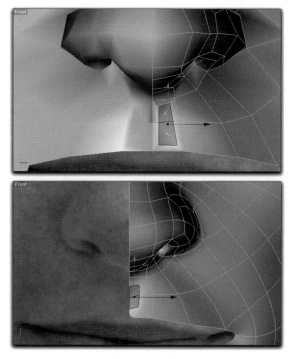

Figure 3.25: The indentation between nose and upper lip

Modeling in this way enables you to have a wide range of possibilities available when developing different moods, such as happiness, rage, or sadness, simply by using blend shapes or morphing out of the relaxed position.

Morphing: Generally this is the deformation of the object from a start state to a target state. Multiple copies of the model, with the relaxed expression, are created, which then are remodeled to have different expressions. Often, different shapes of the lips are created for all the letters or sounds. Also common are models for wrinkling the nose, laughing, or frowning.

In order to make the morphing work, all target state objects have to have their origin in the same object. Existing points may not be deleted or new ones added. Therefore, it is important to add the necessary subdivisions of the creases to the model in the relaxed pose.

When the object is animated, the different faces can then be blended with new ones. Most of the time it is enough to use just a limited number of well-chosen poses to reproduce a variety of facial expressions.

On the upper eyelid, pull the points slightly forward, while in the area of the crease, move backwards in direction of the eyeball. Depending on the view you are working in, the upper eyelid appears either thin and stretched or massive and heavy. In dealing with the transition to the upper nose, many different types of eyes can be created.

Take your time, especially when working on this part of the object. The personality and appearance of the area around the eyes have an important influence on the overall look of the head, even the whole character.

Model the area around the eye as if it were in a relaxed state. This is especially crucial for when the character is to be animated later. Try not to emphasize the creases too much unless it is supposed to be an older character.

3.4.4 Mouth and Lips

Let us take care of the area around the mouth. We will start with modeling the typical dent between the nose and the upper lip. The outer border should already exist as an edge. The only thing missing are a few

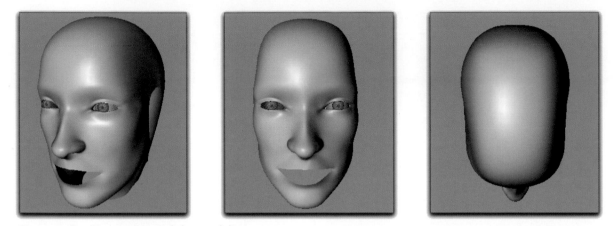

Figure 3.26: Current state of the modeling

points in the space between to create the dent. Figure 3.25 shows the procedure.

Extrude the two faces between the nose and upper lip and slightly reduce the resulting new faces. Then delete the faces, indicated in green in the same image, and move the points, located along the open edge of the face, to the symmetry plane so the mirroring of the face will work.

Finally, pull the new points slightly into the head. The image series in Figure 3.26 shows what we have accomplished so far. The head slowly takes shape.

In Figure 3.27 you can compare the polygon structure, shown from two different views, with your own model.

Let us continue with the lips. First, make sure that all points along the open edge of the mouth are already following the contours of the lips. Be sure that three points are relatively close together in the area of the corner of the mouth. Later this will be important when making sure that the

corner of the mouth looks neither too soft nor too hard-edged.

Also note in the following steps that the lips curve inward in the area of the corner of the mouth, and partly disappear inside. This becomes more apparent when the mouth is opened wide. In this instance, the lips would appear much wider in this area than when the mouth is closed.

Don't overdo the outward bulging of the lips. In the age of plastic surgery we have become used to the voluminous lips of celebrities. However, the natural look should remain the norm. Generally, the lower lip has more volume than the upper lip.

After so much theory we will begin to extrude the complete edge of the mouth opening. Pull the new points to the visible separation line in the front view where both lips meet. Remember to pull the points slightly into the virtual inside of the mouth.

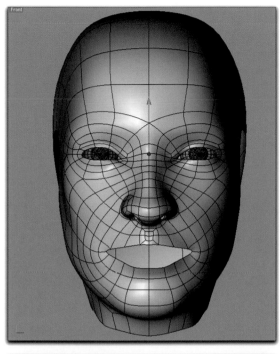

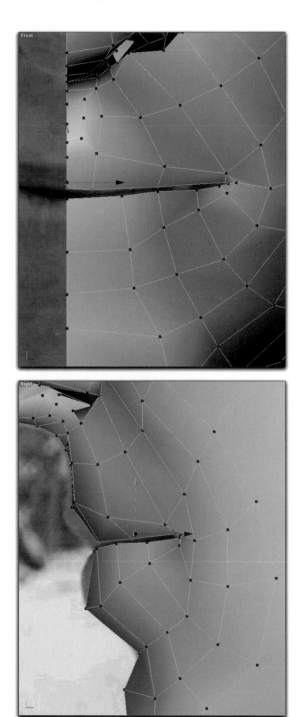

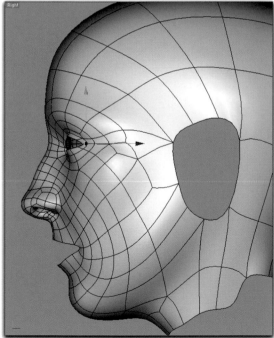

Figure 3.27: Polygon order of the head

Figure 3.28: Creating the lips

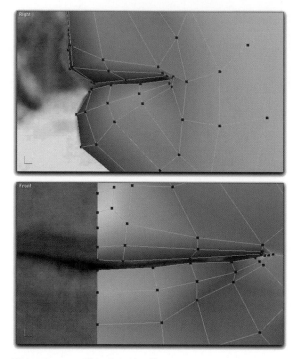

Figure 3.29: Shaping the lips

The still flat lips now get an additional subdivision as can be seen in Figure 3.29. Pull this subdivision forward in the side view so the bulge of the lips fits the reference image. The points in the corner of the mouth remain in their position. Thus, the outer shape of the lips is now complete.

Since it might be possible to see the teeth through a gap between the lips, the lips shouldn't remain at their meeting point. Instead, they should be extended into the inside of the mouth.

Therefore, select and extrude the open edge of the lips in the center of the mouth.

Pull the new edges into the inside of the mouth, up to the point where you expect the location of the teeth to be. Extrude the edge one more time and pull the edge of the upper lip upward and the edge of the lower lip downward.

Pull the inner points of the corner of the mouth in the direction of the inner cheek. This way the lips curve naturally into the inside of the mouth.

When looking at close-ups, you might have noticed that, especially in the area under the nose, the upper lip has a relatively sharp edge. This is especially apparent during certain lighting situations when highlights appear in this area.

This edge also marks the color change from the skin of the face to the skin of the lips. This transition is less defined at the lower lip, where the color blends more softly.

Also, with regard to the anticipated texturing of the head, we should model this edge along the upper lip.

Therefore, add an additional edge loop along the outer edge of the lips. Move these new points closer to the upper edge of the lips, especially under the nose, to emphasize this edge when the face is smoothed.

On the lower lip and in the area of the corners of the mouth, keep the points farther apart. Just use these points to shape the lower lip more exactly without emphasizing any lines.

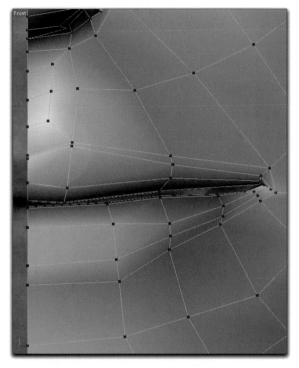

Figure 3.30: Details of the lips

Figure 3.30 shows these steps in detail. On the right you can see the highlighted area where the additional points are used to strengthen the upper lip. When following the course of this edge around the lips, you can see that the new points on the lower lip were just used to further shape this area.

The more we create such subdivisions, the more problematic the situation becomes at the corners of the mouth since the edges get very close together. Make sure that the points are moved toward the inside of the mouth as soon as possible.

This concludes the first stage of the modeling of the head (Figure 3.31). What follows is the modeling of the ear and then a second refinement where the more distinctive female characteristics are emphasized.

Slight mistakes have developed here, because of working closely with the image templates, and need to be corrected. It is also a good idea to get away slightly from the image templates and to add your own ideas for the character's features or expressions.

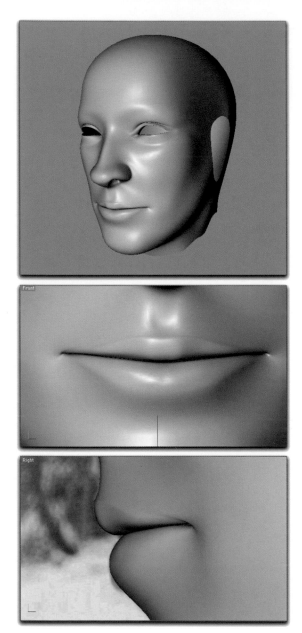

Figure 3.31: The current shape of the head

3.4.5 Tear Ducts and Liquids

Before we get to the ear we will add the missing tear duct and the thin layer of liquid that builds up along the lower eyelid. This liquid can capture and reflect quite a bit of light and should definitely be modeled. It will give the eye more sheen and a wet look.

Select the polygons that define the thickness of the eyelids, as shown in Figure 3.32. Note that the selection does not incorporate all faces, but is instead restricted to the corners of the eye and the lower eyelid.

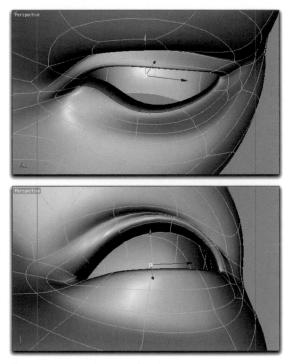

Figure 3.32: Polygon selection

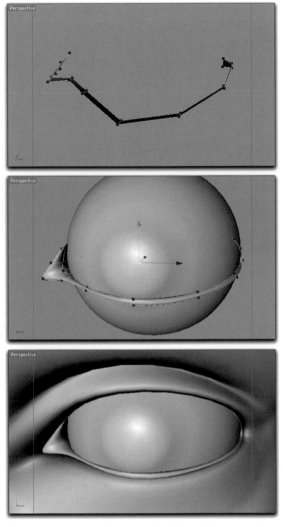

Figure 3.33: Modeling the liquid and the tear duct

Show the eye object to see if there are any gaps between the eye and the liquid or the eye and the tear duct.

Make this polygon strip disappear between the eyelids at the outer corner of the eye. The liquid collects mainly above the lower eyelid. There, the majority of the faces should remain visible.

Also work on the smoothed version of the thickened polygon strip so it is aligned precisely along the eyelid and the eye.

The series of images in Figure 3.33 documents the original shape of the doubled polygon strip. The center image shows the extruded and smoothed version, and the bottom one shows the result.

3.5 Ear

The ear is probably the most complex part of the head. The surface is folded multiple times and then disappears inside the head.

Because the ear will be connected with the geometry of the head, the number of polygons should not be too high. Otherwise, we would need too many connecting polygons at the base of the ear that could lead to irregularities in the smoothed version of the head.

It is also possible to put too much work into the ear without ultimately getting much use out of it. Characters with long hair, or whose heads are covered with a hat, often don't show any ears.

We will make a compromise in our example and only model the most important geometry of the ear.

Duplicate the selected polygons and copy the duplicate into a new object.

Thicken the polygons by extrusion and increase the volume of this polygon strip, at the inner corner of the eye, in order to shape the tear duct.

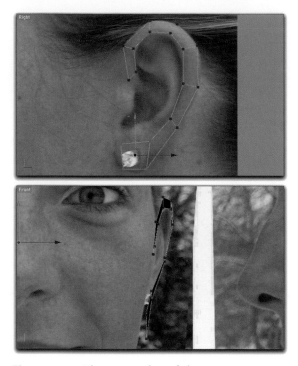

Figure 3.34: The outer edge of the ear

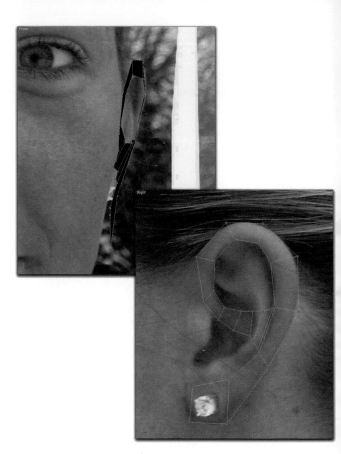

Figure 3.35: Creating the connection

3.5.1 From the Outside Inward

Another difficulty when modeling the ears is to find sufficient image templates. It is quite easy to find side views of heads, but in front views the ears are mostly covered. This makes it difficult to determine the proper distance between the elements of the ear and the side of the skull. On the other hand, a view of ears from behind is almost impossible to find.

We can start with placing a polygon strip on the edge of the ear in the side view. This strip could be extracted from a distorted disk or it can be created by placing new points directly on the image.

Try to create as few subdivisions as possible, and adjust the position of the points also in the front view so the slight angle of the ear away from the head is achieved. Figure 3.34 shows the result.

Create additional faces that, following the image template, connect the front part of the ear with the middle of the rear ear curve. Figure 3.35 shows this connection between the edges of the ear.

In the front view move the points of this connection slightly into the outer ear and out again at the edges.

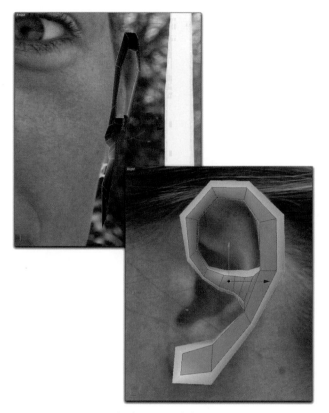

Figure 3.36: Thickening of the structure

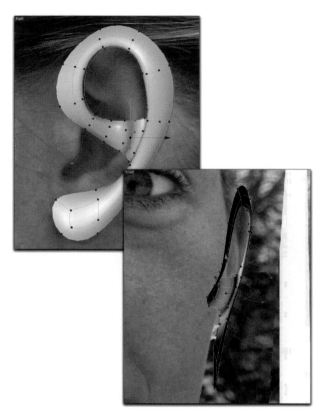

Figure 3.37: Smoothing the ear polygons

So far it is a flat polygon strip. In order to get the faces around the bulge of the rim of the ear to the back, extrude all faces slightly outward and then shrink them slightly.

Next, use the inner points along the inside edge of the circular surface in the upper part of the model to shape the upper rim of the ear. Move the described points slightly in toward the surface of the outer ear and radiate them a bit outward.

This folds the surface to the inside around the bulge of the rim. Repeat this procedure using the points along the outer edge of the structure.

Activate the smoothed version of the ear model to better judge the final shape. Start by adding the low and high parts of the outer ear where the connection forms to the outer ear rim. There the outer ear first curves outward, almost to the level of the ear rim, before it turns inward.

Figures 3.36 and 3.37 show this step. Don't be deceived by the apparently different scales in the front and side views. Because of perspective distortion during the photo shoot, the ear appears to be smaller in the front view than in the side view.

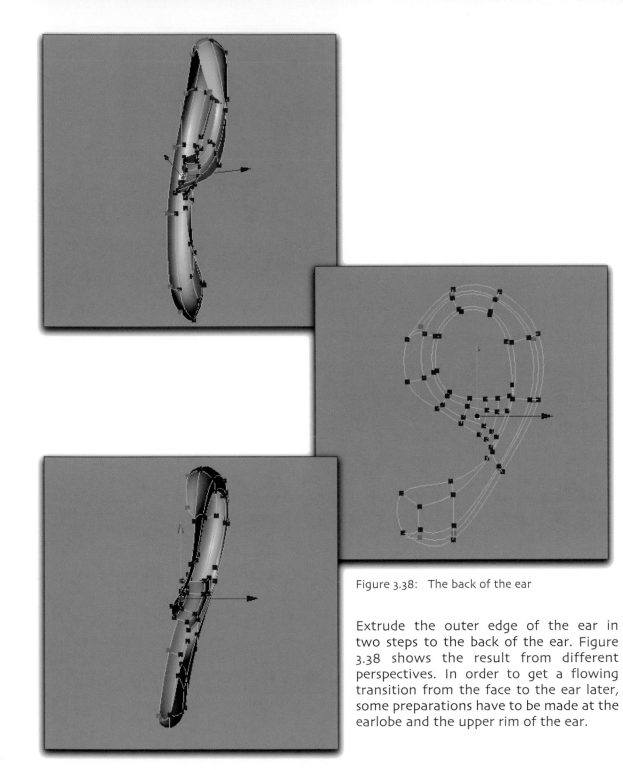

Figure 3.38: The back of the ear

Extrude the outer edge of the ear in two steps to the back of the ear. Figure 3.38 shows the result from different perspectives. In order to get a flowing transition from the face to the ear later, some preparations have to be made at the earlobe and the upper rim of the ear.

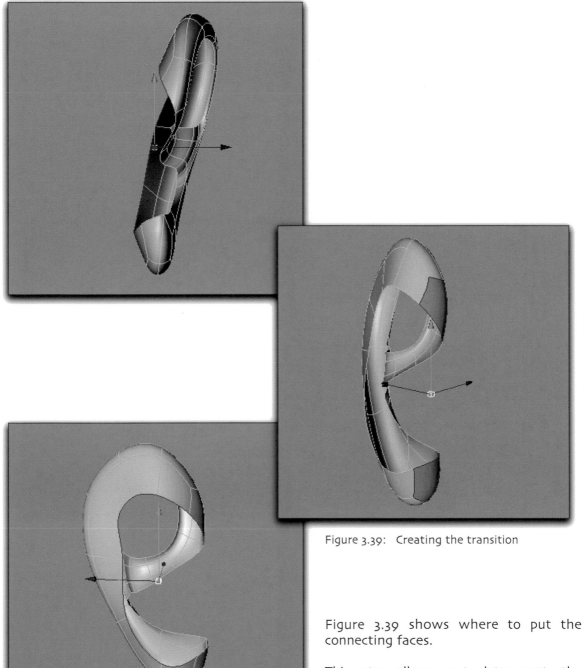

Figure 3.39: Creating the transition

Figure 3.39 shows where to put the connecting faces.

This setup allows us to later create the transition between the head and the front and back of the ear with just two points.

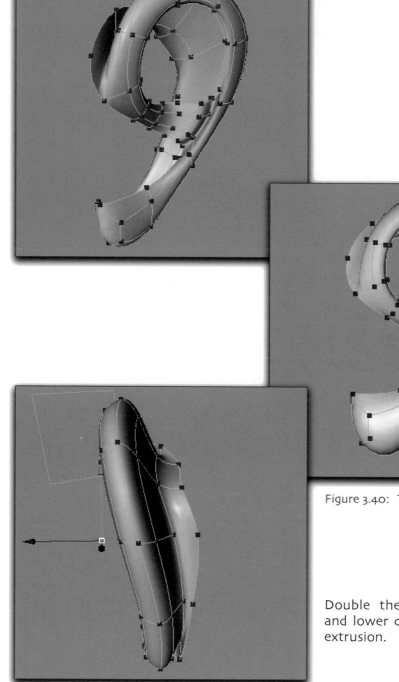

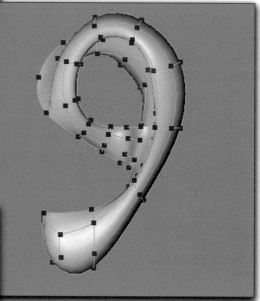

Figure 3.40: The back of the ear

Double the edges between the upper and lower connection point by means of extrusion.

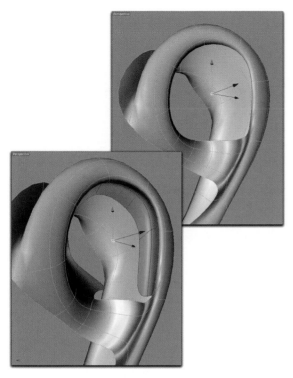

Figure 3.41: The approach for the upper outer ear

Move these new edges toward the head and radiate them outward to model the part of the head behind the ear.

3.5.2 Outer Ear

This concludes the transition to the head behind the ear and now we can concentrate on the visible outer parts of the ear.

Starting from the inner edge loop of the upper outer ear we will work inward.

In the first step we create a new polygon strip based on this edge loop. Note that not the entire edge loop is used. Figure 3.41

shows where the newly created faces are, marked in red.

There would have been too many new faces if we would have extruded the complete edge loop.

This would have been especially problematic in the area of the transition between the bridge and the outer rim since the faces are very close together.

Ultimately it must be our goal to have a manageable number of faces in all areas of the model. It is also advisable to use quadrangular faces as often as possible since they have advantages when the object is smoothed or being deformed during animation.

Even though deformation can be disregarded when it comes to the ear, it doesn't hurt to stick to the rules. This way makes it easier to get used to working with quadrangles, making it less tempting to use the triangular faces, which are generally easier to handle.

This is a good time to step back and to make the best out of the existing faces and points before we add more polygons.

Therefore, take a critical look at the model of the ear from different angles and correct possible errors.

The outer shape, size, and position of the ear to the head are already modeled. Because the details of the outer ear are still missing, it is relatively simple to correct the location or size of the ear.

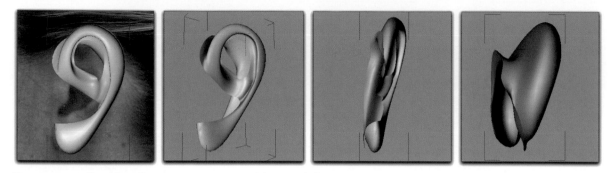

Figure 3.42: Checking the ear geometry, position, and size

When you are happy with the result, close the upper outer ear as can be seen in Figure 3.42.

It is important to work with the smoothed version of the model. Since the surface of the outer ear shows many changes in a small space, the points of the low-resolution model have to maintain extreme positions in order to bring the smoothed version of the outer ear into the desired shape. This can result in a rather confusing appearance of the nonsmoothed object, as shown in Figure 3.43.

Continue extruding the faces along the inner edge of the ear and then create faces to close the upper part.

As shown in Figure 3.43, relatively few faces need to be used to get the necessary details of the outer ear.

Control and correct the position of the points in the different views before you continue.

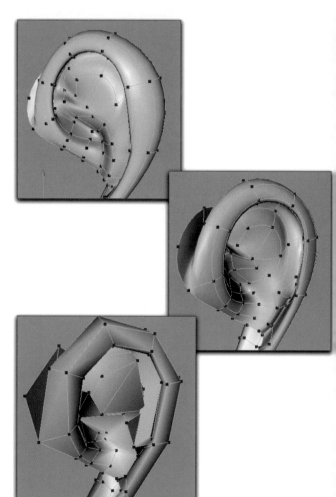

Figure 3.43: The outer ear

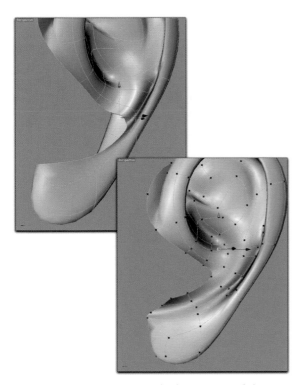

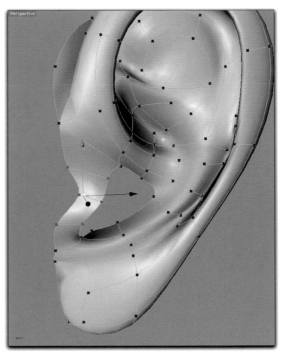

Figure 3.44: Transition to the lower part of the ear

Figure 3.44: Connection between earlobe and the bridge

3.5.3 Lower Part of the Ear

Extend the small bulge, which we created in the beginning, between the bridge and the outer edge of the ear in the direction of the earlobe.

Let the crease at the ear bulge slowly expire at the earlobe by moving the points at the earlobe into one plane.

Figure 3.44 shows these steps in detail.

It is almost done. Create four faces that will be used to connect the upper edge of the earlobe with the edge of the bridge. Be sure that these faces don't just form a flat bridge but swing outward at the level of the ear canal.

This cartilage bulge can also be seen well in the front view and should definitely be modeled. This helps the ear to integrate more harmoniously into the head and not just appear to be stuck to it.

Figure 3.45 shows the connecting polygon bridge in the side view.

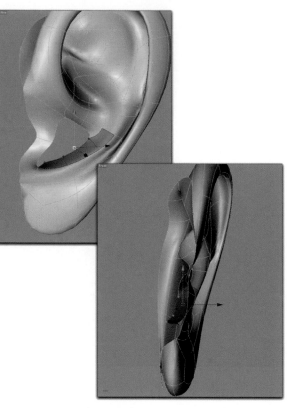

Figure 3.46: Shaping the transition to the ear canal

Then make sure that the faces above the earlobe already curve slightly inward toward the ear canal. Figure 3.46 shows these faces in red.

The edge between the earlobe and the cavity for the entrance of the ear canal can, depending on the shape of the ear, be very sharp. You should base this on your reference images.

Generally, it is true that ears can be shaped quite differently. Besides obvious differences, like the base and size of the earlobes or the angle between the ear and the head, there are also the details of the outer ear and the edge of the ear that can differ from person to person.

Close the now small area from the outside inward with new faces. Make sure that the new faces are positioned favorably for the shaping of the ear canal, which follows.

The ear canal itself can then be created, similar to the modeling of the nostril, by extruding it by one or two faces in toward the skull.

The ear canal is covered by the front part of the ear and therefore doesn't have to go deeply into the head. But it shouldn't be missing completely because characteristic shadows could appear in this area.

Figure 3.47 is a close-up of the structure of the faces at the base of the ear canal and the complete view of the finished ear.

In the next step we will connect the still separate objects of the ear and the half head. The ear on the opposite side will then be created, just like the face, by mirroring it.

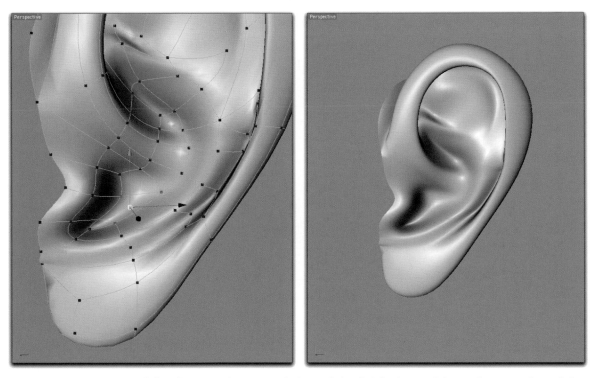

Figure 3.47: Structure of the closing polygons and view of the finished ear without the extrusion of the ear canal

3.5.4 Connecting the Face and Ear

Because we limited the number of polygons used when modeling the ear, the connection between the faces of the ear and the side of the face shouldn't be a problem.

Copy the faces of the ear model, add them to the face model, and correct the hole left for the ear at the side of the head, making sure there is enough space for the connecting faces. As always, be sure to use only quadrangles to bridge the gap to the ear.

Check again the size and location of the ear in relation to the already modeled face. The faces of the ear are still easy to move or rotate without influencing parts of the face.

When your software allows it, you should select all the faces of the ear and save this selection for future use. This can be helpful for correction of the ear or the eventual work with UV coordinates and textures.

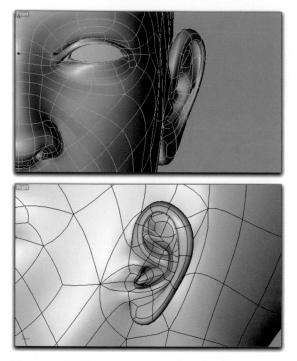

Figure 3.48: The ear connected to the face

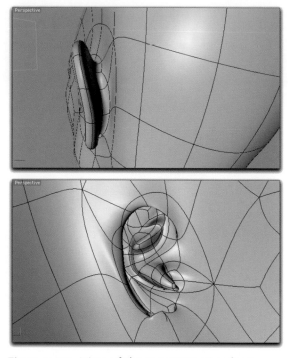

Figure 3.49: View of the ear connection from behind and from the inside of the head

Figures 3.48 and 3.49 show a possible connection.

Make sure that the upper edge of the ear emerges naturally from the head. Generally, for places where organic transitions have to be created, such as between the ear and the side of the face, the connecting faces should be larger. Changes in a small space require the faces to be closer together and to be smaller.

The advantage of all this work is that the ear can be used repeatedly with other characters as well.

As I already mentioned, there are hardly two people with ears that are identical. Because we worked with relatively few faces and points, changing the model with little effort is possible.

This concludes the modeling of the head for now and we can take a final look at the procedure.

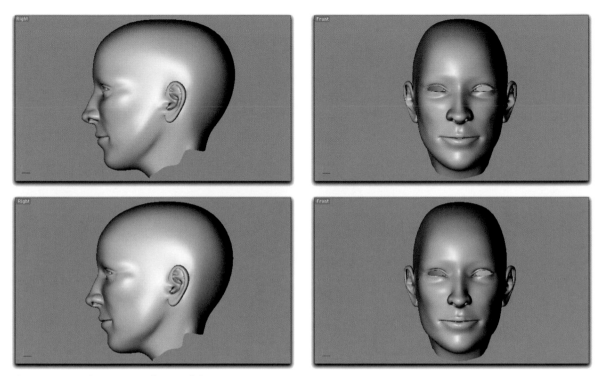

Figure 3.50: Changes on the model

3.6 Details and Checkup

Before we close this part we will check the model one last time.

In the side and front views the model seems to match the image templates well but it is missing the female features. The head could, with a little imagination, belong to a male person.

This is mainly the fault of the incomplete information of the reference image. We used only two views, each of which had a differently distorted perspective.

We have to compensate for the lack of information with theoretical knowledge and with comparison of our visual memory.

Women, for example, have a less defined jaw. The angle of the bone is, starting from the chin, much steeper heading toward the ear. Therefore, the chin often appears to be narrower and pointier than a man's chin.

The femininity of the face is also supported by defined cheek bones, less defined eye sockets, and a narrower nose.

When we take a look at our model and modify these areas, a more harmonious result is achieved without changing too much the likeness to the image templates.

Figure 3.50 shows the starting model in the upper row and the resulting model, after modification, on the bottom.

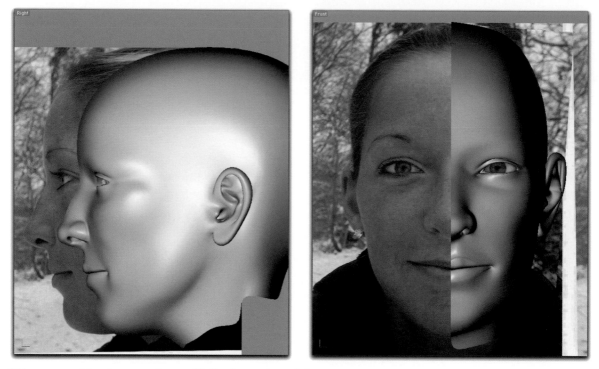

Figure 3.51: Direct comparison with the image templates

A direct comparison to the image templates in Figure 3.51 shows that we are not far from the original image. Lastly, upon closer examination, there are only small details that stand out.

The nostrils could be shaped better. The edge of the side of the nose has a hard edge in reality and isn't as soft as on our model.

Also, the lips appear shapeless and flat on our model. Because they are important for the feminine appearance of the character, we have to correct this as well.

We can barely see three swellings of the upper lip and two of the lower lip. The upper lip is thicker directly under the nose and again at the outer edges. The lower lip is thicker to the left and right of center. When these shapes are hinted, the line of the lips appears more natural. These additional faces also help to achieve extreme shapes of the mouth, like a smile or the pronunciation of the letter O.

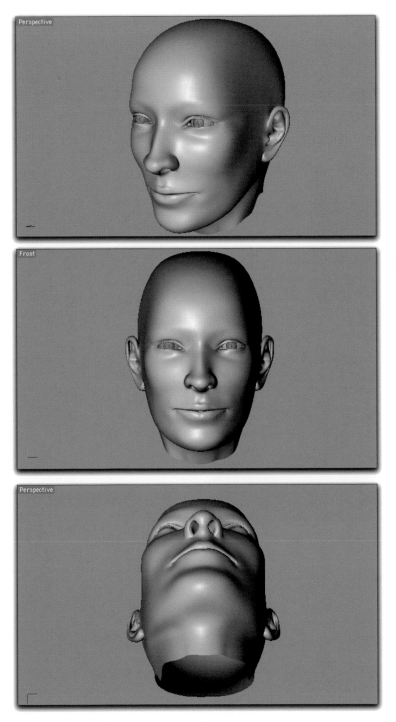

Figure 3.52: The head seen from different angles

3.6.1 Nostrils

Let us start with the nostrils. There, the transition between the side of the nose and the tip of the nose should be sharpened. As mentioned a couple of times before, the smoothed version of the model shows only harder edges where edges are closer together.

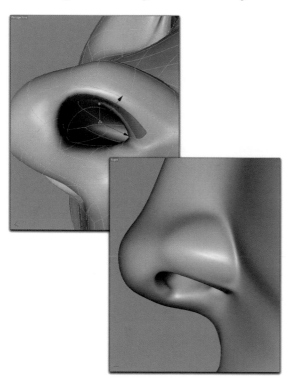

Figure 3.53: Sharpening the nostril

In order to give the outer edge of the opening more definition, select a polygon strip at the transition to the inner nostril and extrude these faces. Figure 3.53 shows this step and marks the faces in red.

The faces that were doubled by the extrusion are then slightly shrunken. The result can be seen especially well in the side view, which is also in Figure 3.53. The edge of the nostril, as shown at the side of the nose, is now much more defined.

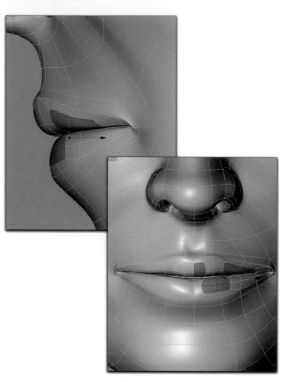

Figure 3.54: Accentuating the lips

3.6.2 Shaping the Lips

As already described, the lips are not made of one continuous mass but are thickened at different spots.

Because we still work with just one half of the face, which will be mirrored, the changes only affect one half of the lips. These areas are marked in red in Figure 3.54 and show the faces of the lips that were first extruded and then shrunken. In addition, these areas were moved out and slightly away from the plane of the lips.

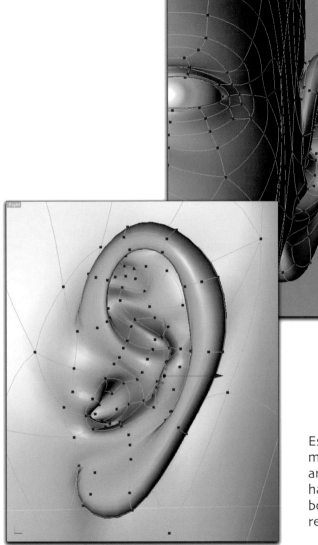

Figure 3.55: Shaping the ears

Especially in the middle of the upper lip, make sure that there aren't two extruded areas created by mirroring. There, the faces have to snap to the symmetry plane. The bottom image of Figure 3.54 shows the result.

I also worked on the ears, as can be seen in Figure 3.55. The outer edge of the outer ear has been moved further outward and the earlobe was thickened to create more volume.

Now the model of the head is finally complete and done.

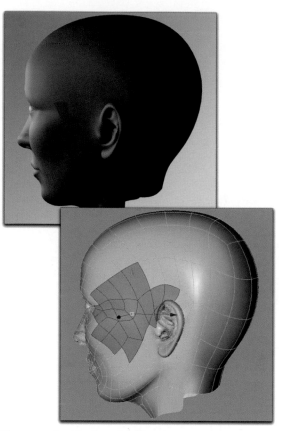

Figure 3.56: Finding shading errors

light source in your 3D scene and render the model from different angles. You may discover errors in the shading of the surface, as shown close to the temple in Figure 3.56.

Before we get to this you should learn about shading surfaces. When surfaces are rendered, the angle between the so-called surface normals and the incoming light is calculated. This normal is a vector that sits perpendicular to the surface of the calculated polygon.

The direction of this normal also defines which side of the polygon is the front and back since, regardless of how thin an object is (think about a piece of paper), the face has a front and a back.

When a face is upside down, which means the back is in front, it doesn't change anything about the shape of the object, but the normal points in the opposite direction. The calculation of the angle between the incoming light and the normal would have a different result.

This explains the difference in brightness of these turned faces when compared to neighboring faces, which are facing the right way.

Depending on which tools you have available in your 3D software, these flipped faces are colored differently. The bottom image in Figure 3.56 shows this clearly with blue coloring, compared to the red-colored faces that are in the right direction.

In many cases these wrongly oriented faces can be easily found and flipped with a certain command.

Surely, more details could be added and the model refined and subdivided, but this would also make it more difficult to animate. I believe, with this level of detail, we have found a good compromise between realism and the ability to further edit the head.

There are also further possibilities during texturing to increase the level of details without having to change the basic model. More information about that can be found in the next workshops.

Before we close this section, we should check the quality of the surface. Place a

This concludes this segment and we can work on the hands in Workshop 4.

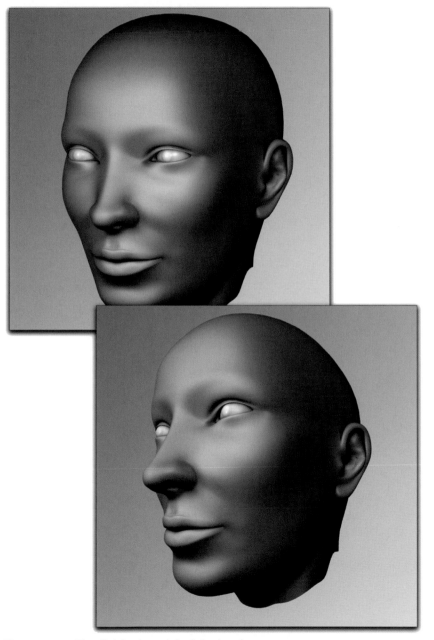

Figure 3.57: The finished model of the head

Modeling the Hands

Similar to the face, the human hands contain many details that can make modeling difficult. It is therefore recommended to first work on the basic shape of the hand and fingers and to add details when necessary.

Complex structures like the raised veins on the back of the hand or the deeper creases at the knuckles and finger joints can often be simulated with textures.

Thankfully, all fingers are built in a similar manner, even though they differ in length. This will save us some work, as we will see during the modeling process.

As with all modeling, there first should be thorough research for references. Different from the face, for which a mirror is needed to model from, hands are always in our line of sight. Thus, our own hands should be used as reference as well, even though they might be male hands. The structure of male hands is identical to female ones.

In our case I look for photographs that, as described in the first chapter, match in size and position, and trace their contours. Figure 4.1 shows the result. This helps us to keep our focus on the essential shapes.

Especially important is, besides the size of the hand, the position and appearance of the fingers. Fingers are rarely completely straight and their length differs greatly from one person to another.

Figure 4.1: Sketch as a reference

Special attention should be paid to the thumbs. It is especially common for beginners to attach the thumb at the side of the hand. This might be true when the hand is pressed flat on a table, but when it is relaxed or grabs something, the thumb rotates away from this plane and is then almost in a position perpendicular to the finger plane.

In order to be able to generate different poses of the hand, it should be modeled in a relaxed pose.

Figure 4.2: An octagonal cylinder as the base for finger modeling

It is also important to arrange the fingers along a slight curve and not in a straight line like the teeth on a fork.

Another thing to consider is that the transitions between the fingers are not shaped like a V but are more round. We will get into that during the modeling process later.

Start by loading the created image templates for modeling the hand into a new, empty scene and place them according to the editor views.

4.1 Fingers

Create a basic cylinder object without caps. The object should look just like a pipe. Subdivide the pipe into eight parts. The pipe now looks like an octagon. Since the object will be rounded later, this number of subdivisions is sufficient.

Place the cylinder over the top-view image template and adjust the radius and length to the shape of the middle finger. This is the longest finger of the hand.

Before you start adjusting the outer shape of the octagonal pipe to the fingers, add more subdivisions where the finger joints are located. One of the three subdivisions is placed exactly in the middle of the joint, and the other two subdivisions border the outer area of the joint where the deepest creases are located.

The upper screenshot in Figure 4.2 shows the result of these subdivisions. In the lower part of the figure the octagonal profile of the pipe can be seen.

The additional subdivisions at the joints have two benefits. We define an area where the creases can be easily created. The second, more practical use is that because of the subdivision at the joints, the hand becomes mobile in 3D programs. By adding deformers, these areas can later be bent and the fingers moved.

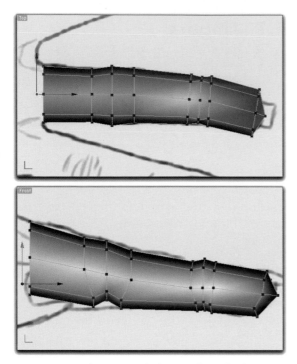

Figure 4.3: Shaping and closing the cylinder

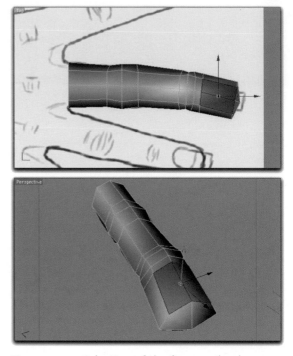

Figure 4.4: Selection of the fingernail polygons

It is, therefore, important to place these subdivisions on the joints as exactly as possible.

Then begin in the next step to adjust the shape of the pipe to the image template. As we can see in Figure 4.3, it is a three-dimensional procedure because the shape should fit in the top view as well as in the side view.

Use the subdivision at the joints on the underside of the fingers to create a distinctive groove. Note that the finger thickens mainly at the first joint. This is not so distinct at the joint closest to the tip of the finger.

When you are pleased with the result, add another point at the fingertip and connect it, with quadrangular faces, to the front edge of the pipe. The finger is now closed at the fingertip. The base of the finger remains open.

4.1.1 Fingernails

The fingernails are the most complex part of the finger. They grow out of the finger and are connected to it at the base end, while at the other end , they are completely separated from the tip of the finger.

The skin borders the nail bed and along the side of the nail, and bulges slightly upward.

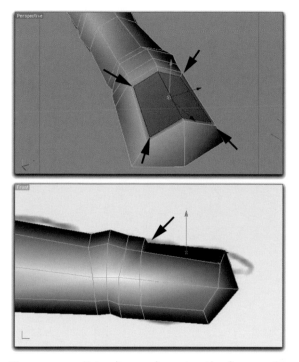

Figure 4.5: Extruding and moving the fingernail polygons

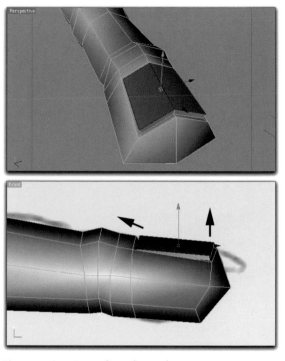

Figure 4.6: Extruding the nails

We start by selecting the two polygons at the upper part of the fingertip. From these faces we will model the nail bed and the nail itself. Figure 4.4 shows this selection from different perspectives.

Because the finger should bulge next to the nail and the nail at its base should disappear inside the finger, we cannot use these faces directly for the modeling of the nail. We first have to create a base.

Therefore, extrude these two faces and shrink the resulting faces slightly. Move the new points located at the nail bed slightly downward and in the direction of the leading finger joint. Figure 4.5 indicates these two steps with arrows.

This base is then extruded another time but this time mainly upward, vertically. The height of this extrusion determines the thickness of the nail. The height of the extrusion can be slightly less at the base of the nail since this is where the nail disappears under the skin.

The necessary move is indicated in Figure 4.6 with the arrow pointing in the direction of the first joint. The amount of movement will later be checked on the smoothed object.

If necessary, pull the edges of the extruded nail further upward in order to frame the nail more by the finger. At the base and sides of the nail it shouldn't look like the nail was placed on top of the finger. Only when the nail reaches the fingertip should it be slightly separated from the finger.

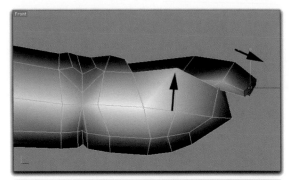

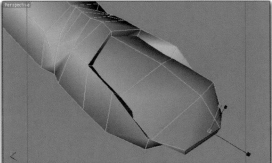

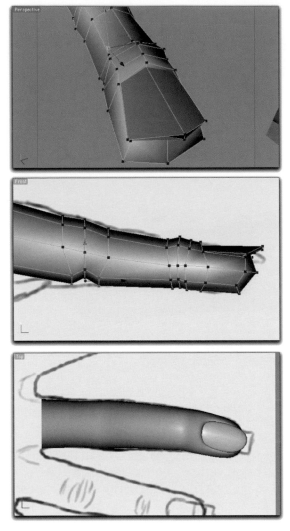

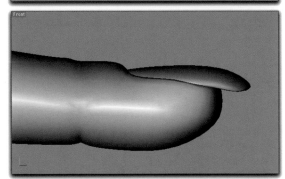

Figure 4.7: The finished fingernail

Depending on how long the fingernail should be, the shape can now be finished with the available polygons. A possible result can be seen in Figure 4.7. Note the area of the nail bed where the nail polygons are moved far into the finger to better integrate the nail.

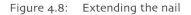

Figure 4.8: Extending the nail

When the nails are longer, the polygons in front of the nail should be extruded, as shown in Figure 4.8. This allows you to adjust the shape of the nailtip more precisely.

Subdivide the edges that border the joints on the underside of the finger, as shown in Figure 4.9.

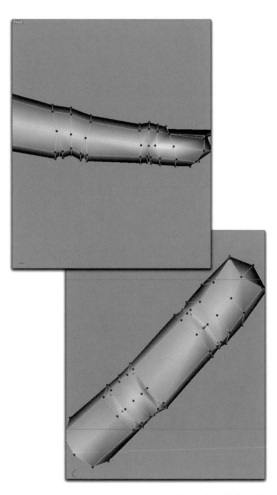

Figure 4.9: Creases on the underside of the finger

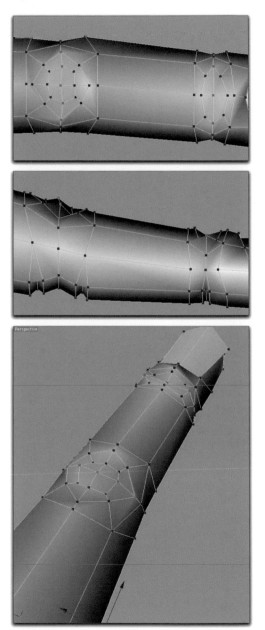

4.1.2 Joints

To create the creases under both joints, we need more subdivisions in these areas.

Figure 4.10: The upper creases on top of the joints

This is where we create V-shaped indentations. Two indentations at the joint closest to the base of the finger and one at the joint near the tip should be enough.

On top of the joints we create rhombic or circular subdivisions, as can be seen in Figure 4.10. This is similar to the concept of the polygon loops that we used when modeling the face.

Especially at the larger second joint in the middle of the finger, it is apparent that the creases of the skin are running in an elliptical course around the joint when the finger is extended. The only exceptions are the creases that are located directly above the joint. These cross the finger perpendicular to the direction of the bone.

This circular arrangement of the faces can be used to reproduce the creases. This loop also helps us to limit the number of faces needed in the area of the joint, so we don't have to make so many cuts through the whole finger. Too many cuts could result in problems on the underside of the finger.

We need at least two additional vertical cuts on the second joint, since the area of the creases there is quite large and we will need to create at least three more creases. The smaller creases can be added later with a material.

The additional edges can be seen in the side view of the finger in Figure 4.11.

Lower the edges over the joints slightly so a small indentation appears.

Skip the following edge loop and lower the next one. This creates a zigzag shape on top of the joint that will result in nice creases when smoothed.

Don't overdo the depth of the creases on the finger. After all, these should be the hands of a young woman. The rules that apply to the hands also apply to the face: Creases are added only where they are necessary for the function of the joints, muscles, or skin, or

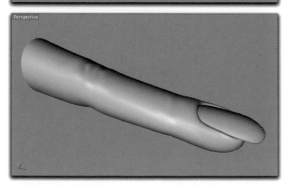

Figure 4.11: The creases of the joints

support the character of the person. Creases caused by age generally don't need to be added.

Also note how additional subdivisions at the underside of the fingers are used to narrow the joints and to add more volume to the area between the joints.

Figure 4.12 shows the smoothed version of the finger model. Clearly visible are, especially on the underside of the finger, the voluminous areas between the joints, bordered by the joint creases. This is the location of the muscles that give the fingers the ability to move.

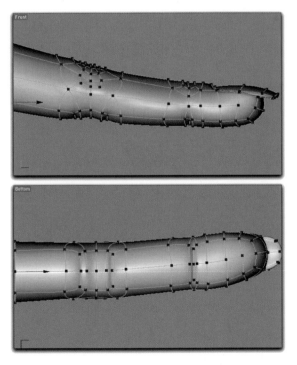

Figure 4.12: The smoothed view of the finger

Also take note that the last portion of the finger, meaning the fingertip, is modeled to appear very soft and voluminous. This prevents the finger from appearing too pointy.

4.1.3 Remaining Fingers

As mentioned at the beginning, the fingers differ mostly with regard to thickness and length. The basic construction of each finger and the proportion of the segments between the joints, with relation to the overall length of the finger, are the same.

Therefore, we can use the modeled finger as a base for the remaining three fingers. I deliberately exclude the thumb since it contains a different order of joints and even lacks one near the tip.

But even with the thumb we will use parts of the basic model of a finger and save ourselves a little work.

We start by duplicating the existing finger and moving the new object so it fits the sketch of the index finger. The profile of the middle finger and index finger are almost identical. Therefore, when changing the size, only the length should be changed.

Because the fingernails stay the same, regardless of the length of the fingers, reducing the length of the fingers should be achieved by shortening the segments between the joints.

As a basic rule, the shorter middle segment of the index finger, compared to that of the middle finger, makes the difference in length between these two fingers. By comparison, the ring finger has a shortened segment between the hand and first joint.

With the little finger, the first two segments are shortened, meaning the segment between the hand and the first joint, and the one between the first and second joints. Keep this in mind when copying and

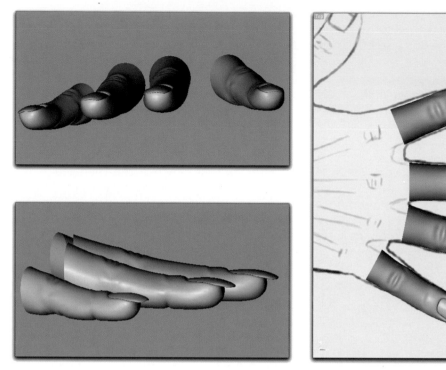

Figure 4.13: Scaling and placing the finger copies

scaling duplicates of the basic finger. Also use the image templates, which show the length of the fingers when viewed from above, as a guide.

After a first rough placement, correct the shape of the fingers. As mentioned before, fingers are seldom completely straight. Rather, the fingers, when placed next to each other, angle toward each other, especially at the fingertips.

When considering the palm of the hand as the base, the overall shape of the fingers looks like a triangle. The fingers don't just run straight out of the palm.

In addition, the fingers, with their complex joints and tendons, follow, at their base, the curve of the rounded shape of the back

of the hand. The fingers therefore vary in height as well as in length.

As can be seen in Figure 4.13, the fingers form a soft curve. It is important to consider this so the hands don't appear unnaturally stiff.

This curve is continued on the side toward the thumb, which we still have to add and which, of all the fingers, has the most space in which to maneuver.

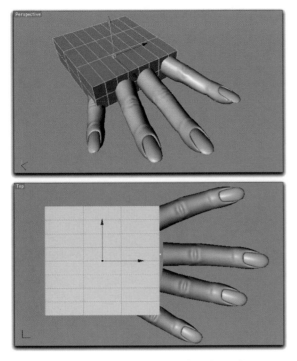

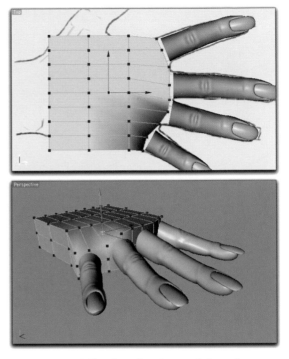

Figure 4.14: A cube as the base for the palm

Figure 4.15: Adjusting the shape of the cube

4.2 Palm Object

Before the missing thumb can be added, the basic shape of the hand should be created. This contains the back and the palm of the hand. These faces connect the fingers to each other and end at the wrist where the forearm connects.

In order to keep to a minimum the number of faces connecting the hand to the arm, the number of faces at the wrist, where the forearm connects, should be reduced.

We start with the modeling of the basic shape of the hand. The object to use would be a basic cube, as shown in Figure 4.14.

In order to have enough faces available to connect the fingers, the cube should have eight subdivisions in its width, three in its length, and two in its height. This results in four polygons for each finger on the front surface.

Move the points at the front surface of the cube so that a small gap remains between the fingers and the cube.

In the side view adjust the position of the faces of the front surface so four polygons are centered behind the open end of each finger cylinder.

This results in a slight bulge of the back of the hand, as can be seen in Figure 4.15.

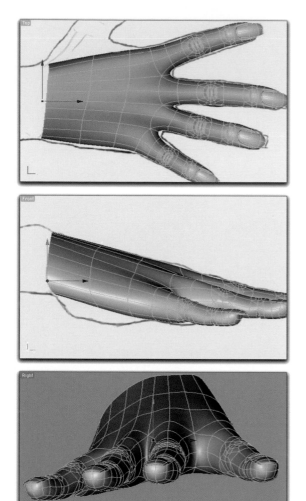

Figure 4.16: The smoothed version of the cube with the connected fingers

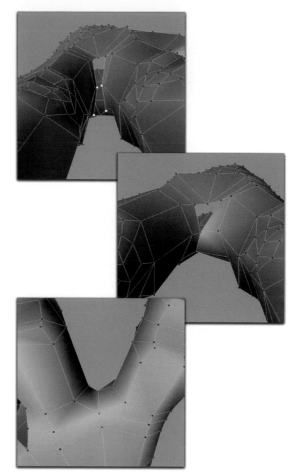

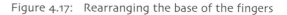
Figure 4.17: Rearranging the base of the fingers

Then unite the fingers and the new cube to a single object so we can create connecting faces between the separate elements in the next step.

Delete the polygons at the wrist and finger ends of the cube so a flat square tube is created. The fingers can now be connected, on top and bottom, directly to the now open edge of the cube. Simply merge the lateral points between the fingers, as can be seen in Figure 4.16.

Add another subdivision to the transition between the fingers and the hand, at the base of each finger. This prevents this area from appearing too pointy.

Then delete the faces that previously connected in the middle. The result is an opening as shown in Figure 4.17. Combine the middle and lower points of the edge

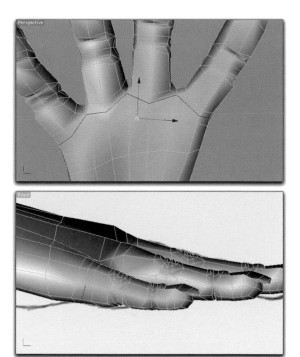

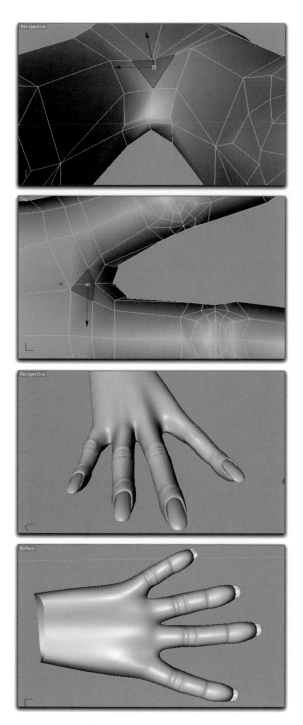

Figure 4.19: Edge selection at the underside of the hand

Figure 4.18: The new finger base

of the opening. These points are marked in white in Figure 4.17.

With the help of a new quadrangular face, the remaining hole can be closed. This face is marked in red in Figure 4.18.

Part the edges in the area between the fingers, as shown in Figure 4.18. This area represents the skin that looks like a web when the fingers are spread apart.

The connection of the fingers is now complete for the upper part of the hand. However, a look at the underside of the hand reveals that contours are missing. The fingers appear to simply grow out of the hand without creases, which indicate the joints above them.

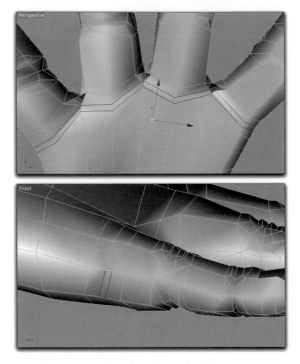

Figure 4.20: Parting the edge selection

Also, there is still a lack of subdivisions that could create these details sufficiently.

Select these edges at the underside of the hand, where the fingers connect. Expand this selection to the middle of the edge of the hand and to the area between the index finger and the still missing thumb. Figure 4.19 shows the path of the edge selection in red.

Double or part these edges to get two parallel edges. Figure 4.20 shows the result of this action in red.

Then delete the connecting faces in the area between the fingers. The resulting gaps are also shown in the image above.

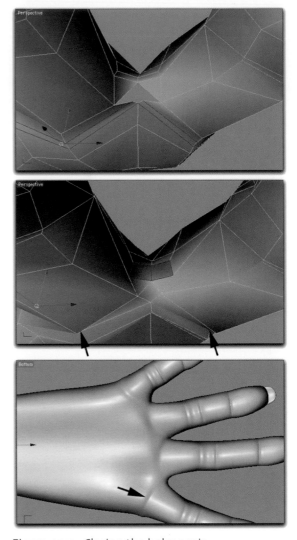

Figure 4.21: Closing the holes again

Close these holes with new faces, as shown in red in Figure 4.21. These faces can be used to further shape the skin between the fingers.

The newly created edge is then moved upward toward the finger knuckle and thereby creates a crease, as shown with arrows in Figure 4.21.

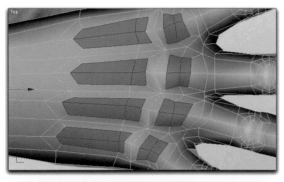

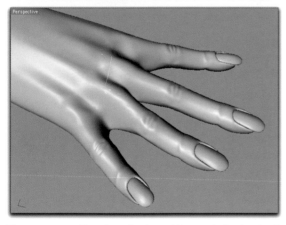

Figure 4.22: Shaping the knuckles and the back of the hand

4.2.1 Back of the Hand

Depending on the position of the hand, the back of the hand can be flat or, when making a fist, is shaped by knuckles. It also shows tendons when the fingers are spread.

We will discard blood vessels for now. These can be added later with a texture, just as long as they are not so defined.

However, even if knuckles and tendons are not to be very pronounced, the subdivisions should still exist. This gives you the freedom to attach these details to certain positions of the hand when, for example, morphing the surface.

Generally speaking, just a few faces have to be added since only the surface is raised slightly. Therefore, select four polygons on top of each knuckle and an additional four polygons between each knuckle and the wrist. Extrude these faces and scale the results slightly. The corresponding faces are marked in red in Figure 4.22.

Depending on the desired definition of this area, move the knuckle faces upward. The faces for the tendons should be raised down the middle so only small segments protrude. Reverse this in the middle of the hand so the tendons disappear completely under the skin again, keeping this effect more subtle.

It is important that the tendons not remain parallel, but instead move closer to each other as they head toward the wrist.

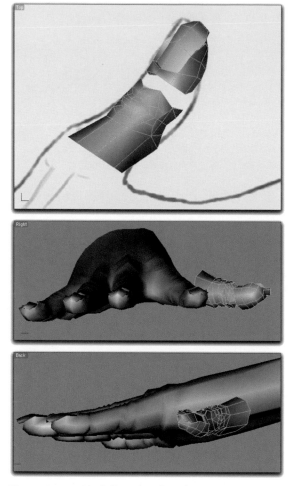

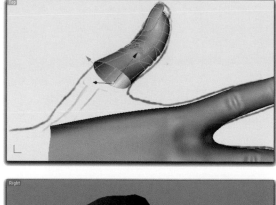

Figure 4.24: The assembled thumb

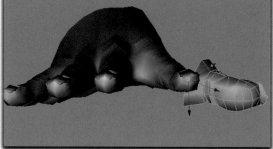

Figure 4.23: Modeling the thumb

4.3 Thumb

Now we get to the thus-far-disregarded thumb. It has, as we can see on our own hands, one less joint and is more compact and thicker than the other fingers. Nevertheless, we will reuse parts of the existing fingers.

For that reason, separate a copy of a complete finger from the hand. Keep the complete tip of this finger, including the nail and the first segment with the joint.

Move the two remaining segments of the finger toward each other until the length of the thumb is achieved. Increase the circumference of the object to create the thickness of the thumb. The upper image of Figure 4.23 shows this end result.

Rotate the thumb around its length axis until the side of the fingernail points upward. Make sure that the base of the thumb follows the curve of the other fingers.

Then connect the two separate segments of the thumb with each other, as shown in Figure 4.24.

In addition, widen the opening of the thumb above the joint. Then delete the faces along the side of the hand next to the index

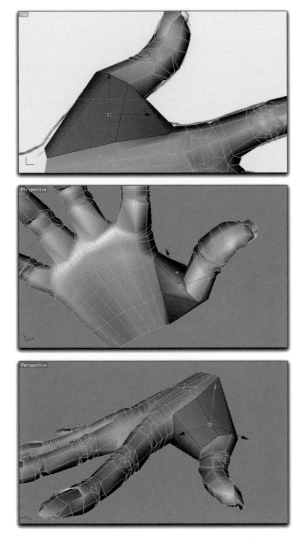

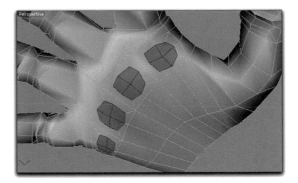

Figure 4.26: Thickening of the underside of the hand

4.4 Adding Details

The basic shape of the hand is now recognizable, but there are still details missing from the transition of the thumb to the hand and from the underside of the hand.

We will start with adding volume to the base of the fingers. The extrusion depends on how meaty the hand should appear.

The extrusion should be a little on the lighter side, since it is a female hand. With a male hand this area could be more pronounced, since calluses often appear there.

Figure 4.26 shows in red the resulting polygons after the extrusion.

Depending on the shape of the hand, this area could be extruded as a continuous strip and not separately above each joint. This can also help to border the lifeline that begins at the edge of the hand.

Figure 4.25: Connection between hand and thumb

finger and create new connecting faces that connect the thumb with the hand.

These faces marked in red can be seen from different perspectives in Figure 4.25.

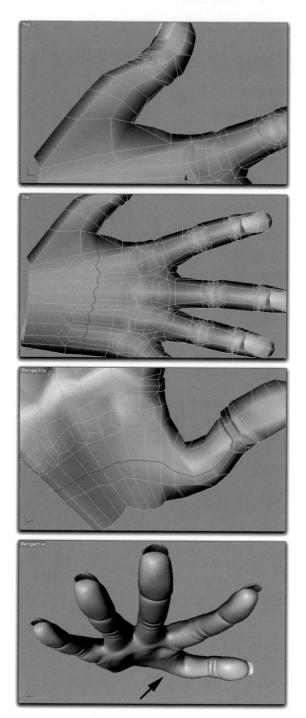

4.4.1 Muscle at the Base of the Thumb

So far, the palm of the hand does not have enough subdivisions to show details like single lines or to model the bulges. Therefore, we will add a continuous subdivision in this area.

As you can see in Figure 4.27, the path of this cut goes through the polygons on the back of the hand, continues to the base of the thumb, and through the crease at the joint. At the inside of the hand, the cut curves again in the direction of the palm and connects at the edge with the starting point of the cut.

Add a continuous cut at the base of the thumb, as can be seen in the top image of Figure 4.27. Use these new faces to better control the shape of the thumb in the area of its base.

Move the new edges of the inside of the hand, in the area of the ball of the hand, downward. This spot is marked with an arrow in Figure 4.27. The goal is to simulate the bulge of the thumb muscle in the palm.

The characteristically round shape of this muscle is still missing. The points in this area need to be moved in order to restrict this area. Figure 4.28 shows this step.

Figure 4.27: The bulge at the base of the thumb

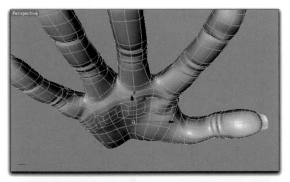

Figure 4.28: Shaping the muscle groups of the underside of the hand

In Figure 4.28 you can see how the additional points and edges, created by the last cut at the base of the thumb on the underside of the hand, were moved in the direction of the base of the fingers.

A similar movement is also necessary in the area of the outer edge of the hand. Located here are larger muscles that bulge out from the palm of the hand.

Between these two "hills" the palm recedes slightly and creates a dent. In the center image of Figure 4.28, you can see this dent at the location of the thin red arrow of the coordinate system of the hand.

Use the faces located between the wrist and the previously moved edges to shape the described muscle groups. In an unusual view, originating from the wrist, the volume of these muscle groups and the resulting dent in-between can be seen very well.

In the next step we will refine the transition to the thumb. Here too is the characteristic stretching of the skin when the thumb is spread out, as we have already modeled between the other fingers.

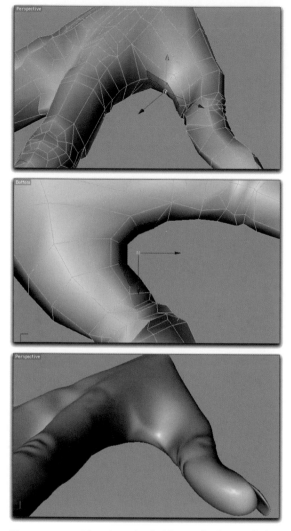

Figure 4.29: The stretched skin at the base of the thumb

Select the connecting faces between the thumb and hand and extrude them. Slightly shrink this polygon group and pull these faces slightly outward.

The image series in Figure 4.29 shows these extruded faces in red. As can be seen in the last image of the series, a nicely defined web of skin has been created.

Figure 4.30: Emphasizing the muscles of the thumb

Additional details should be added to the palm if this part of your 3D character is to be visible very often. A reason for this is that the muscle at the base of the thumb should have a more visible border at the wrist and at the center of the palm.

This is accomplished by extruding all faces and then shrinking the new polygons. Figure 4.30 shows the corresponding selection in red. Use the newly created points at the edge of these faces to create a crease at the wrist and in the center of the palm, as shown in the lower image of Figure 4.30.

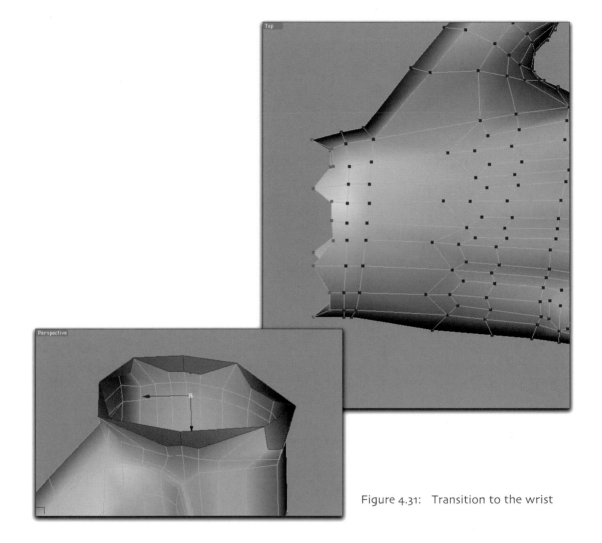

Figure 4.31: Transition to the wrist

4.4.2 Wrist

As mentioned before, the faces in the area of the wrist should be reduced so fewer subdivisions transfer into the structure of the forearm.

First, extrude the oval edge at the open end of the hand, doing this twice. These additional subdivisions are necessary so the hand can later be bent at that spot.

Then pull out, a little bit, every third point at the open edge of the wrist. A zigzag structure is created, which can be seen in Figure 4.31.

This irregular shape allows us to create quadrangular polygons in the next step. These again create a closed and smooth edge. These new faces are highlighted in color in Figure 4.31.

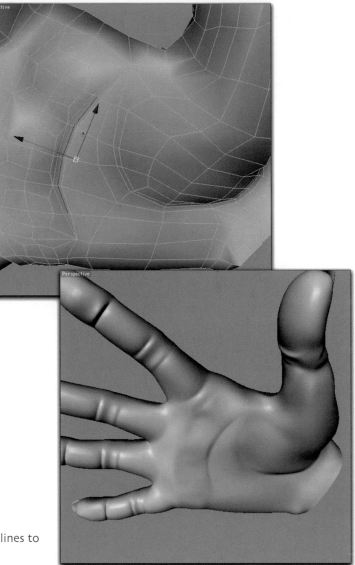

Figure 4.32: Adding lines to the palm

As you can see, the shape of the object has not been changed, but the number of polygons at the wrist has been reduced to just eight.

Simple parting of edges can be used when more details are needed on the palm. Figure 4.32 shows an example.

However, this can only work without problems when the edges already run in the direction of the desired creases. Therefore, pay attention to the structures of the palm during modeling.

This concludes this complex step, and we can now take a final look at the finished model (Figure 4.33).

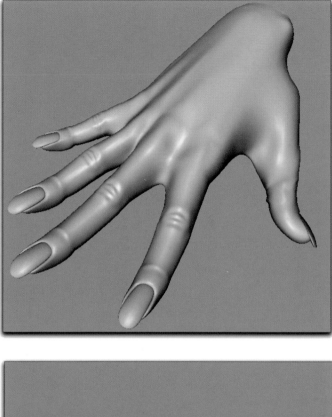

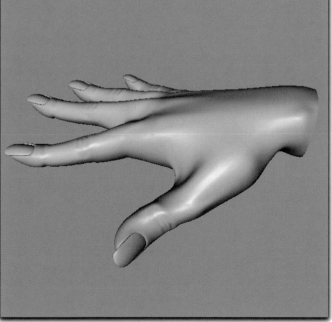

Figure 4.33: The finished hand model

Texturing and Lighting

We have finished modeling the head and the hand. The other hand can be added by copying or mirroring it. Deformations allow us to create individual positions of the hand. We will talk more about this subject later. First, we have to prepare the objects for texturing.

5.1 Working with UV Coordinates

In order to connect images or shaders to the 3D object that the properties of the surface respond to when it is deformed, we have to assign UV coordinates.

UV coordinates could be seen as a two-dimensional reference system. Since the smallest units of a 3D object, the polygons, are just flat objects, their corner points can also be described in a two-dimensional system.

In order to do this, these polygons have to be flattened onto a two-dimensional plane. This procedure is also called "unwrapping an object."

Don't be deceived by the terminology and the following images. The actual geometry of the object remains untouched. The goal is only to assign two-dimensional polygon coordinates to the polygons. There are different tools available for this within the 3D program.

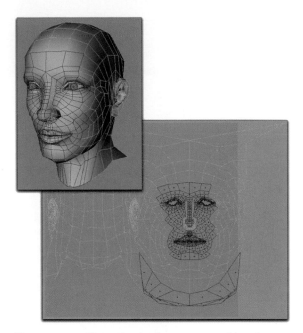

Figure 5.1: The spherically unwrapped head

The goal is to unwrap the selected objects, resulting in pieces that are as big and connected as possible. Therefore, there are standardized functions that can unwrap objects cylindrically or spherically. Figure 5.1 shows an example of a spherical unwrapping of our model head. As you can see in the bottom image, the polygons are already aligned on a plane.

Because of the spherical unwrapping, there are distortions of the UV coordinates, such as under the chin. This affects all parts of the object that stand up vertically or point down.

The cleanest way of unwrapping is to unwrap segments of the object and later combine them into a single group.

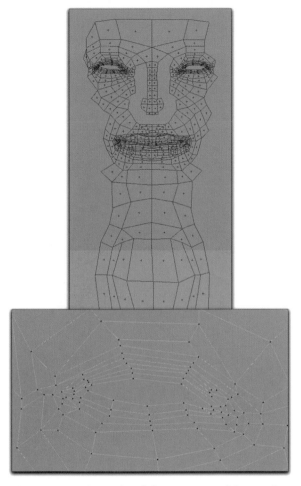

Figure 5.2: Example of the unwrapped front of the head

Figure 5.3: Straighten out inserted polygons

For that purpose, select all polygons of the face and the front part of the neck that are in about the same vertical plane when the model is seen from the front. These faces are then unwrapped as one plane. The few faces that are perpendicular to this plane, like the ones under the chin, are unwrapped manually and copied into the remaining gaps of the unwrapping.

The result can be seen in Figure 5.2. A connected strip is created, which contains planar polygons, from the forehead to the neck.

As can be seen at the eye in Figure 5.2, all UV polygons have to be moved so all creases and overlaps disappear. Every area of the model has to be clearly visible.

Continue to add the still-missing surfaces, such as those on the side of the nose. Be sure that every UV face has about the same size as

those in the real 3D model. Otherwise, there could be distortions in the texture later.

Then unwrap the sides of the head to a plane as well, and connect these newly straightened UV polygons with the corresponding areas of the front part of the face. The result now looks like a mask.

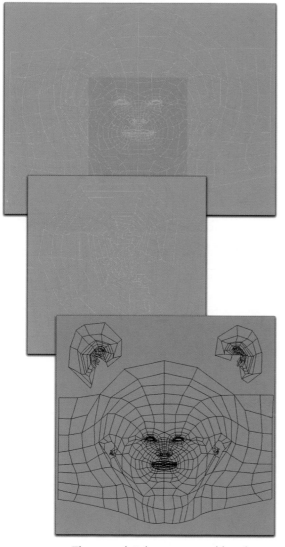

gure 5.4: The completely unwrapped head

This kind of unwrapping creates edges where a UV polygon group ends and begins again on the other side of the head. Also, there are usually areas that can't be easily integrated into the main group of the unwrapped mesh.

A typical example is the ears or the inside of the mouth. These features protrude out of the main mass of the object and consist of such a high number of subdivisions that the space available at the main unwrapping is not large enough.

Such components are often separated completely and unwrapped in another location. This can be seen in Figure 5.4, which shows an example of the ears I have placed above the unwrapping of the head.

Generally speaking, the rule for unwraps that will be placed separately is to place their edges in locations where they will not be as noticeable on the finished model. In this case, the hair will cover a possible edge. The edge of the ears will be covered because they are in the back by default.

As for the UV coordinates, it is good to note that their value ranges between 0 and 1 in most programs. This is true for both axis directions.

This means that the unwrapped polygons need to fit within a square having an edge length of 1. Most of the time, the UV editing programs provide guidelines to define the allowable area of the UV coordinates.

Contrary to the time-consuming manual unwrapping of the UV coordinates, there are also automated solutions. Here, faces are automatically separated from their neighboring faces and placed, aligned facing front, next to each other.

Figure 5.5: Unwrapped hand

Figure 5.5 demonstrates this technique with the example of our hand model. It is clearly visible that the top and bottom part of the hand remain as mostly one area.

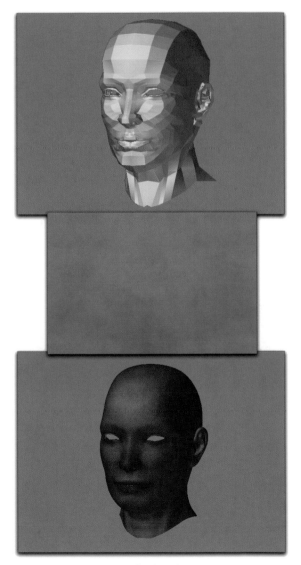

In a technical sense this is the cleanest solution, since the proportions of the faces are perfectly preserved. Unfortunately it is then almost impossible to guess, based on this puzzle of faces, which face represents what area of the object. Painting directly onto these scattered faces would be very difficult.

In addition, because of the number of open edges (every polygon has three to four edges without neighboring faces), it could result in visible jumps and gaps when the textures are assigned.

A good compromise would be the automatic unwrapping of connected segments to be as large as possible. In this procedure the angles between the polygons are analyzed and, when the angles are similar, these polygons are unwrapped together.

Figure 5.6: Painting the head

5.2 Painting the Objects

In the end, it doesn't matter which technique is used for UV unwrapping. It is only important that all faces are visible for the material projection.

In the following steps we will paint our models. There are many programs and techniques available for this.

If your 3D program does not provide tools for painting directly onto the object, a screenshot can be taken of the unwrapped UV coordinates. In Photoshop this screenshot can be painted on directly.

Here it is essential to see, based on the shape of the UV coordinates, which part of the object is currently painted.

The finished image can then be loaded again into the 3D software and placed onto the model with a material. The painted faces and the surface are then a perfect match.

It is more direct and much easier to paint directly on the 3D object. There are many special programs available, such as ZBrush (www.pixologic.com), Deep Paint 3D (www.righthemisphere.com), or Bodypaint 3D (www.maxoncomputer.com). There are also solutions that are integrated into the 3D software.

Generally speaking, painting in 3D is similar to painting in 2D. The only difference is that the canvas is a three-dimensional object that can be painted and viewed from all around.

The following section is based on the software ZBrush, but it can also be found in a similar manner in all the other programs (see Figure 5.6).

First the object to be painted has to be imported. Generally there are enough import formats available so at least one of them will be supported by your 3D software. In addition, ZBrush has the ability to paint and deform the object at the same time.

Since our head model was modeled with sufficient details, we can restrict ourselves to the coloring and the painting of small skin irregularities like creases and pores.

I start by blurring the front view of our reference image and then painting or stamping the parts that don't belong to the skin on our face with skin color. These areas are the eyes, nostrils, hairs, and all highlights and shadows.

What remains is an image with medium skin color. This can be used as a base for further editing. This way, we already have a relatively natural base coloring as a background image. Figure 5.6 shows this color map in the middle.

Vary the skin color toward red and blue/violet for purposes of tinting separate areas of the face.

The areas under the eyes, the tip of the nose, and the ears should be tinted more red. At spots where the blood vessels are closer to the skin, like the area of the neck or the jaw, it should be more bluish.

This shouldn't be done in a larger area, but rather in a more loose way. Generally, there are many brush tips available.

In Figure 5.7 there are close-ups of several areas with the tints I have chosen. All this concerns just the pure coloring of the skin. Don't try to add shadings or highlights. These

variations in color value are calculated later by the 3D software, based on the lighting.

The functions of your 3D paint software determine how the irregularities of the skin can be added. In ZBrush this can be done with the same paint tools as the ones we used for the painting of the color. In addition, the effect can be seen instantly in the 3D viewport. If this is not possible in your software, save the color map as

Figure 5.7
Details of the coloring

a TIFF or JPEG, and then apply 50% of this map as a base color to the object. Add lighter gray tones where the skin bulges outward, and darker tones where the skin is recessed. This way the fine creases and faces can be created as dark lines.

The job is made even simpler when complex patterns like pores already exist as grayscale images. These patterns can then be stamped directly onto the skin.

The more distinct lines, which should definitely appear, are the lower eyelids, the laugh lines, and the deep lines on the lips.

Finer details only make sense when they are shown in close-ups.

Besides the previously saved color texture, this grayscale image of the surface structure provides you with either a bump map or normal map.

The latter map form can be seen in Figure 5.8 on the left. This color coding of the surface alignment has to be calculated by the 3D paint program and can't be randomly painted by hand.

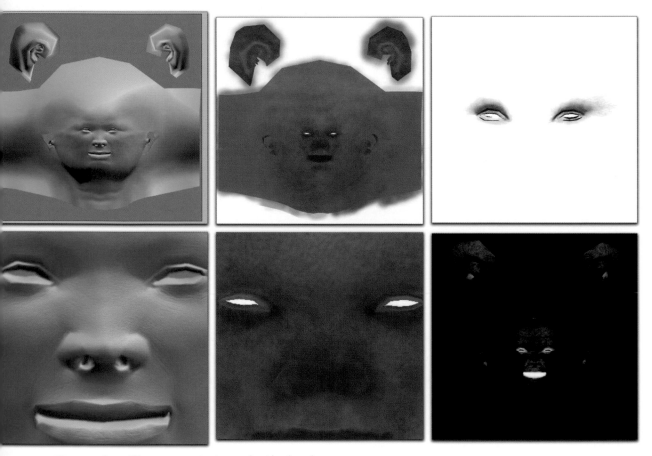

Figure 5.8: All necessary textures for the head

If the possibility of calculating a normal map isn't available, save the grayscale image instead.

Create another texture the same way, again only with grayscales, but this time with black as the base color. Brighten up all areas that are supposed to reflect a lot of light. These can be wet spots, like the lips or the edges of the eyelids, or greasy spots, like the nose or the forehead. This texture can be seen in Figure 5.8 on the bottom right.

A grayscale map can also be helpful that only emphasizes the area around the eyes, where the makeup should be applied later, with different shades of gray. That way the makeup doesn't have to be painted directly into the skin texture, but instead it can be applied separately over this mask. This makes it much easier to control the intensity and color. The mask can be seen in Figure 5.8 on the upper right.

For the head there are now four different textures available: one image for the color, one for the alignment of the normals or bump rendering, a grayscale image for the definition of highlighted areas, and an additional map for the makeup on and around the eyes. We will talk about another texture, which is still missing, in a moment.

First repeat this whole procedure for the hand model. Here you don't have to be so careful. A color map is enough. You could add a bump texture for the fine creases on the knuckles, but I will skip that step. Since I want the hand to be in a bent position, these creases will be mostly smooth anyway.

The highlight properties are also not that different so as to justify a separate texture. This would only be necessary if sweat, which

builds up much more on the inside of the hand than on the back, were to be portrayed.

Only the fingernails have much different color and highlight properties. We will apply a different material to them to have better control over their appearance. That way, for example, the color of the nail polish can be changed much easier.

Figure 5.9: Unwrapping of the painted hand

The resulting unwrapped color map of the hand can be seen in Figure 5.9. It shows how difficult it would have been to paint directly on the UV polygons. The investment in a specialized program for painting 3D objects is definitely worthwhile.

5.3 Blending Objects

As you certainly discovered when painting the objects, it is much easier to paint easily accessible places than folds, cavities, or other tight spots. For that reason, most 3D models are modeled in a neutral pose in which the arms are stretched out to the side and the fingers are outstretched as well.

When the model has been painted, it can then be put into the desired pose. For this purpose the so-called bone objects are used and work like virtual bones or joints inside the 3D model. Figure 5.10 shows these bones as long green objects.

Every bone is then assigned to an area of the model that will surround it. This procedure is called rigging or weighting. The image series

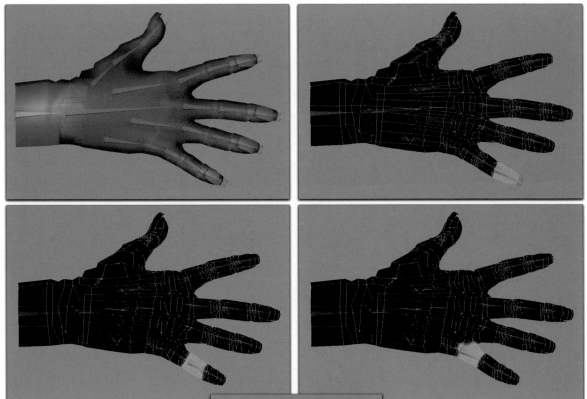

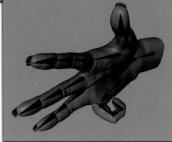

Figure 5.10: Bone deformation

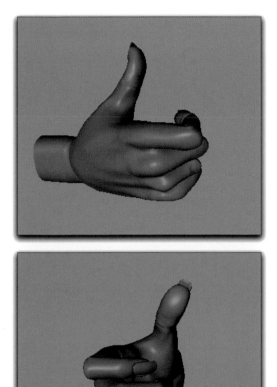

in Figure 5.10 shows this with the example of the little finger. When all bones are assigned to the corresponding segments of the 3D object, rotating the bones can then move the finger.

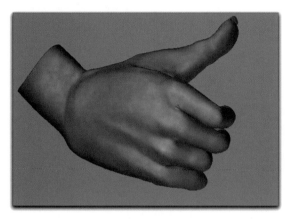

Figure 5.12: The color texture moves with the deformed hand

After all the fingers have been set up like this, a pose such as the one in Figure 5.11 can be created with ease.

Because of the edited UV coordinates, the painted texture follows the changes of the fingers. An example is shown in Figure 5.12.

The pose of the second hand can be identical so the work of weighting and rigging has to be done only once. Simply duplicate the posed hand and mirror it so the thumb is positioned on the anatomically correct side.

Our character consists only of the head and hands so far, but the head should be able to move too. This is done the same way as with the hands. Add several bones following the real-life structure of the joints, including bones of the neck and head.

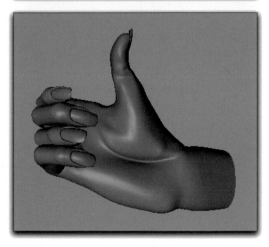

Figure 5.11: The new hand pose

Figure 5.13: The bones in the head model and the eyelids

Then assign the appropriate areas of the head model to each of the bones. It should be enough to create two groups, one for the head and one for the neck. After all, it should be possible to just slightly tilt or rotate the head.

In addition it could be helpful to add a bone to each of the eyelids. These bones should be placed exactly in the center of the eyeball. The lower edge of the upper eyelid is weighted to the bone so rotating the bone can then close the eye.

In the lower image of Figure 5.13, the weighting is highlighted in yellow. It allows us to influence expressions very easily. The weighting could also be used at the jaw and the lips. This technique can be applied anywhere a joint deforms an object in a circular path.

Linear movement of the surface can be achieved more precisely through morphing, which means animating the points of an object.

This is just a rough overview since animation is handled differently in each 3D program.

It should be enough for us to be able to put the hands into any pose and to slightly move and rotate the head.

Before we start assigning the created textures, I'd like to add the hairs around the eyes. You will quickly see what an influence this little detail has on the overall expression of the face.

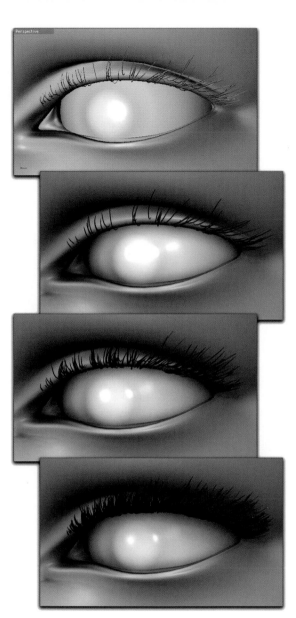

Figure 5.14: Adding the eyelashes

5.4 Eyelashes and Eyebrows

Many 3D programs have the ability to generate hair, so I will talk about that function as well. The concept is always similar. First, certain areas of the 3D object are selected that should receive hair or fur.

We will start with the eyelashes. Select the slim polygon strip at the front edge of the upper eyelid. Then activate the generation of guides on these faces.

> Guides: These are splines or curves that can be shaped with special tools. Often, larger groups can be combed in a certain direction with comb or brush tools. Generally, collision detection can be activated as well between guides and 3D geometry. This prevents the guides from entering the object when being edited, since the hair shouldn't protrude into the skin.

Depending upon the complexity of the hair simulation, often only a few guides are needed. These guides do not represent the hairs themselves but act only as a guide for their interpolation. The hairs align to the guides in their vicinity.

This has the advantage that the density and number of hairs can easily be determined without having to create a new guide each time. Figure 5.14 shows an example of this effect. You can see how the number of lashes can be varied.

Additional setting possibilities include the thickness of the hair and, of course, their color. Concerning the coloring, you can't go wrong with either a dark brown or even black. Also note that the upper lashes are thicker than the lower ones.

Do the same to the eyebrows and lower eyelashes.

objects. This can be deactivated for the eyelashes and eyebrows. These hairs are too short or are too close to the object to respond to such effects.

Figure 5.15 shows a possible result after creating the eyebrows.

In addition to the color and density, and contrary to the eyelashes, the shape plays an important role.

Figure 5.15: The eyebrows

Figure 5.16: Different facial expressions created by using multiple eyebrow shapes

Depending on the hair simulation, all these areas should be set up as a separate simulation so the color, length, thickness, and density can be adjusted individually.

The current hair simulations also provide dynamic effects, such as gravitation or collision detection with other polygon

With the eyelashes, this was determined by the edge of the eyelid. The eyebrows influence immensely the facial expression, because of their distance from the eyes and their slant, and therefore the impression that the viewer gets from the character. Just a small movement of the eyebrows can change the expression of the face to angry, surprised, sad, scared, or happy. Figure 5.16 show some examples.

Pick a neutral position for the eyebrows, one which fits the overall expression and the character in general. Note that most women pluck their eyebrows. The eyebrows then have a larger gap to the bridge of the nose and don't necessarily follow the same curve of the eye socket.

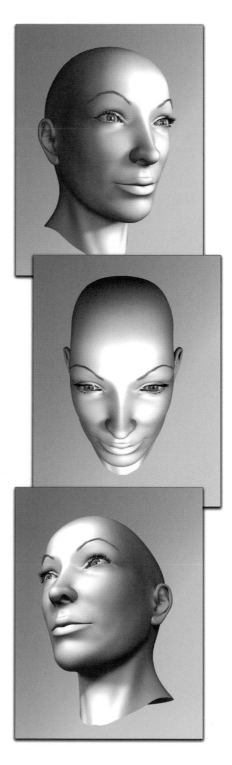

Figure 5.17: The head with eyelashes and eyebrows

5.5 Assigning Textures and Working with Materials

The material systems available are so different from each other that I can give you only general information about their structure. It can then be applied and adjusted to the system used by your software.

One common feature of all systems is the separation of surface properties into several channels. The color or diffusion channel of a material defines the coloring, the bump channel defines the surface roughness, and the specularity or highlight channel defines the highlight properties.

The art of realistic materials is to break apart the desired surface into its separate components and to determine the correct settings in each of these channels separately.

On the face we will start with the color channel. In order to have more control over the saturation of the skin, I first make a copy of the previously created color texture of the face. In Photoshop I then replace all areas that are too red with normal skin tone. Only the lips should remain untouched.

Now we have two textures for the skin, each of which represents an extreme state. One texture is very even and the other one is highly accentuated by the red coloring of the area around the nose, cheeks, eyes, and ears.

Depending on what possibilities your software offers regarding the mixing of textures directly on the object, create a mask that defines where and how much the textures are to be mixed at that spot.

This mask ensures that the areas around the nose, cheeks, and ears show more of the highly saturated texture, while the rest of the face has neutral skin texture. The mask

Figure 5.18: The two color textures including the mixing mask

allows us to correct the skin tone without having to change the textures again. It can also be used for animations, where a step-by-step change of the mask can shift from one material to the other.

Figure 5.18 shows, from left to right, first a neutral skin texture, then the mixing map projected directly onto the head in the middle image, and on the right the original saturated texture.

If there weren't certain properties of the skin that make further adjustments necessary, this could actually conclude the coloring of the surface.

Surely you noticed once before how red ears are when they are lit from behind or a fingertip when in front of a light. This coloring is mostly independent from the skin color and is caused by light scattering in the lower layers of the skin.

There, the light is colored red by the blood. This effect is especially prominent when light protrudes deep into the tissue and is able to exit again on the surface.

Such effects can be simulated with the so-called subsurface scattering calculation, or SSS. Here, the maximum protrusion depth into the object is determined and then combined with a color gradient.

Since this is a calculation-intensive technique, there are special solutions available for this effect that are made exclusively for skin and are implemented in the most-used 3D programs.

5.5.1 Light Scattering within the Object

In case you haven't already worked with the SSS effect, Figure 5.19 should help you to understand.

As you can see, there the effect depends on the direction of the light and the distance that the light travels within the object.

With increasing depth the light becomes weaker, yet at the same time, more and more saturated. As mentioned, this scattered color can be determined and doesn't necessarily have to match the color of the surface.

> SSS: The term SSS is an acronym for subsurface scattering, which stands for the scattering of light under the surface of an object. Many materials like plastics, marble, or skin can be rendered more realistically when this scattering is simulated.

In order to make the effect visible, two criteria have to be fulfilled. First, the lighting has to be set up so light travels through a part of the object before it gets to the camera. Second, the maximum depth of penetration has to be determined so it is in relation to the size of the object.

It will not make sense to raise this value to extremes in order to get the SSS effect under any lighting situation. Light, which travels from one half of the face to the other through the whole head, makes the head look translucent like wax. Only use the SSS effect as a supporting element and not as the main goal.

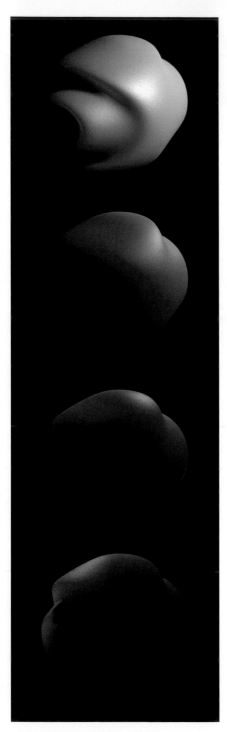

Figure 5.19: The SSS effect

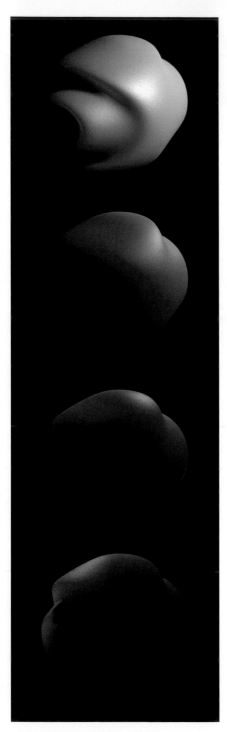

Figure 5.20: The definition of the SSS effect

Use masks when you want to partially increase the effect in order to have deeper penetration depths at the tip of the nose or the ears than the rest of the head. The concept is similar to the one we used for mixing the color textures.

Generally, the SSS effect is created with a special shader that works in the illumination or glow channel of the material. That way the surface can be lit where there is normally no light, such as illuminating shadows.

Depending on the way the shader works, different depths can be combined with textures to show the different layers of skin.

I will restrict myself to two textures, one for the upper skin layers, which will get a more saturated color texture, and one which defines deeper layers with different red tones. Both textures can be seen in Figure 5.20.

Figure 5.21: Setting up the lighting

As for the penetration depth of the SSS effect, the best way is to measure the thickness of the ears or the width of the tip of the nose of your 3D model. These measurements should give you a guideline as to the maximum penetration depth.

In the remaining material channels, the normal or bump texture is used for the bump effect and the highlight texture for the intensity of the highlight. A second material with blue coloring and the mask for the makeup is also applied. We can

comfortably control the intensity and color of the makeup this way.

The hands are textured the same way, yet the SSS effect is not as intense here. The color for the deeper skin layers can be just red.

5.6 Lighting

For the purposes of lighting, it first has to be determined what kind of mood is to be simulated. Is it a studio environment or an outdoor scene?

Based on the reference images, the character will be placed outside in a wintry landscape. This means that we will have one basic light direction—the sun.

The entire sky also emits brightness. This lighting will be the diffused light and we will deal with it at the end. The sunlight reflected directly from the ground can be more intense, especially when the ground is covered by water or, like in our case, partly with snow.

We will create these two lighting directions with two light sources: one for the sun and one for the reflected light. The virtual sun is placed slightly elevated, in the viewing direction of the 3D character. This light source is marked with a circle in Figure 5.21.

Across from the sun is a larger area that emits the indirect light. Both light sources will cast shadows, but are different in intensity and coloring. I kept the indirect light white, while the sun emits a slightly yellow light.

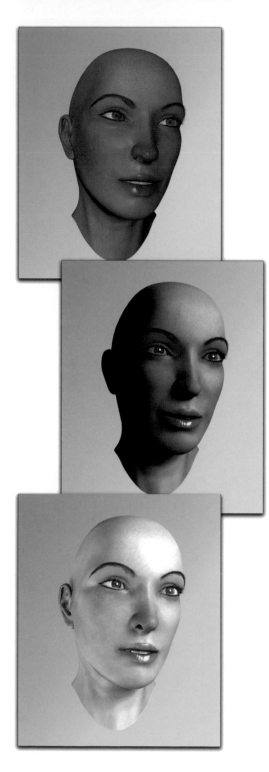

Figure 5.22: Lighting tests

In order to simulate the diffused lighting, I surround the objects with a large, invisible sphere and activate global illumination, or radiosity, for rendering.

This activation allows any object to reflect incoming light, which then illuminates other objects as well. The sphere captures the light beams that pass by the head and hands and reflects them back onto our models. The simulation of the light reflected by the environment is complete.

Let us look at these effects in detail in Figure 5.22. In the top image you can see the head as it looks with frontal, standard lighting and without shadows. The head looks flat and is lit unnaturally.

The same model looks much more alive with a lighting setup as shown in the center image of the series. Also note the details like the highlights of the eyes and lips, which positively add to the overall appearance. This is the lighting that is generated by our sun light source.

In the lower image you can see the activated diffuse radiosity lighting, including the effect of the light source, which is positioned across from the sun. The main direction of the sun remains, but areas previously in the shade are now lit.

It depends on you how strong the light sources will be. On the one hand, the sun should be recognized as the main lighting source. On the other hand, shadows that are too intense in outdoor scenes are unusual and should be balanced and softened by diffused and supporting light sources.

In Figure 5.23 you can see the lighting mood I have chosen. Only the two described light

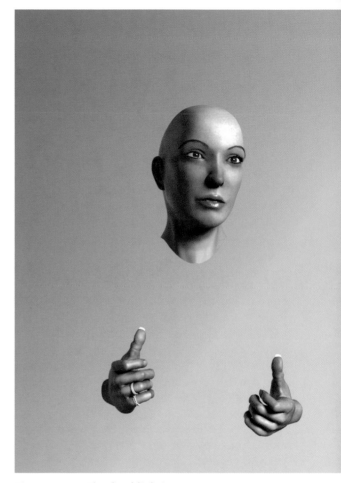

Figure 5.23: The final lighting

sources were used. In order to loosen up the symmetry of the hands, I added some simple ring models.

Clothing and Hair

All visible body parts are to be modeled and textured. In this workshop we will begin by working on the clothing. Then we will add the hair on the head and render the final image. This workshop will then be complete.

The character is supposed to wear a jacket that fits into a wintry mood. We also need a scarf and a simple T-shirt, like our model was wearing in the original reference images in the first workshop.

6.1 Modeling the Clothes

Since these are preparations for a still image, not all objects have to look good from all possible directions. It is enough when the character looks believable in the chosen camera perspective and that the incomplete part of the character is not revealed, for example, by the shape of cast shadows.

We will put the jacket together using single parts that are each easy to model. This way we don't need a complex cloth simulation that might not be available to each user of 3D programs.

Figure 6.1: Modeling the collar

Figure 6.2: Extending the basic shape

6.1.1 The Scarf

We will start the clothing with the scarf, which is held under the chin with a loop.

Create a simple polygon loop with about six to ten faces. Place these faces parallel to the neck and bend the shape to the back of the neck and to the chin in the front. The result can be seen in Figure 6.1.

Then extend the polygon row at the front so the shape resembles a tie. Figure 6.2 shows this shape from two perspectives.

Make sure at this point that the polygon strip twists and turns properly. The scarf is placed parallel to the neck, while it lies flat as it hangs against the body.

As you can see in the figures, we model only one side of the scarf. The missing side will be modeled from a separate object. This has the advantage that the knot, or rather the loop of the scarf, is easier to model. The fact that the scarf is not one object, and that it ends at the shoulder under the jacket, will not be noticeable.

When you are satisfied with the shape of one side of the scarf, add a new polygon strip. It can consist of only a few faces. In our case, two faces are enough for the first step.

Move the corner points of the new polygon strip so an acute angle is created between the faces. Then move this structure in front of the neck of the character, so that the first polygon strip runs through the V-shaped tip of the second object. Figure 6.3 shows this position and the shape of the new polygon stripe.

Figure 6.3: The second half of the scarf

This pointy shape will later be the loop through which the scarf will be placed. Add some vertical cuts to this object to get some new edges and points. Use these new faces to round the loop, especially at the spot where it goes around the other end of the scarf.

Be sure to keep a sufficient distance between the two scarf objects. The scarf itself will eventually have a certain thickness that we will add later.

Continue with both polygon strips as shown in Figure 6.4. The end on top travels around the neck and meets the beginning of the first scarf object in back of the neck. You can combine both scarf objects into a new object, if you like, and close the gap at the back of the neck. However, this is not necessary for our still image.

Figure 6.4: Continuing the second polygon strip

Add more horizontal and vertical subdivisions to both objects to further influence the shape. These additional small folds and creases help to build the natural look of the scarf. Figures 6.5 and 6.6 show the result.

Figure 6.5: Shaping folds and creases

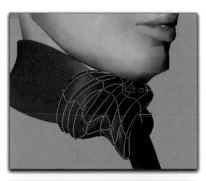

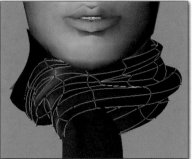

Figure 6.6: The shaped loop

When you are satisfied with the look of the creases and the path of the scarf, thicken both objects by means of extrusion to create the thickness of the scarf fabric.

Afterwards you might have to correct areas of the scarf objects where overlaps were created by the extrusion. The same is true for spots where large gaps remain between the fabric panels of the scarf.

Figure 6.7: The fringe

Figure 6.8: Folds on the loop

As can be seen in the reference images, the scarf has long fringe at the lower end. This can be created by extruding the end polygons. Depending on the amount of fringe, the number of subdivisions might have to be increased. The area marked in red in Figure 6.7 shows how this should be done. With this triangular structure a polygon strip can turn into two polygons.

Make sure that the entire fringe does not hang down the same way and that there is some variety.

Add some subdivisions to the width of the upper area of the hanging part of the scarf. This enables small creases and folds to be built at the loop.

The scarf is heavily constricted and its width dramatically reduced in this area (see Figure 6.8).

This concludes the modeling of the clothing and now it can be covered with an appropriate material. Based on the color of the scarf in the reference images, I apply a dark blue as the surface color. The highlight properties

Figure 6.9: The finished scarf with additional fringes

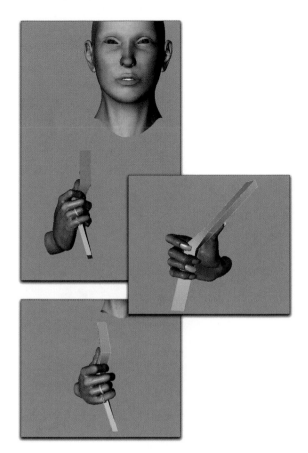

Figure 6.10: The seam of the jacket

should also be reduced significantly. It is, after all, a very rough surface.

The finishing touch will be added to the object by adding some very short, curly hairs with a fur or hair simulation. This will represent the wool scarf's typical fuzz and knots on the surface. Figure 6.9 shows the rounded result, including the fur, as a rendering.

6.1.2 The Collar of the Jacket

Start with a new object to model the seam and the collar of the jacket. A slim cube with some subdivisions along its length is suited very well for this.

Place the cube in the right hand of the character as shown in Figure 6.10.

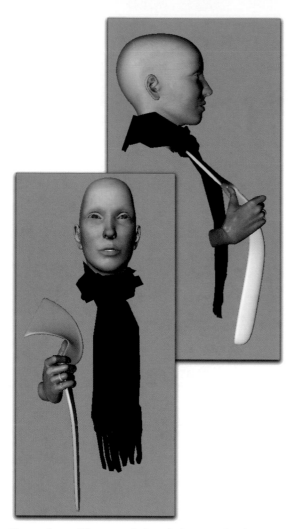

Figure 6.11: The rounded and elongated cube

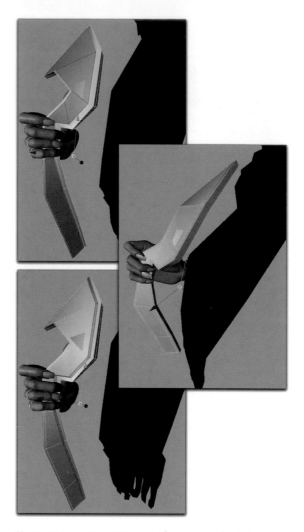

Figure 6.12: Transition to the material of the collar

Adjust the size and shape of the cube so that the object is as close to the fingers, and especially to the outstretched thumb, as possible. Then elongate this cube by extruding the top and bottom faces.

Expand the shape to the side on top, so a collar is created, and just continue the shape on the bottom. Be sure to bring the lower end closer to the body. The hands pull the

jacket to the front and away from the body in the upper part only.

Figure 6.11 shows the result.

In order to create a better transition from the inner lining to the outer collar itself, extend the polygons in front and shrink the faces slightly. This will support the smoothing of the object later on.

Figure 6.13: The collar

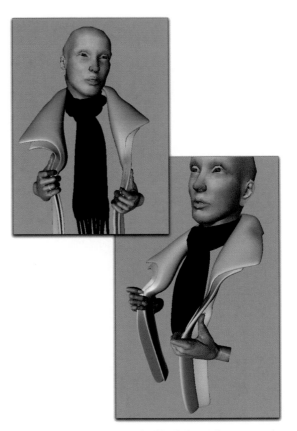

Figure 6.14: The second half of the collar created by mirroring it

Elongate and widen this shape, especially in the upper area, to model the collar. Extend it to the back of the neck, as shown in Figure 6.13.

As you can see there, it only needs a few faces to obtain this shape. The rest will be accomplished by smoothing the faces.

When you are happy with the result, duplicate both the collar and the lining objects, and mirror both of them on the other side of the character, as shown in Figure 6.14.

After that, widen the lateral polygon strip by extruding it a little. This will create a small polygon strip as seen highlighted in red in Figure 6.12.

Copy these faces into a new, empty polygon object. Then extrude these faces outward and, in a second step, to the side. This creates faces that run parallel to the modeled edge of the lining as it currently exists.

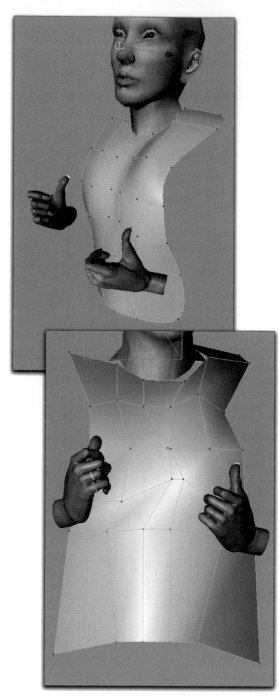

Figure 6.15: The stylized T-shirt

Adjust the path of both objects, especially in the left hand, so a believable appearance of the fabric is achieved.

The upper collar can be varied slightly. Mirroring the object helped us to speed up the process.

6.1.3 The T-Shirt

The T-shirt doesn't need extensive and complex modeling, since there will be only a small part visible. Along the side, the jacket covers the majority of the shape. In the middle there is the scarf.

We can concentrate on the few remaining visible parts and use a simple plane as the start object for the modeling. Roughly adjust this plane to the probable course of the upper body as it is shown in Figure 6.15.

It is important that the character remains as one piece from the viewpoint of the camera. This means that there shouldn't be any visible parts of the back of the jacket or even the background of the scene.

Be sure that the plane is neither too flat nor too vertical. The faces should move backward along the side of the waist, bending the surface. Otherwise the light could cause unnatural shading in this area.

Because of the large amount of covering, it doesn't make sense to create single folds or to model a more detailed version of the area above the chest. A slight bulge outwards of the surface is enough.

If necessary, correct the position of the scarf so it lies against the T-shirt in the upper area.

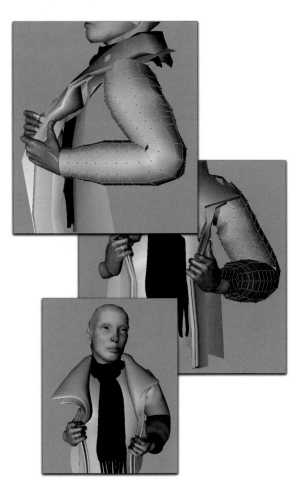

Figure 6.16: The arms

Figure 6.17: The area of the jacket

6.1.4 The Sleeves of the Jacket

The collar covers the area where the sleeve is sewn onto the rest of the jacket. Therefore, here we can work with a separate object.

Use a cylinder that has a high number of subdivisions in its circumference and along its height, making it easier to bend.

Bend the cylinder in the area of the elbow as it is shown in Figure 6.16. Taper the cylinder slightly near the area of the wrist. Copy and mirror this sleeve to the other half of the body.

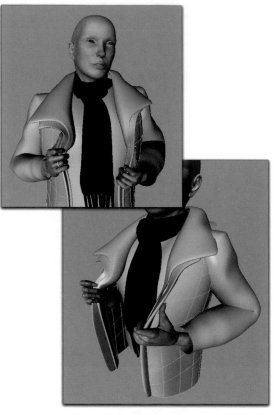

Figure 6.18: The completed jacket

6.1.5 The Remaining Jacket

Create a large cylinder that surrounds the body entirely (see Figure 6.17).

Open the cylinder in the front by deleting some polygon columns. Adjust the resulting edges to the shape of the lining so a closed surface is created that bends around the sides and back of the character.

Figure 6.18 shows the shape from two perspectives. As you can see in the lower image of the figure, the palms of the hands and the inside edges of the sleeves disappear

into the jacket a little. Possible shadows are not influenced negatively by that. This is acceptable because, for us, it is important that the scene looks right from the view of the camera.

6.1.6 Adding Details

So far the fabric of the jacket appears rubbery, since there are no folds at the bent arms. Of course these could be created by adding cuts to the arm cylinder, but it is easier and faster by painting them in, for example, ZBrush.

Figures 6.19 and 6.20 show the results for both the right and the left sleeve.

The sleeves are subdivided in ZBrush and the surface is deformed with diverse painting tools. With this method, the wave-shaped folds are created quickly, especially on the upper arm.

When this work is finished, the deformations can be rendered as a displacement texture and brought into your 3D program as a JPEG or TIFF image. If this possibility is not available, use another painting program and paint the lighter areas on the sleeves where the surface is supposed to bulge out. Then load this texture into the displacement channel of your material in order to deform the surface during rendering.

As you can see in Figures 6.19 and 6.20, the areas around the wrists and close to the shoulders were ignored so the deformation of the surface would not penetrate the surrounding objects.

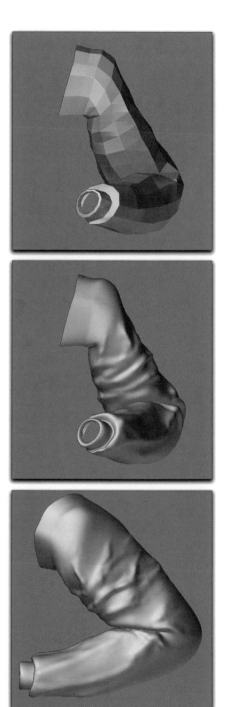

Figure 6.19: Painting folds

Figure 6.20: Painting folds

Figure 6.21: The stud

The Stud

The ear facing the viewer should receive a small stud. The small size of this object makes extensive modeling unnecessary.

As you can see in Figure 6.21, I use a cylinder as the base object and extrude four equal segments out of its upper cap. These create the mounting for the diamond, which I have modeled from a suitable basic object.

Generally, you could also use a sphere with highly reduced faces, so a similarly angled shape emerges.

Assign a metal material to the cylinder and a glass material with strong refractions and reflections to the gemstone.

Figure 6.22: A snap

The Snaps

In order to close the jacket in front we will add snaps. These are created from simple basic objects, as you can see in Figure 6.22.

Figure 6.23: The snaps on the jacket

A slight shift of edges on the cap of the basic cylinder creates the typical embossment.

Apply a reflective material to the snaps and create four to five copies. Place these objects, evenly spaced along the edge of the jacket as shown in Figure 6.23.

Across from the snaps place the same number of flat cylinders along the other edge of the jacket. These are the back sides of the receiver for the snaps. These objects should receive a dark material with slight highlights.

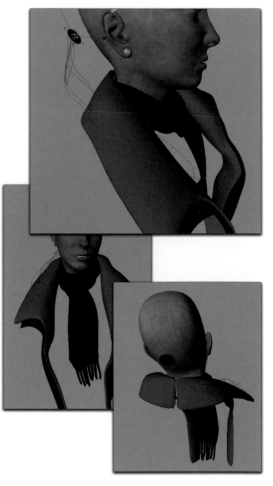

Figure 6.24: The ponytail

6.2 The Hair

Finally we will take care of the hair. We will start with the most difficult part, the ponytail. The hair should not simply hang down behind the head but instead fall forward over the shoulders.

Since hair generally needs polygons as a starting base, I create a small polygon disk and let some hair guides grow on it (see Figure 6.24).

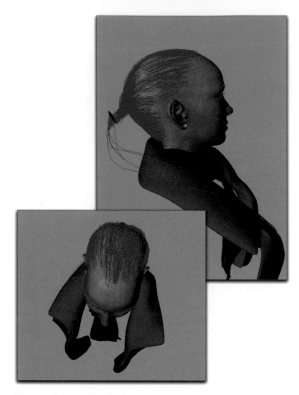

Figure 6.25: The hair on top

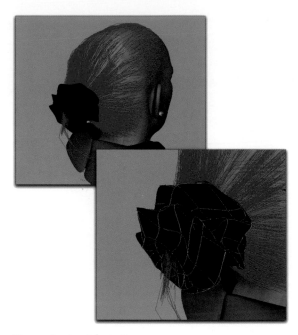

Figure 6.26: A hair tie

These guides, which will later control the direction of the hair, are created in a soft curve, first to the side and then forward over the right shoulder where they end on top of the collar.

Be sure that the guides aren't too close to the jacket or the neck. Otherwise, the generated hair, which has a certain volume, could possibly penetrate the surrounding objects.

Then let the guides grow on the head and the neck as shown in Figure 6.25. The hair can be guided backward around the head. Usually there are comb tools available that simplify this procedure.

Note how the guides run from the bottom up in the neck area. All hair will meet there where a hair tie bundles the hair and the ponytail begins.

This transition between the two hair groups can be covered with a slightly deformed cylinder, as shown in Figure 6.26.

In our example, this extra work isn't necessary since the rear of the head and the hair style is completely hidden.

More important is the base of the hair at the temples and the forehead. I created this area with several manually applied hair groups. This has the advantage that the thickness, curls, and color of this hair can be adjusted separately. This hair is highlighted in yellow in Figure 6.27.

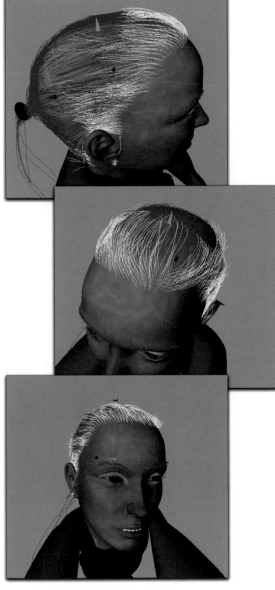

Figure 6.27: The front hairline

As you can see there, this hair has a medium length. It isn't necessary to extend this hair to the back of the head. Instead, make sure that the hairline is less uniform.

You can see in the middle image of Figure 6.27 how a parting of the hair is hinted at. With this arrangement, the hairs do not run straight back from the root.

In the area above the ears, hair is allowed to fall downward, slightly behind the ear. To some extent, the strands of hair should be divided and shaped separately from the surrounding hair. I did this with several hairs in front of the ear to loosen up the uniformity a little.

Using this method, add more hair groups that step-by-step move toward the forehead. This creates a multilayered hairline that can camouflage the otherwise evenly distributed hair simulation.

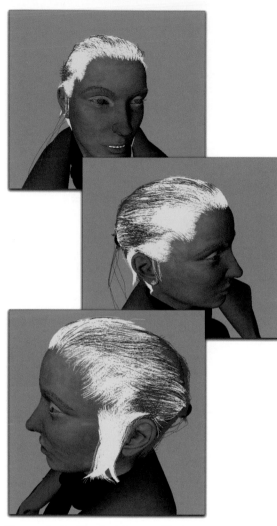

Figure 6.28: The last layer of hair

Figure 6.29: The finished scene

Figure 6.28 shows how my last layer of hair looks. You can see, on the left half of the face, a wide section of hair that comes down in front of the ear. This is not especially realistic, but it will frame the face when seen through the view of the camera later, and therefore look more realistic. Otherwise, in my opinion, the face would appear too serious.

To make the jacket look more wintry, I create very short and tight fur on the collar.

Figure 6.29 shows the finished character, and on the bottom, the additional hairs of the fur on the jacket in blue.

6.3 The Rendering

Now you can render the scene. The alpha channel should be rendered as well so the background can be exchanged easily.

Figure 6.30: The alpha mask

How such an alpha mask can look is shown in Figure 6.30. All areas that don't belong to the character are shown in black.

This information can, for example, be loaded as a selection into Photoshop. Then you can extract the character from the rendered image and place it in front of a different background.

Another useful addition would be the calculation of a depth map. It consists only of gray shades, but uses these for portraying different distances between the rendered objects and the camera.

Figure 6.31: The depth map

Objects that are farther away from the camera are lighter than the components that are in the immediate vicinity of the camera. This kind of calculation makes it necessary to determine at least two distances. Then

the gray shades can be divided between these two extremes.

The 3D program needs to know from which camera distance the gradient should start and where it ends. I chose these distances, deciding that the gradient should start at the eyes and that it should end at about the rear elbow. This way, we can use the entire spectrum of the gradient.

The gradient, as it is shown in Figure 6.31, can also be loaded as a selection and combined with a blur. That way, a depth of field is simulated. Figure 6.32 is the final result of this workshop.

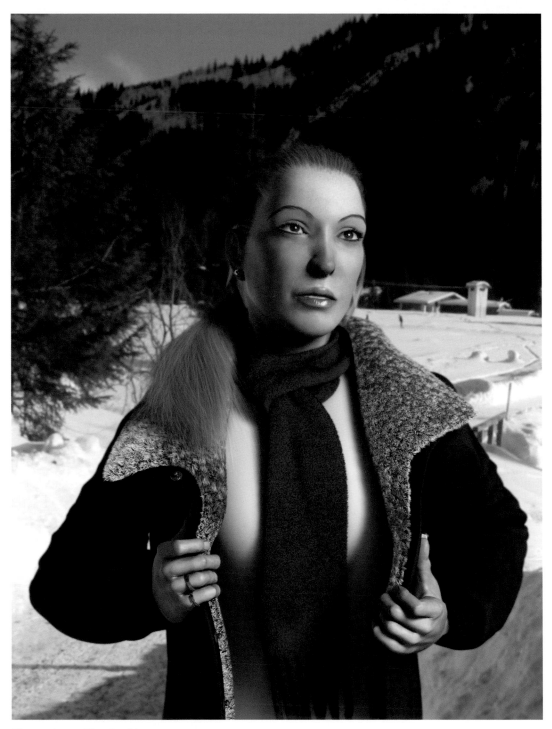

Figure 6.32: The final image

Modeling the Female Body

In the previous workshop only a few parts of the body were visible. The rest of the body was covered with clothing. In this example we will put the main focus on the modeling of the body itself.

7.1 Choice of Modeling Technique

Generally the same techniques can be used as the ones for modeling the head and the hands. As an alternative I would like to show in this example the so-called box modeling.

With this method the modeling starts with a simple cube, which is then subdivided and extruded to model it into the desired shape. The decision of whether one wants to work with poly-by-poly modeling, which is the step-by-step buildup of an object as it was done with the head, or the box modeling, is often just a preference.

The box modeling works from a rough model toward a more refined one, while the poly-by-poly modeling starts directly with the details and puts the pieces together one by one like a puzzle. Both methods have their advantages. Therefore, both methods should be taken into consideration when deciding which method is more suitable, based on the model. Of course, mixing both methods is also a possibility.

In any case the preparation, which is the search for fitting image templates, is the same.

In this example I will use whole body images that were provided courtesy of the Internet site www.3d.sk. Thank you very much to the site owners, Richard Polak and Peter Levinus.

Meanwhile, there exist thousands of high-resolution reference images of men and women of every age and stature. There are even movies with movement studies for perfecting your own animation.

These two gentlemen also offer another website especially for modeling female characters at www.female-anatomy-for-artists.com. The images are not free at these sites but it would be a worthwhile investment if you are modeling humans more often.

As an alternative, there are also free resources at the site www.fineart.sk, which are not of such high quality, but can serve well as a base for your own sketches.

I chose the model Sonia from the comprehensive assortment of images. Unlike the previous example, I don't want to create an exact copy, but instead use the images as a guide to keep the proper proportions.

We will therefore not use the images as often, but instead use them only to check the shape of our character. You could work with any images that you have created yourself or got off the Internet. The demonstrated techniques can be used with any body shapes.

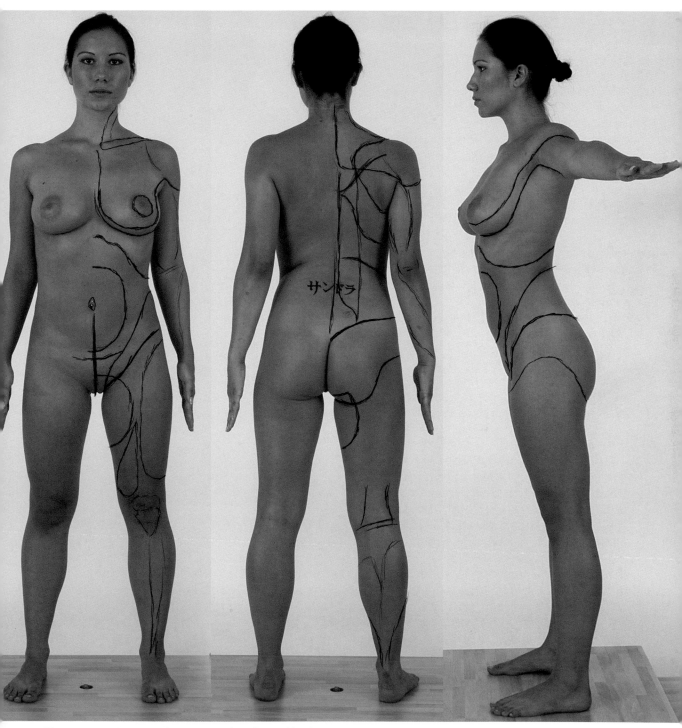

Figure 7.1: Image references with indicated body contours

7.2 Preparing the Image References

As you can see in Figure 7.1, I combined three views of the body into one image and made sure they are about the same size.

Generally speaking, images can't be transferred on a 1:1 ratio to a 3D model since they always contain perspective distortions. This is also true for photos taken in a studio environment such as the ones here that can't be taken with an infinite depth of focus.

In the front view, the feet appear distorted. Ideally we would see only the tips of the toes, and the toenails would be barely visible. At such places we have to depart from the image templates and use additional reference material containing detailed views of these body parts.

As you can also see in the figure, I have already roughly drawn in some edge loops, lines and edges that follow folds, muscles, or other distinctive structures.

These lines are important and help us to keep the overall shape in mind during modeling. We have already seen, when modeling the head, how important the correct position of the polygons is to accurately reproduce the natural direction of folds and muscles.

In this example we will not go into so much detail, but instead try to work with the least amount of effort and polygons. This will make it easier to animate later or to further refine in, for example, ZBrush.

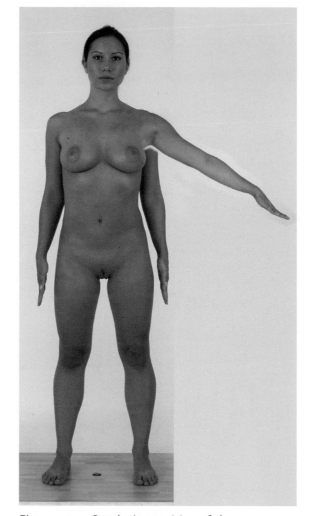

Figure 7.2: Overlaying position of the arm

Because characters are modeled in the neutral T-pose most of the time, which means with outstretched arms, I overlay the frontal image in the sequence with a laterally stretched arm, as shown in Figure 7.2. This makes it easier to work with bone deformers and textures at a later time.

Because we will use the symmetry function, it is enough to use one half of the body as reference.

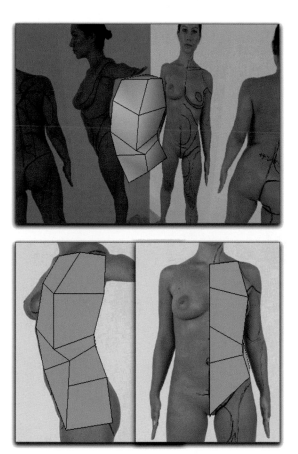

Figure 7.3: A cube as the base object

Figure 7.4: Shaping the cube

7.3 Box Modeling

Load the image reference either onto two planes positioned perpendicular to each other, or blend the images into the background of your 3D program.

One image reference should be shown in the front viewport and one in the side viewport, as shown in Figure 7.3.

Then create a slim cube, which covers the torso of the character in height. This cube should have four subdivisions along its height and should cover the right side of the body in the front viewport.

Then move the points of the cube so it roughly takes on the contours of the torso.

Especially interesting is the beginning of the leg which, together with the shoulder joint, is an important area for deformations. The leg actually starts above the hip joint. This joint doesn't come straight out of the hip. Instead it is positioned diagonally below the crest of the hip.

Therefore, when the leg is angled, the fold does not form a lateral line from the crotch outward. Instead, the fold runs from the crotch slated upward toward the hip joint.

The shape of the torso is already roughly defined and we can now take care of the extremities, the beginnings of which can be extruded directly out of the model.

7.3.1 Neck and Head

Select the three faces at the beginning of the leg, at the shoulder, and the base of the neck, and extrude them as it is shown in Figure 7.5.

Move the new point at the beginning of the leg so that a wedge is created. The part next to the center line of the character defines the distance between the upper legs.

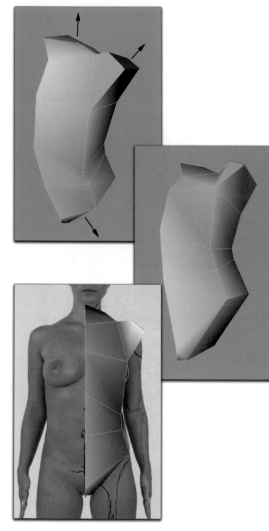

Figure 7.5: Creating the base for the neck, arm, and leg

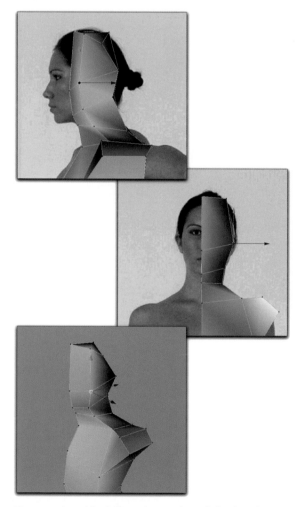

Figure 7.6: Modeling the neck and the head

Let us first take care of the neck and head. Create three additional extrusions of the uppermost polygon and orient them, during the correction of the shape, to the front and side view of the reference images.

As you can see in Figure 7.6 these faces cover the entire neck but only the rear half of the head. This makes it easier to model the face and especially the protruding shape of the jaw, including the transition to the front of the neck.

Also note that the head is not placed vertically above the shoulder girdle because the neck is tilted slightly forward. The side view in Figure 7.7 shows this clearly.

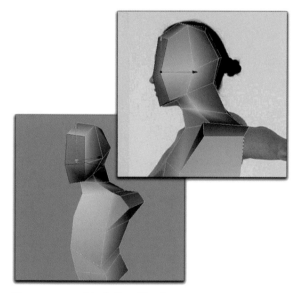

Figure 7.7: Modeling the face

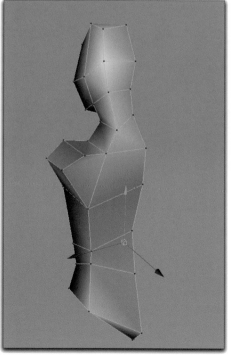

Then select the two front faces in the area of the head and extrude them forward, as can be seen in Figure 7.7. These new faces should cover the complete face and end under the chin.

Check the shape of the skull in the top view as shown in Figure 7.8. In the current state the head should look similar to an elongated sphere.

Figure 7.8: Views of the model

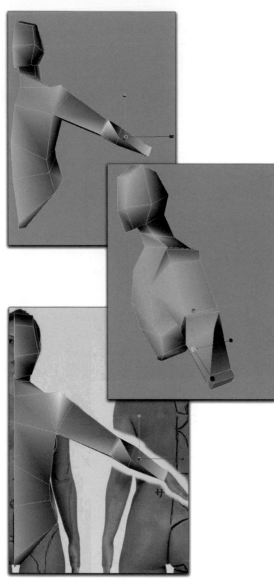

Figure 7.9: The arm

7.3.2 Arm

We will continue with the arm, which will be extruded out of the lateral shoulder area in several steps.

Cover the distance to the elbow in one step. Add a short extrusion to define the area of the crook of the arm.

Add two more extrusions that cover the area to the base of the wrist.

When you take a closer look at Figure 7.9 you can see that the last two profiles of the forearm were twisted along the length axis of the arm. The allover rotation is 90°, which is evenly distributed to the two profiles.

This makes sense because the hands, based on the image templates, are modeled with the palm downward. This position of the hand can only be modeled anatomically correct when the forearms are rotated 90°.

This can simply be checked using your own body. The neutral hand position, when the arm is stretched laterally, shows the palm facing forward in the viewing direction. Depending on your flexibility, the hand can be rotated 90° up or down by rotating the forearm.

When this rotation is taken into consideration during modeling, it makes it easier to animate the arm in an anatomically correct manner, creating a realistic twist of the surface.

At the end of the forearm add a short extrusion as the end piece.

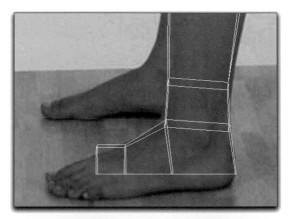

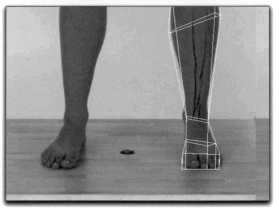

Figure 7.11: The foot

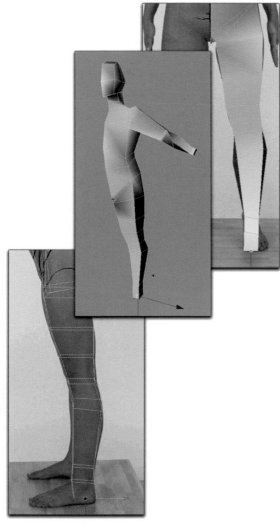

Figure 7.10: The leg

7.3.3 The Leg Including the Foot

We follow the same system with the leg and extrude the face at the beginning of the leg multiple times, along the length of the leg, down to the heel. Try to immediately incorporate the most important characteristics of the leg shape.

Necessary are the subdivisions at the knee and at the ankle. Additional subdivisions define the different profiles of the lower leg and the upper leg.

Add two extrusions at the front face of the lowest element to define the foot.

Disregard the toes and cover only the area up to the base of the toes. Figure 7.11 shows the result from two perspectives.

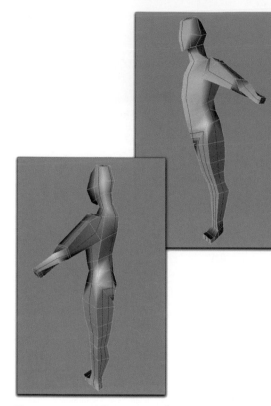

Figure 7.12: Adding circumferential cuts

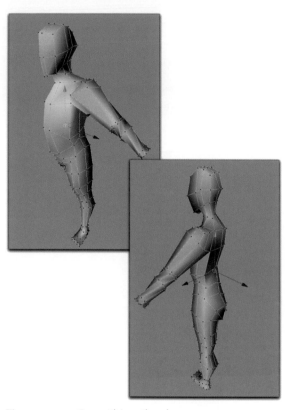

Figure 7.13: Smoothing the shape

Note, as it was mentioned in the beginning, the deviation from the image template that has perspective distortion. After all, the foot should be modeled parallel to the ground.

7.3.4 Adding Subdivisions

Except for the hands, we already have the basic shape of the body. In order to add further details we need additional subdivisions.

These should be created as continuous loops, since our model is currently still a rough structure and would benefit from additional faces and points.

With all of the following steps, where cuts and subdivisions should be added, make sure to use all new points for rounding the character. Otherwise, unnatural angular areas remain that can't be removed, even when smoothing the model.

In the first step, add circumferential subdivisions, as shown in Figure 7.12. Here the subdivision was created parallel to the symmetry axis of the character, taking its course over the head, stomach, through the crotch, and up the back again. Another looped cut runs over the shoulder, down to the wrist, and back again, going up the back of the arm.

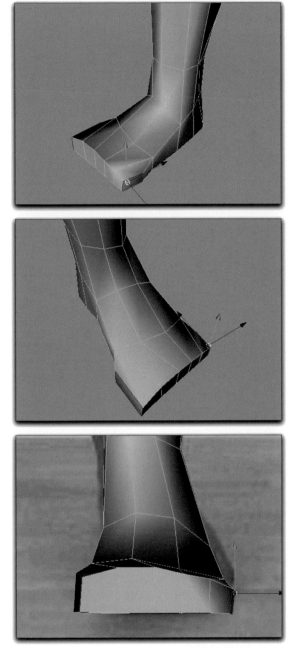

The third loop parts the side view of the character and runs up the side of the leg to the armpit. From there the cut follows the arm down to the wrist and upward, along the top of the arm, to the shoulder and head. Two additional cuts start at the lower stomach, run down the leg, across the foot, and up again behind the leg, where they meet the symmetry axis again at the buttock.

7.3.5 Adding the Toes

Because of the additional subdivisions, the foot has the faces in front. These can be extended to five subdivisions with lateral extrusions.

Execute this as shown in Figure 7.14. Also note the bulge of the foot on top and the resulting variation in size of the front faces.

In the next step we will develop the toes from the five front faces. The big toe should be worked on separately since, because of its size, it has a shape different from the remaining toes.

In the front view select the front face on the far left of the foot and extrude it forward three steps. Use the first extrusion to mark the first joint of the toe and pull the subdivision upward a little. The following extrusions are then moved down again to bring the tip of the toe back to the level of the bottom of the foot.

Use the image template in the side view as a guide for the length of the toes. Figure 7.15 shows this step again from different views.

Figure 7.14: Preparation for the modeling of the toes

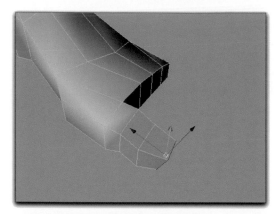

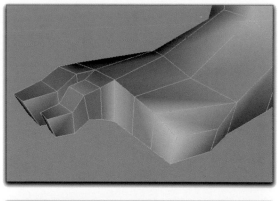

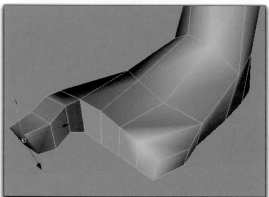

Figure 7.16: The following toe

Figure 7.15: The extruded big toe

Add the following toe the same way. As can be seen in Figure 7.16 this toe has an additional subdivision that reflects the better mobility of this toe.

Note the difference in height and the shorter length in comparison to the big toe.

You can save time with the remaining toes by copying the second toe three times and connecting these copies to the foot. Keep in mind that the toes are getting smaller and shorter and that the copies have to be scaled down accordingly.

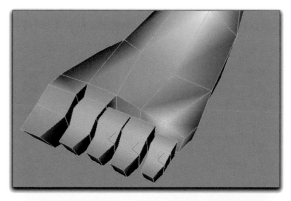

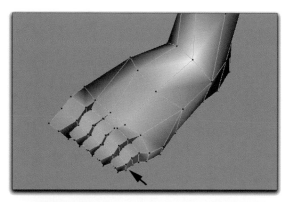

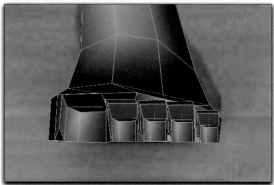

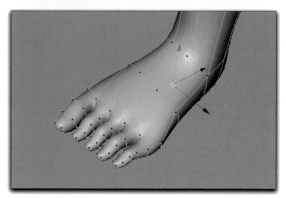

Figure 7.18: Connecting the toes to the foot

Figures 7.17 and 7.18 show this step. As it is indicated with arrows in Figure 7.18, the toes shouldn't simply be connected straight onto the foot. Instead, they should be slanted slightly. Generally speaking, the tip of the toes point slightly in the direction of the big toe.

This completes the foot for now. We will come back to it later to make some corrections.

Figure 7.17: Adding copies of the toe

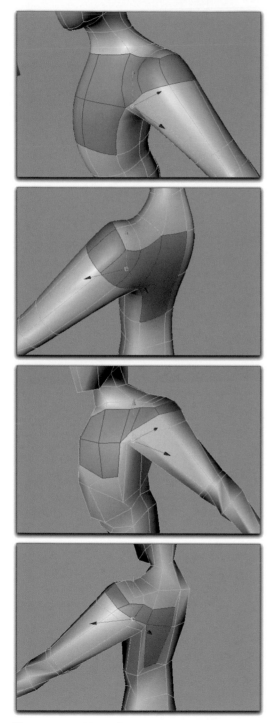

Figure 7.19: Extrusions

7.3.6 Chest and Shoulder Girdle

Let us get to the chest and the female breast. This area is fundamentally different from modeling a male chest.

Generally, make sure that the natural course of the chest muscle is taken into consideration. The muscle starts close to the shoulder at the biceps and continues in a fan-shaped way to the breastbone.

Most of the time, the majority of this muscle is covered by fat and tissue. However, the beginning of the chest muscle at the shoulder is always visible.

That is why it is necessary to add subdivisions in this area. The faces to be extruded can be seen in the two upper images of Figure 7.19.

As you can see in that figure, we also extruded faces at the shoulder blade, because we need more definition there as well.

The two lower images show the result. There, the new points were already moved a little to border the contour of the breast in front and the shoulder blade in the back.

Always remember, when adding new subdivisions, to rearrange the surrounding faces if necessary to get the most out of the new faces. This is the case in the area at the side of the shoulder, which was also subdivided further.

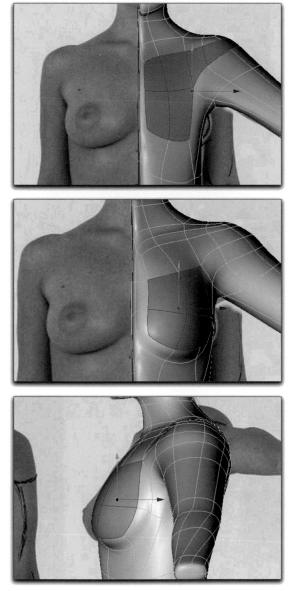

Figure 7.20: Extruding the breast

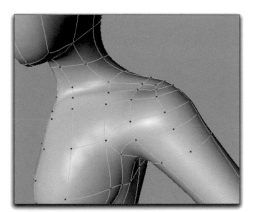

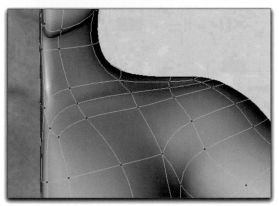

Figure 7.21: The collarbone

Use the faces marked in red in Figure 7.20 for another extrusion. The lower four faces of the highlighted ones can be pulled forward to shape the actual breast.

Use the faces between the neck and chest to frame the collarbone. It is enough to add an edge above, below, and directly on the collarbone.

Note in Figure 7.21 that the line of the bone does not just go straight to the shoulder, but that it runs in a long curve from the front breastbone up to the upper shoulder.

Depending on the look of the character, which can be rather skinny and slim or voluptuous and full, this bone is more or less visible. If in doubt, just hint at the line of the bone and don't overdo the bulge outward.

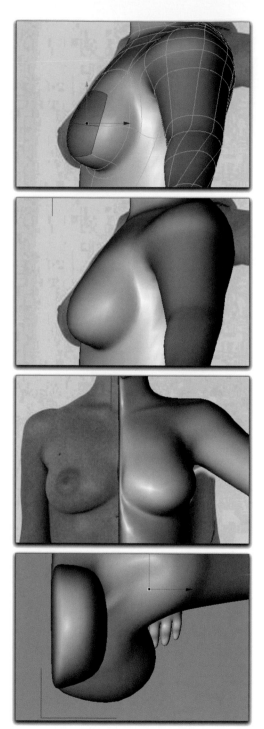

Figure 7.22: The shape of the breast

After all, this is only one detail of the character and it should be harmonically integrated.

Note that, regarding the size of the breast, the faces shouldn't just be pulled forward to shape the breast. The larger the breast is the farther outward and downward it is located.

This can be seen especially well in the view from above in Figure 7.22.

The exception to this rule is breasts with implants since, even though the volume is enlarged, the drooping has been artificially avoided. All reference images help with the modeling in both cases.

In any case, the breasts should be aligned so the nipples don't point straight ahead, but instead create an angle between 60° and 90° with the spine. This angle depends on the size of the breast.

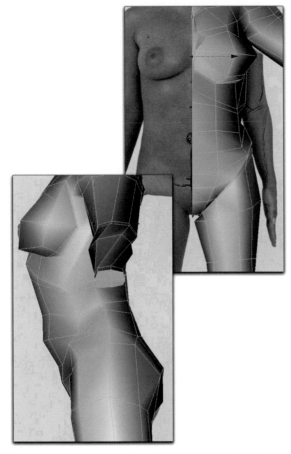

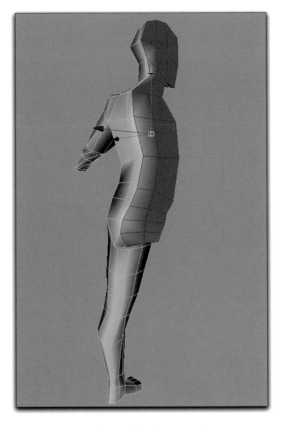

Figure 7.24: Deleting the faces on the symmetry plane

Figure 7.23: The low-resolution view of the model

In the next segment we will take care of the lower torso, which includes the lower stomach, the buttocks, and the lower back.

7.3.7 Defining the Lower Torso

The character slowly takes on female characteristics. Let us add more details.

Noticeable here is the stomach, which is not defined much yet. Therefore, start by separating the lower ribcage from the upper stomach with an additional subdivision.

Use the existing edges at the stomach to hint at the characteristic distribution of female fat pads.

These are directly beneath the navel and above the crotch. These bulges can be seen very well in the side view of the low-resolution model in Figure 7.23.

This is a good time to select the faces, which are left over from an early phase of the modeling, at the symmetry plane of the character and delete them. These faces are highlighted in red in Figure 7.24.

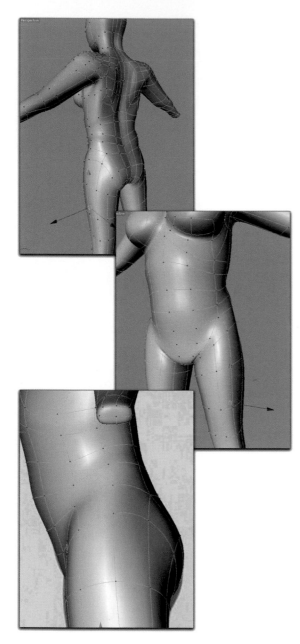

Figure 7.25: The completed and smoothed model

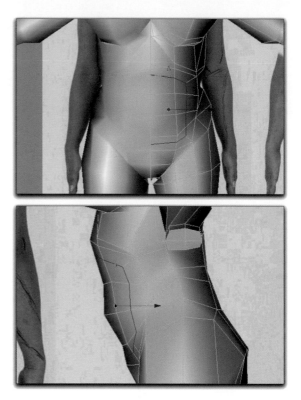

Figure 7.26: Adding new edges

Then the model can be automatically completed with the symmetry function of your software. This makes it especially easy to work on the fold between the buttocks since we can better control the roundness of the buttocks.

Stomach

In order to define the stomach, it has to be delineated, particularly at the side. Create a half-circular cut starting from the symmetry plane as shown in Figure 7.26.

Pull the newly created points at the side of the stomach slightly backward to define the waist and lateral stomach muscles.

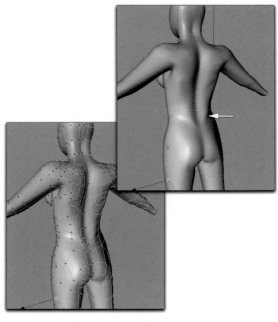

Figure 7.28: The lower back

The new edges, on top and bottom, used to further define the separation between the ribcage and the lower fat deposit of the stomach.

Smooth the course of all points and faces as seen on the interactively smoothed model in Figure 7.27. The border along the side, top, and bottom of the stomach should be made distinctly visible.

Also use the existing faces on the back of the character to shape the base of the large back muscle. This starts directly above the tailbone and then spreads, in a trapezoid shape, up to the shoulder blade and the neck.

This base is indicated by an arrow in Figure 7.28. Of course, how distinctly these details are to be modeled depends on the muscularity of the character. Eventually, such shapes then have to be further subdivided and edited some more.

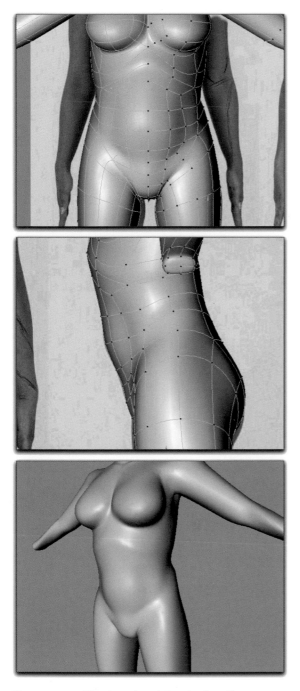

Figure 7.27: Shaping the abdominal wall

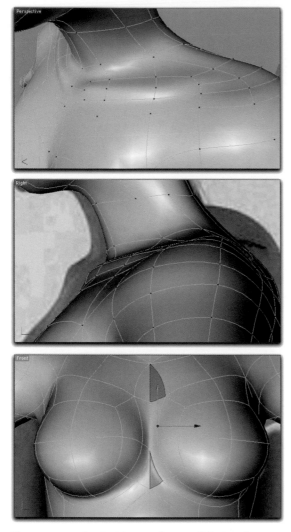

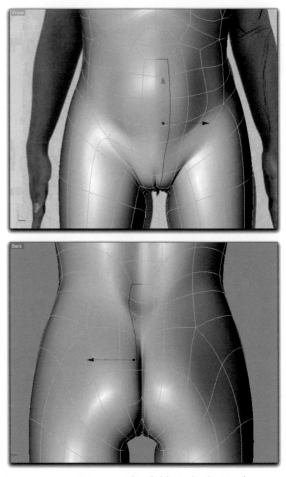

Figure 7.30: Creating the fold at the buttocks

Figure 7.29: Optimizing and consolidating faces

Before we continue with the shaping of the lower torso, I'd like to optimize and consolidate some faces that are located on the symmetry axis. This especially concerns the area between the breasts.

As you can see in Figure 7.29 I deleted some faces and connected others with triangles. The high resolution of the symmetry later on will convert these triangles into quadrangles

again and will not influence the quality of the surface smoothing.

The Fold at the Buttocks

Depending on the pose and the clothing, details such as the vulva or the center of the buttocks are often not visible.

But for completion sake we will model both details. As you can see in Figure 7.30 I make a cut starting at the stomach, passing over

Figure 7.31: The navel

Figure 7.32: The modeled navel

the crotch, and up the buttocks to the base of the tailbone. The lowering of the neighboring edge along the symmetry plane then creates the visible fold.

Navel

The newly added subdivisions are also helpful for modeling of the navel. This was one reason why I made the cut so far up the stomach.

At the height of the navel, extrude two faces and then shrink them. These faces are marked in red in Figure 7.31.

Of course there are many different navel shapes, but generally they can be created with just a few faces.

In our case we extrude both marked faces one more time, but now each one separately so a split is created. Figure 7.32 shows the result seen from the symmetry plane. In the lower part of the figure the complete model, including surface smoothing, can be seen. Depth and shape of the navel can easily be adjusted by moving the faces.

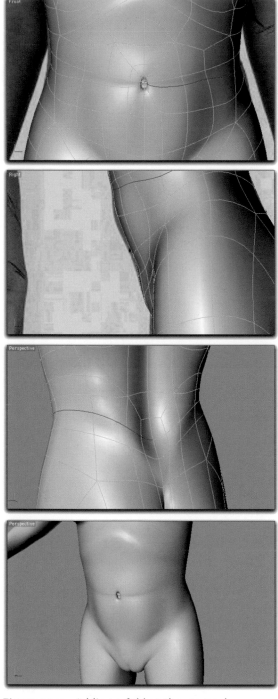

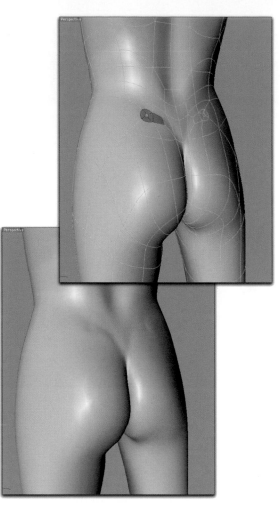

Figure 7.34: The hip bone

Depending on if the stomach is covered by folds or defined by stomach muscles, such details can be added easily by making additional cuts as seen in Figure 7.33.

Tailbone

With extruding and shrinking of faces, the characteristic structures above the buttocks can be created, which are often created by the tailbone and the hip bone (see Figure 7.34).

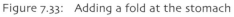

Figure 7.33: Adding a fold at the stomach

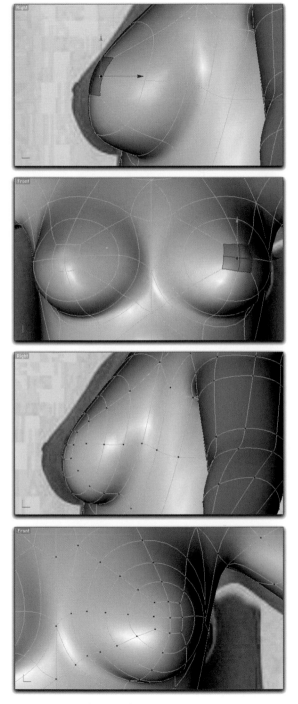

Figure 7.35: The nipple

Nipple

Generally speaking, the nipple is only needed when the character is supposed to be naked.

This elevation can be modeled directly out of the front of the breast. However, there should be a sufficient number of subdivisions added to the breast so the shape of the remaining breast stays the same (see Figure 7.35).

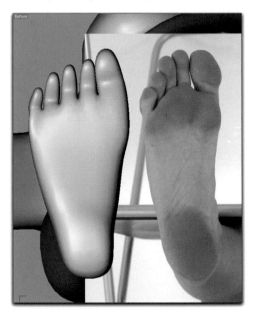

Figure 7.36: Reference for the foot

Correcting the Shape of the Foot

As previously mentioned, the use of proper references cannot be emphasized enough. During the modeling of the foot we made several mistakes that weren't as apparent in the usual side and front view. When we compare with an image of the sole of a

foot, the differences become quite clear (see Figure 7.36).

The foot in the area of the ball is way too wide. We will correct this with an added subdivision above the sole and by shrinking the front half of the foot.

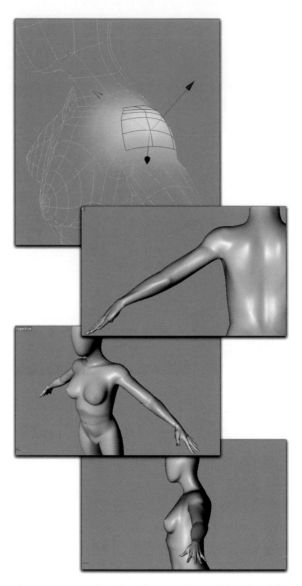

Figure 7.38: Adjusting the rotation of the shoulder

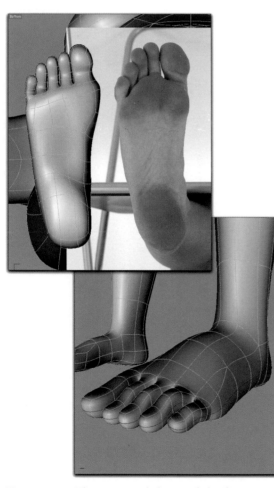

Figure 7.37: The corrected shape of the foot

Figure 7.37 shows the corrected foot model and the additional cut, marked in red, close to the sole in the lower image. This cut allows us to define the outer edge of the toes more and to improve the border of the sole.

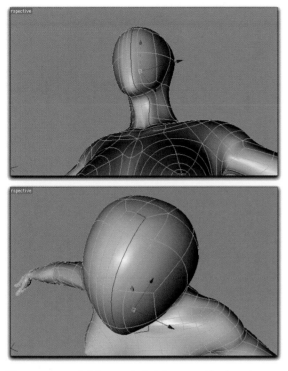

Figure 7.39: Adding subdivisions on the head

Finishing the Modeling of the Body

Now, upon completion, we will examine the whole body again. To save time we will add the missing hand from the model in the first workshop. Be sure to have the correct scale. The image references help here, too.

Little mistakes, like in the example of the shoulder rotation in Figure 7.38, can be adjusted easily because of the polygon density.

Head and Face

We saved the modeling of the face for last. Continue working using the same method

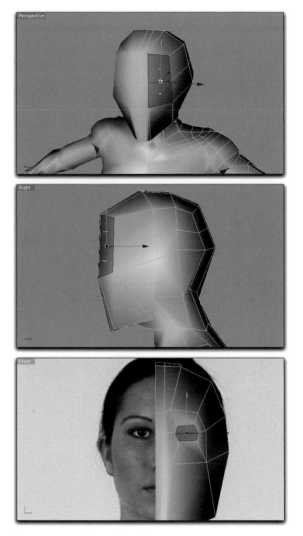

Figure 7.40: Preparing the eye

of extruding and subdividing. The image references are more a reference for the proper proportions than for exact modeling.

We start by placing an additional edge next to the center line of the head. We do not extend this subdivision around the whole character like before since we do not want to influence the body anymore.

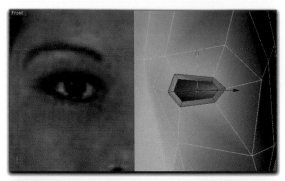

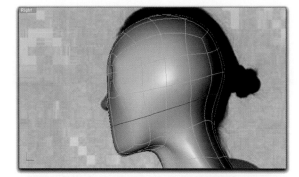

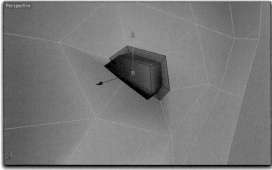

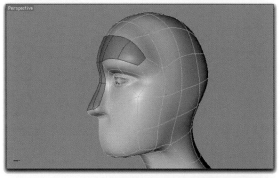

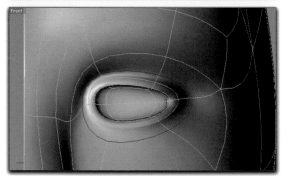

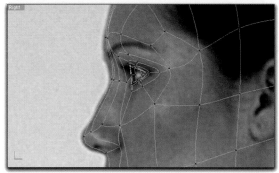

Figure 7.42: Top of the eye socket and the bridge of the nose

Instead we start the cut on top at the parting of the hair and bring it back to the symmetry plane, passing the collarbone. Figure 7.39 shows the course of the cut.

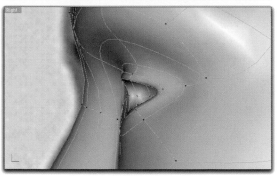

Figure 7.41: Shaping the eyelids

Eye

The basis for modeling the eye is the two outer faces in the upper half of the face. These are marked in red in Figure 7.40.

Extrude and shrink both faces to create the outer border of the eyelids. Another smaller extrusion determines the thickness of the eyelids. The last extrusion, into the inside of the head, creates the eye socket.

Add a circular subdivision around the eye and use all faces in this area to shape the eyelids. The image series in Figure 7.41 documents this step.

7.3.8 Forehead and Nose

The forehead bulges out slightly above the eyes. At the same time, the bulge between the eyes merges into the nasal bone. Thus, it makes sense to model these two parts in one step.

Therefore, select the polygons above the eyes and the faces next to the symmetry axis where the nose is to be placed later. The center image in Figure 7.42 marks the selection of these faces in color.

Extrude these faces slightly forward. The movement should be more pronounced at the nasal bone than at the forehead. Use the side image template as shown in Figure 7.42 as an example. We will take care of the tip of the nose and the nostrils later.

Mouth

For the mouth we first need a center line. Therefore, add a circulating subdivision as shown in the upper image of Figure 7.43.

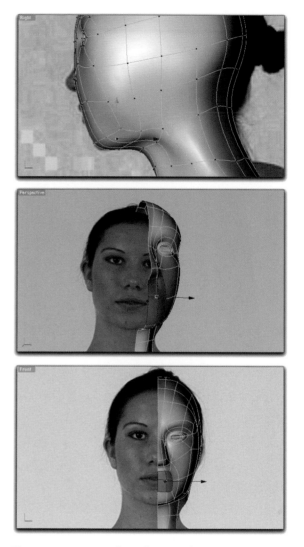

Figure 7.43: Extruding the mouth

Be sure, as always when adding subdivisions, that all points are used to create more details on the character. In this case this also concerns the back of the head. Otherwise the back of the head will appear too angular when being smoothed later.

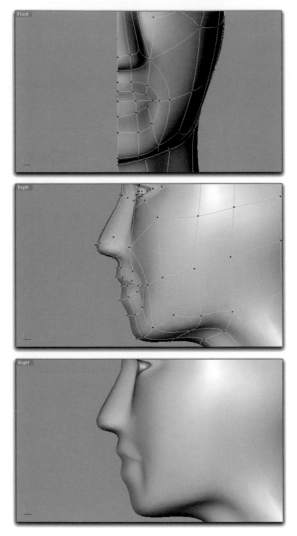

Figure 7.44: Shaping the lips

Figure 7.45: Defining the lips

Then use the four faces between the nose and chin to define the contours of the mouth by extruding and then shrinking them.

The new subdivision will allow you to properly adjust the front part of the chin to the image template. Both steps are shown in Figure 7.43.

Shrink the faces in the lip region one more time by extruding and use the new points to define the outer border of the lips.

As can be seen in Figure 7.44, the shape of the lips and mouth are already looking very nice.

Extrude the two face loops twice within the lip area and use these faces to further work on the shape of the lips.

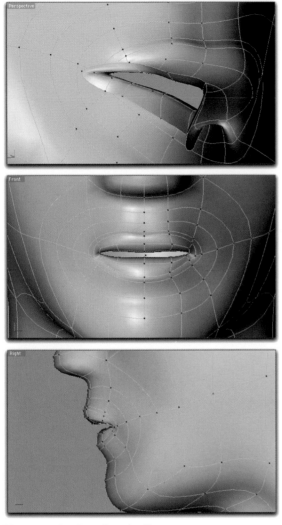

Figure 7.46: Opening the lips

Figure 7.45 shows the result from different angles. In the bottom image you can see, from within the head, how the lips are curved inward.

Then delete the points at which the upper and lower lips touch. The lips are parted by this action, allowing you to later form different shapes of the mouth.

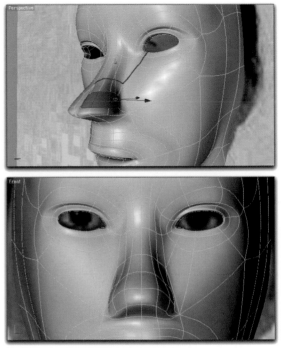

Figure 7.47: Shaping the nose

Extend the open edge of each lip by extruding it deeper into the mouth cavity. This models the complete profile of the lips. The result is shown in Figure 7.46.

Tip of the Nose

In order to better isolate the necessary subdivision of the tip of the nose, add a cut from the inner corner of the eye over the bridge. Figure 7.47 shows this cut with a red line.

Then select the three faces that form the tip of the nose and extrude them. After shrinking the resulting faces, adjust them better to the shape of the nose by moving the corner points. Use the new faces for a general widening of the tip of the nose. This can also be seen in Figure 7.47.

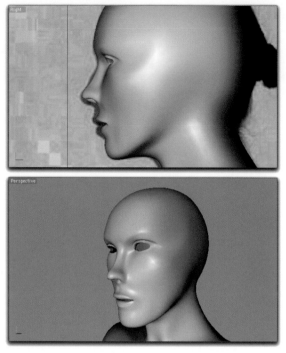

Figure 7.49: State of the modeling

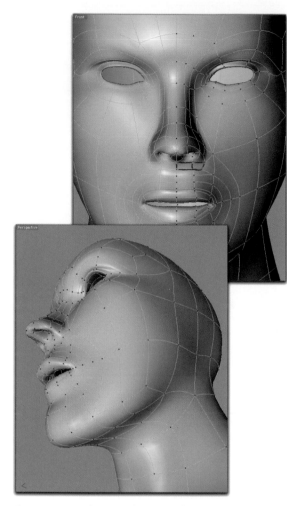

Figure 7.48: Shaping the nostrils

The face under the tip of the nose is extruded inward to shape the nostrils. Then add the face extrusion under the nose to give a better shape transition to the upper lip.

These faces are marked in red in Figure 7.48. There you can also see the nostrils, which were extruded up and toward the inside.

Working on the Smoothed Shape

Up to this point I wasn't sure what kind of hairstyle the character will receive. Because of that, I didn't work on the modeling of the ear since longer hair would cover this element anyway.

Meanwhile, I got the idea to transfer the character into an African-American disco queen in the style of the seventies. A fitting hairstyle would be a short afro that doesn't cover the ears. Therefore, we will need to add the ears later.

First, we should check the existing structure and make it more striking. The model was created with a relatively low number of polygons. This has the disadvantage that the

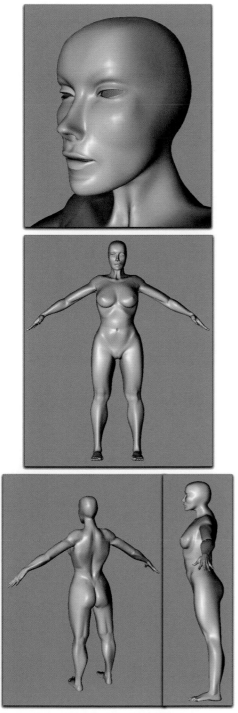

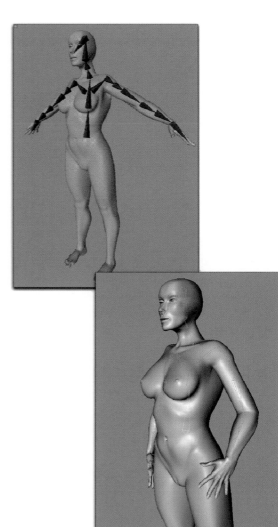

Figure 7.51: Posing the character with bone deformations

character looks very soft and round after the subdivision surfaces, when the smoothing by polygon subdivision, is activated.

This can be changed by moving some points of the model to more extreme positions. This can be done at, for example, the chin, the cheekbones, or at the bulge above the eye. The best way is to do this directly on the smoothed object because the effect can

Figure 7.50: The finished model

be seen instantly. The character gets its own personality. Don't be afraid to deviate from the image templates and work using your own ideals.

Of course the proportions should remain, but other than that feel free to experiment. You will see that with relatively little effort different facial expressions and personalities can be created, which is an advantage of the low number of polygons. The model is therefore also suitable for further detailing in ZBrush, Mudbox (www.mudbox3d.com).

We will keep the current level of details though. A possible result can be seen in the previous image series. There, only the existing points were moved and no new ones were added.

7.3.9 Creating the Pose

Since the rough work on the character has been completed, we should think about the pose of the character and the scene.

To achieve a result as fast as possible, bones should be added to the character. We used these deformers already when deforming the hand in the first workshop.

We could actually add a complete skeleton to the character to gain as much control as possible over the pose and a possible animation of the character. In our case, it is enough to add bones just to the upper body in order to move the arms and head into any pose.

In Figure 7.51 you can see the bones as short green blocks. It often makes sense to add several bones to body parts. I have applied two bone objects to each upper arm

Figure 7.52: Image template for the modeling of the bikini bottom

and forearm. This gives us better control of the rotation along the length of these segments.

In the lower image of this figure you can see the pose of the character that was created by rotating the bones.

7.3.10 Clothing of the Character

As attractive as the body might be, we shouldn't present our beauty completely naked. In order to not cover too much of the tediously modeled curves, I decided on tight-fitting clothing. This has the advantage that the clothing can be modeled easily from copies of the existing surface of the character.

I thought about a fantasy bathing suit, the style of which would fit nicely to the character.

Start by selecting those faces, on the lower stomach between the legs and at the buttocks, which will later be covered by the bikini bottom. To gain more control over these faces, I used a more subdivided copy of the character and made the selections there. You can see the selected faces in red in Figure 7.52.

Then delete all faces that are not selected (of course this pertains only to the high-resolution copy of the character) to get the basic shape of the bikini bottom. The shape can be seen in the lower image of Figure 7.52.

In order to keep the bikini on the hips, we need only one more element on the side that connects the front and back.

Since these faces are also snug to the skin, we cannot work freely but have to orient ourselves to the shape of the body.

Unfortunately, the course of the existing polygons is slanted, and not horizontal, in the area of the top of the leg. We therefore have to improvise.

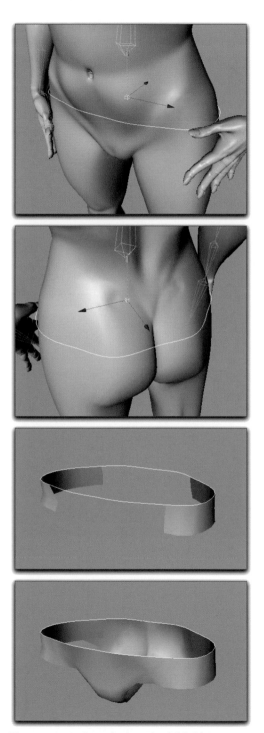

Figure 7.53: Completing the bikini bottom

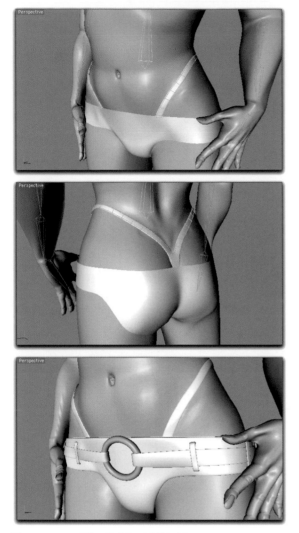

Figure 7.54: The finished bikini bottom

Create a circular spline curve as a helping object and place it around the character at the height of the hip. Depending on the possibilities of your software, project this spline onto the surface of the character or adjust the shape manually by moving its points as precisely as possible.

Then extrude the spline so that a polygon strip of the desired width is created. Connect this polygon strip to the existing faces of the

bikini bottom to finish it. The result can be seen in Figure 7.53.

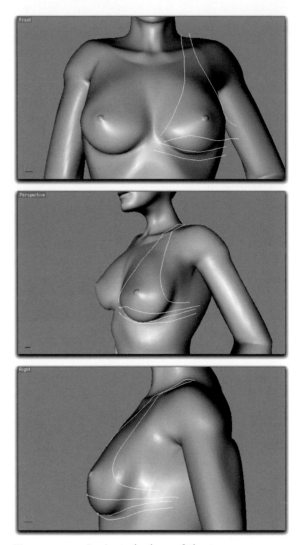

Figure 7.55: Projected edges of the top

The same way, I also add two strings to create the impression of a thong underneath the bikini (see Figure 7.54).

Figure 7.56: The bikini top

Add further design elements at your discretion. Remember to give all elements a thickness so the clothing looks realistic. You should also simplify the faces of the bikini bottom so intimate details of the character, such as the fold at the buttocks, are not visible anymore. The clothing shouldn't be that tight.

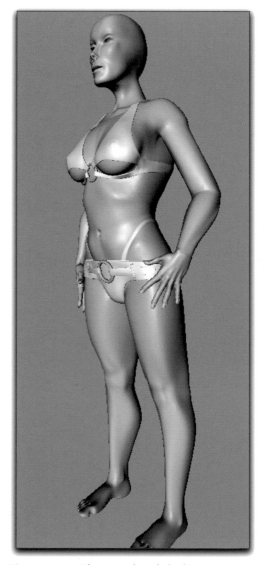

Figure 7.57: The completed clothing

Bikini Top

I create the edges of the shape of the bikini top with projected splines, as shown in Figure 7.55. Then I separate the faces within as a copy of the character and adjust the edges of these faces to the splines with the snapping function (see Figure 7.56).

Do not forget to give the bikini components a thickness and to add more design details if desired. For example, I used the ring-shaped closing element of the bottom and added it to the front of the top (see Figure 7.57).

7.3.11 Eyelashes and Teeth

Hair simulation does not always have to be used. Because the character will not be shown close-up, it is enough to use a few faces with drawn eyelashes.

I create the teeth, which can only be seen as a small strip between the lips anyway, with a cylinder placed inside the mouth (see Figure 7.58).

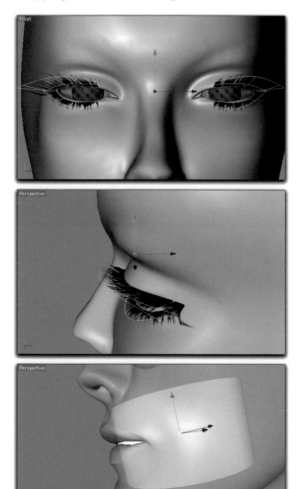

Figure 7.58: Eyelashes and teeth

Figure 7.59: New faces for the ear

The eyebrows are created in a similarly simple way. I use bent and rounded cubes that are adjusted to the surface of the character. A material with dark coloring is enough. Single hairs don't have to be shown.

7.3.12 Ear

As previously described, a short hairstyle is suitable for this type of character. This makes it necessary to model the ears, but we do not have to dwell too long on this. The basic shape of the ear can be created in just a few steps.

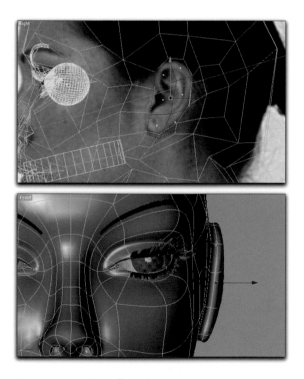

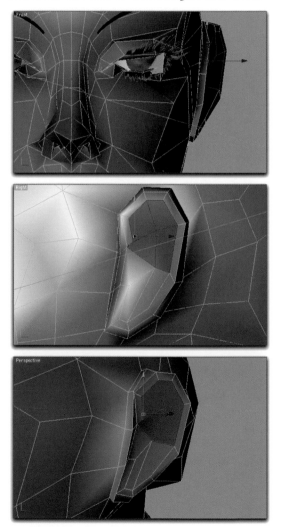

Figure 7.60: Extruding the ear

Figure 7.61: Shaping the outer ear

We need a few more subdivisions at the side of the skull. Add these new faces by

extruding the eight polygons that are shown in the upper image of Figure 7.59.

Select the eight faces, which are marked in red in the lower image in Figure 7.59, and move the corner points so the outer edge matches the one in the image reference.

A possible result can be seen in Figure 7.60. Move the still selected faces outward, away from the head, with another extrusion to

create the thickness of the outer ear and its distance from the skull. This is also shown in Figure 7.60.

Rotate the faces of the ear model so the ear is farther away from the head in the rear than in front. Use the selected faces again for an extrusion and the following shrinking in order to model the thickness of the rim of the ear.

Points, which are inside the rim, are moved toward the skull to hint at the actual depth of the outer ear.

Then select the faces in the upper area of the outer ear as shown in Figure 7.61.

Use these faces again for a scaled-down extrusion to have more points available on the inside of the ear. There are just a few edges and points available but they should still be sufficient to create the most distinctive attributes, such as the earlobe, the depth of the outer ear, or the edge of the ear. Just add more subdivisions when there aren't enough faces available.

Finally extrude the face located above the ear canal into the skull as it is shown in Figure 7.62. This concludes the modeling of the ear, which has sufficient details for our purpose.

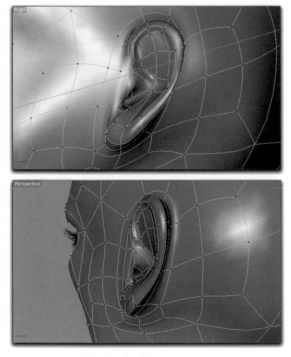

Figure 7.62: The finished ear

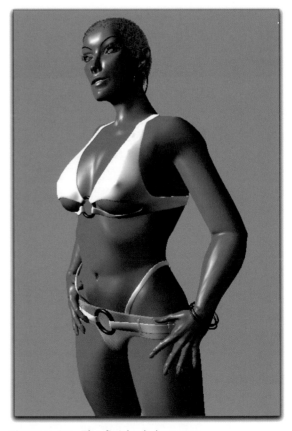

Figure 7.63: The finished character

7.3.13 Finishing the Character

The work on our character is almost done. How you create the hair is completely up to you. If your software includes a hair module, create very short hair close to the skull. It then gets a black material applied to it.

Figure 7.64: Detailed views of the character

If you don't have this possibility then you can, for example, simply paint the hair, as small dots, directly on the skull or apply with a shader as a material. The hairs are so short that the difference will not be noticeable.

Further details can be added as desired. Figure 7.64 shows that I added earrings and a bracelet that fit the style of the design elements of the clothing.

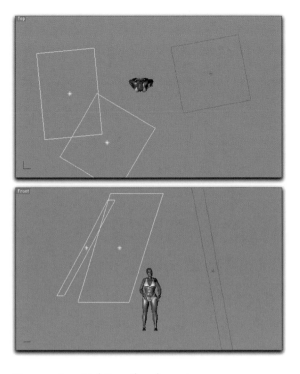

Figure 7.65: Lighting the character

The eyes of the character were taken from our first workshop and only the color of the iris is adjusted. I decided on a very dark brown tone.

I also tried to loosen the symmetry of the character with small details like the thumb tucked under the bikini bottom and the slight tilt of the head.

7.3.14 Lighting of the Character

For the lighting I decided on relatively strong area lights. Area lights are light sources that emit light from the whole surface. These lights have the advantage of emitting a natural light and also look better on reflective surfaces.

I applied a highly reflective white lacquer material to have a nice contrast to the dark skin color.

The placement of the light sources can be seen in Figure 7.65. Two white light sources to the left of the character take care of the base lighting and strong highlights on the skin and the clothing.

Another area light, but this time with a reddish tint, is located to the right of the character and brightens the shadows of the first light source. Also, the coloring of this light source supports the shading of the character's surface, for which I plan to use a dark red material with strong highlights.

For the highlight in the eyes I create a separate point light. This light does not have any influence on the lighting of the objects but is used only for the highlights.

The scene is finished with a few flat cylinders made of colored glass. They are placed in the background of the character as homage to the disco era of the seventies.

The finished image is shown in Figure 7.66.

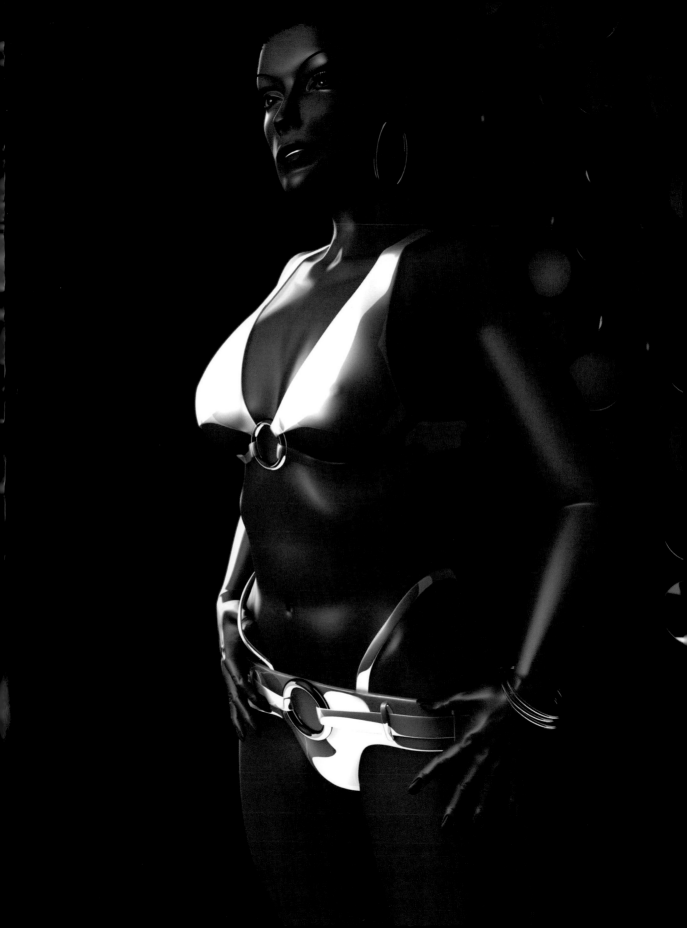

Glossary

Bump: Height information of the surface encoded as a grayscale image. It is used for influencing the surface shading.

Displacement: This is the movement of the polygon corner points in order to deform the surface. This effect is controlled by a grayscale image. That way, details can simply be painted, which is much easier than modeling the details.

Extruding: This action moves selected edges or faces. At the same time new faces are created at the edges of the moved elements. That way, thin objects can be thickened or, for example, bulges can be created as we need them at the pupil.

Fresnel: This term describes the calculation of the slant of the surface in relation to the line of sight. Surfaces that are facing the camera can be calculated differently from the ones that are angled away from the camera. This effect can be tested when standing in front of a window and looking straight ahead. Ideally, the window becomes invisible and the objects behind the glass become more apparent. But when looking parallel to the window or in a flat angle, then the glass looks more like a mirror and the items can hardly be seen behind the glass.

This effect can be used in 3D programs for many reasons. It could be used to control the relation between transparency and reflection as explained in the example of a window. Additionally, the brightness of an object can be controlled so that the contours of a model are brighter than the front faces. This gives the illusion of the surface being covered by fine fuzz or hairs capturing additional light.

This effect is also useful when simulating fabrics like velvet or wool.

GI: This is the further development of radiosity, where light not only radiates from light sources but could also come from objects. Applied materials could simulate, for example, the light from the sky shining onto the landscape by using a sky panorama applied to a half sphere as a light source. Often GI is used together with the already mentioned HDRI images to create a reproduction of natural color and brightness values.

Guides: These are splines or curves that can be shaped with special tools. Often, larger groups can be combed in a certain direction with comb or brush tools. Generally, collision detection can be activated as well between guides and 3D geometry. This prevents the guides from entering the object when being edited, since the hair shouldn't protrude into the skin.

HDR images: HDR is an abbreviation for high dynamic range and stands for images with a large range of values. Normally these images have 16- or 32-bit color information for each channel, compared to the usual 8 bit. These images could also be saved in a much higher color depth, but the color gain wouldn't be worth the much larger file size. Images with this increased color depth can be used in 3D programs, for example, to light objects and to simulate reflections to create an accurate simulation of environments. HDR images can be created in Photoshop by layering a series of different exposures of an image.

Mesh: Common term for a 3D object made from polygons.

Morphing: Generally this is the deformation of the object from a start state to a target state. Multiple copies of the model, with the relaxed expression, are created, which then are remodeled to have different expressions. Often, different shapes of the lips are created for all the letters or sounds. Also common are models for wrinkling the nose, laughing, or frowning.

In order to make the morphing work, all target state objects have to have their origin in the same object. Existing points may not be deleted or new ones added. Therefore, it is important to add the necessary subdivisions of the creases to the model in the relaxed pose.

When the object is animated, the different faces can then be blended with new ones. Most of the time it is enough to use just a limited number of well-chosen poses to reproduce a variety of facial expressions.

Normal texture: The alignment of the surface can be coded as a color image. That way, the fine details of a highly subdivided object can be realistically transferred to an object with fewer faces. This technique is used mostly in computer games.

Orthogonal: Objects can be seen without perspective distortions. Parallel lines on the object are actually parallel and the usual perspective distortion to a vanishing point does not apply.

Orthogonal views are used mainly in 3D programs to model and place objects without any distortion.

Passes: This means the splitting of the image into an array of elements like the highlights or the bump channel. That way the depth of field or the color values can be edited without having to render the image again in the 3D program.

Polygons: This term generally describes the smallest unit with which a surface is constructed in a 3D program. These are triangles and squares. There are also so-called N-gons that can contain any number of corner points.

One common requirement of all kinds of polygons is that all corner points have to be on one plane. Otherwise it could result in unwanted changes of brightness when the surface is calculated. Because all polygons represent small surfaces, curved surfaces have to be assembled using multiple polygons. Thus, the modeling of organic shapes requires planning in order to use the least number of polygons possible.

Radiosity: This is a calculation method for 3D scenes where the light is to reflect off faces and encounter other objects multiple times. The light is scattered and simulates the natural behavior of light. Scenes calculated in this manner appear very natural but need, depending on the settings, much longer to calculate. This technique therefore is used mainly for still images and less for animations.

Raytracer: This is probably the most frequently used calculation method that emits rays based on the position of the viewer. When one of these rays encounters an object in the scene, the raytracer can calculate the brightness at this point and combine it with the surface properties.

On transparent and reflective surfaces, additional rays are sent from this point to, for example, objects positioned behind

the transparent object. This method is a good alternative to more precise, but slower methods like the ones that can incorporate diffuse light scattering and reflections. It results in high-quality images over a shorter period of time. The disadvantage of imprecise light simulations can, with a little experience, be compensated by the placement of additional light sources.

Real time: In connection with 3D objects, it means that the result of a manipulation is instantly visible. You don't have to wait for the calculation of an action, like the deformation of the surface, and the result can be seen instantaneously.

Refraction: Deflection of the original direction of light in transparent materials. The strength of this effect can be controlled numerically with the refraction index. Air, for example, has an index of 1.0 at room temperature, liquid water about 1.33, and glass has an estimated refraction index of 1.6.

Shader: These are patterns or surface properties that are implemented into the 3D software. Often no images are necessary in order to create surfaces. The advantage of the shader, in comparison to images, is less use of disk space and the fact it is resolution independent. A surface textured with shader therefore doesn't appear pixilated, even close-up or enlarged, as is common with enlarged pixel images. There are countless shaders that generate, for example, metal, wood, or fabric automatically.

Spline: This is a curve or path. There are several interpolations for spline curves that determine how the curve reacts between the set points. The simplest kind of spline is a linear spline. The set points are connected by straight lines. Other spline types use

tangents to be able to control the curve between the set points. Similar functions are also available in 2D programs to define drawing paths or clipping paths.

Splines can be used for several functions, such as defining the shape of objects, supplying animation paths, or to control the behavior of parameters over time during animations.

SSS: The term SSS is an acronym for subsurface scattering, which stands for the scattering of light under the surface of an object. Many materials like plastics, marble, or skin can be rendered more realistically when this scattering is simulated.

Texturing: This term defines the application of properties to the surface of a 3D object. These properties determine the look of the object and influence, for example, the shininess, bumpiness, transparency, reflections, and, of course, color.

T-stance: A pose where the arms are held parallel to the floor. The legs are stretched and the feet are close together.

UV coordinates: Every polygon can be assigned to a certain area of an image or material. This ensures that when the character moves, the material on the skin doesn't "slip" around. It is therefore necessary to assign each polygon its exact position. This information is saved in the UV coordinates. This principle works best when every polygon of the object has its own area of material. There shouldn't be any overlaps between these areas.

Weighting: This is the connection of polygon corner points of the surface to a deformation. A percentage can be assigned to each point

that determines how much it is influenced by the deformation. Weighting gradients allow a soft deformation, over a certain distance, that appears very natural compared to the abrupt movement of a mechanical joint.

Wireframe: One kind of visualization of 3D objects where the polygon objects remain invisible. Only the edges of the polygons are shown. This makes it possible, for example, how an object is structured on the opposite side since, because of the missing polygons, the otherwise hidden areas can be seen.

Weblinks

Co-Authors

Andrea Bertaccini: www.tredistudio.com

Sze Jones – Blur Studio: www.blur.com

Daniel Moreno: www.guanny.com

K. C. Lee: www.gumfx.com

Liam Kemp: www.this-wonderful-life.com

Marco Patrito: www.sinkha.com

Steven Stahlberg: www.androidblues.com

Internet Pages with Image References

www.3d.sk

www.female-anatomy-for-artists.com

www.human-anatomy-for-artists.com

www.fineart.sk

Interesting Dissertations About the "Beautiful" Face

www.uni-regensburg.de/Fakultaeten/phil_
Fak_II/Psychologie/Psy_II/beautycheck/
english/index.htm

www.beautyanalysis.com

A Variety of Programs Suitable for Working on Characters

Autodesk Maya: www.autodesk.com/maya

Autodesk 3ds Max: www.autodesk.com/
3dsmax

Softimage XSI: www.softimage.com

MAXON Cinema 4D: www.maxoncomputer.
com

NewTek LightWave 3D: http://www.newtek.
com/lightwave/

Modo: www.luxology.com

Hash Animation Master: www.hash.com

Silo: www.nevercenter.com

Pixologic ZBrush: www.pixologic.com

Special Solutions for Posing and Animating Characters

Autodesk MotionBuilder: www.autodesk.
com/motionbuilder

Credo Interactive Life Forms: www.
charactermotion.com

Poser: www.e-frontier.com

Some Internet Communities and Forums About 3D Graphics

www.cgsociety.org

http://forums.creativecow.net